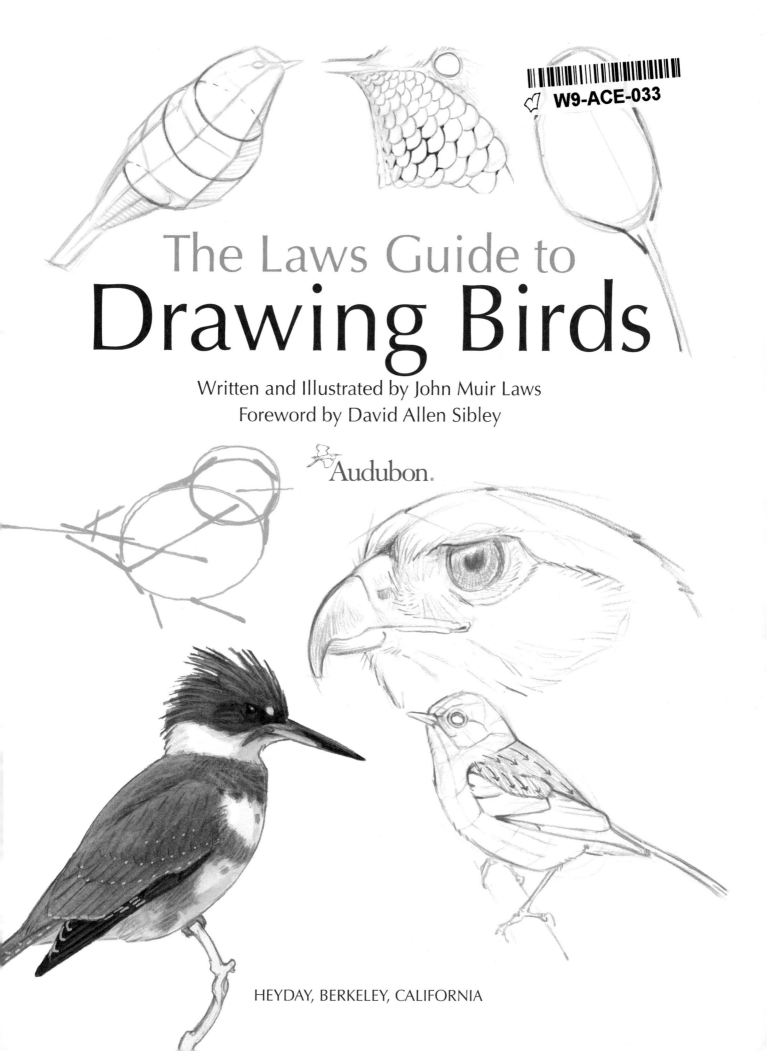

The Laws Guide to
Drawing Birds

Written and Illustrated by John Muir Laws
Foreword by David Allen Sibley

Audubon.

HEYDAY, BERKELEY, CALIFORNIA

This project is made possible in part by generous funding from the Dean Witter Foundation and the following individuals: Anonymous, Hartley and Mary Lou Cravens, Christine and J. Brooks Crawford, M.D., Michael McCone, and Robert and Rosemary Patton.

Library of Congress Cataloging-in-Publication Data is available.

Cover Art: Northern Cardinal by John Muir Laws
Cover design and interior typesetting by Lorraine Rath
Interior design by John Muir Laws

Orders, inquiries, and correspondence should be addressed to:
 Heyday
 P.O. Box 9145, Berkeley, CA 94709
 (510) 549-3564, Fax (510) 549-1889
 www.heydaybooks.com

Printed in China by Print Plus Limited

10 9 8

we to we to we to we to cwalna wren

"sku sku"
Red
Bellied
Woodpecker

Contents

Acknowledgments	vii
Foreword by David Allen Sibley	ix

BIRD DRAWING BASICS — 1

The Joy of Drawing Birds	2
Draw a Bird in Six Steps	4
Posture, the First Line	5
Proportion	6
Head Position	7
Angles	8
Everything Follows Shape	9
Step by Step: Warbler	10
Step by Step: Sparrow	12

MASTERING BIRD ANATOMY — 15

Songbird Bills	16
Cranial Kinesis	17
Feather Groups vs. Markings	18
Step by Step: Drawing Head Details	19
Turning Heads	20
Head Angles	21
Body Feathers	22
Suggesting Feathers	23
Feathers of the Chest	24
Chest Patterns	25
Back Feathers	26
Wings and the Automatic Linkage System	28
Spread Your Wings	29
Wing Tricks	30
Wing Proportions	31
Step by Step: Drawing Wings	32
Technical Points	34
Suggesting Wing Detail	35
Tail Shape and Structure	36
Moving and Foreshortening Tails	37

The Thigh Bone's Connected to the… 38
How to Balance Your Birds 39
Understanding Bird Feet 40
Simplifying Bird Feet 41
Leg Position and Angle 42
Bird Leg Details 43
Windows of the Soul 44
Iridescence 45

DETAILS AND TIPS FOR COMMON BIRDS 47

Birds of Prey 48
Raptor Anatomy 49
Raptor Body Feathers 50
Step by Step: Peregrine Watercolor 51
Drawing Waterfowl 52
The Angles of Heads and Tails 53
Duck Details 54
Duck Heads 55
Waterfowl in Motion 56
Step by Step: Ruddy Duck 57
Working with Waders 58
Wader Heads 60
Step by Step: Shorebird Value Study 61
Hummingbird Helper 62

BIRDS IN FLIGHT 65

Build a Flight Frame 66
Angled Flight Frames 67
Another Angle on Wings 68
Wing Tip Tips 69
Make a Flight Model 70
Sketching Small Birds in Flight 71
Underwing Anatomy 72
Step by Step: Raven in Flight 73

FIELD SKETCHING 75

Go Outside and Draw 76
Field Sketching Is Not Field Guide Art 77
Working in the Field 78
Field Sketching Zen 80
Drawing Moving Birds 81
Birds in Habitat 82
Travel Sketching 83
Documenting Rare Species 85

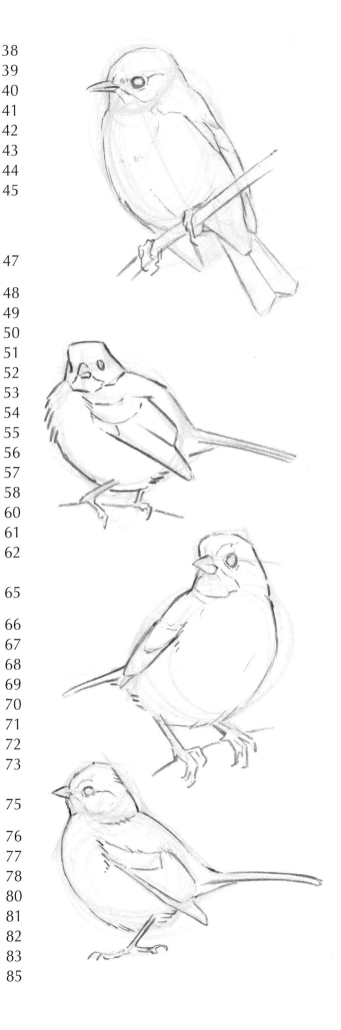

MATERIALS AND TECHNIQUES 87

Keys to Better Drawing 88
Observing Light and Shadow 90
Planes and Texture 91
Using Negative Space 92
Combining Shapes 93
How to Show Depth 94
A Few of My Favorite Things 96
Fast Sketching Combinations 97
A Portable Watercolor Palette 98
Paper Selection 99
Painting on Toned Paper 100
Color Theory Heresy 102
Reinventing the Wheel 103
Using Colored Pencils 104
Step by Step: Colored Pencil Warbler 106
Step by Step: Mixed-Media Steller's Jay 107
Watercolor Choices 108
Watercolor Techniques 110
Mixing Complementary Colors 111
Step by Step: Mixed-Media European Starling 112
Using Reference Material 113

Bibliography 114
List of Illustrations 115
About the Author 117

ACKNOWLEDGMENTS

I owe this book, and the art and scholarship reflected in it, to the mentors, teachers, patrons, and companions who supported, inspired, and trained me to do what I love.

My parents instilled in me a deep love of nature. My mother, Beatrice Challiss Laws, loves hiking and identifying wildflowers and my father, Robert Laws, is an enthusiastic birder. Nature study was not pushed on me but was a regular part of how we explored together. My parents paid attention to what interested my brother and me and encouraged us to follow those interests. My brother, James Laws, draws constantly on his travels and his self-published journals of his adventures helped open the door for my own bookmaking. I am also grateful for the encouragement, support, love, photography, and editing of my dear wife, Cybèle Renault.

I was diagnosed with dyslexia at an early age. Though I could catch on quickly to some new subjects, other basic academic skills languished. Try as I might, I could not spell or get my letters to point the right way, and I reversed numbers as easily as I did letters. Despite the support of family, my confidence in my own intelligence and academic ability drained away. By the time I reached high school I was floundering and a behavior problem. I was pulled from this tailspin by two teachers, Alan Ridley and Leroy Votto at the Urban School of San Francisco, who respected my thoughts over my spelling. Alan, the birdwatching biology teacher, also encouraged my scientific curiosity.

When I left for college, I was reenergized and understood my learning disability was not about intelligence; instead, it was about mechanics that could be overcome with work and modified study skills. At the University of California, Berkeley, I studied under Dr. Arnold Schultz, who helped me merge my creativity and interest in science. I also met Dr. Scott Stine, who told me to find what it is that I truly love and throw myself into it without fear, and that my career would grow from those seeds. I took his advice and trust he was right.

My first art teacher was my grandmother, Beatrice Challiss. She gave me the best art advice I have ever received. "Don't worry about making it perfect. Have fun with it, play with your colors and enjoy it." She hung each new picture on her kitchen wall and made me feel special. This encouragement helped keep me drawing, and as a result, my skill improved. When I was a teenager I took a weekend seminar on drawing birds from Keith Hansen. This class revolutionized the way that I drew and remains the basis for my approach to bird drawing. Keith has continued to inspire and advise me as I have developed as an artist. In 2001, I was accepted into the Scientific Illustration program at the University of California, Santa Cruz. The instructors, Ann Caudle, Jenny Keller, and Larry Lavendel, sharpened my skills and gave me the confidence to do the work I do today.

I learn a tremendous amount from the drawings of other artists. When I find an inspiring drawing or painting, I study it intently, sometimes copying it as best as I am able, line for line and stroke for stroke. When I draw this way I feel as if the other artist is in the room with me, looking over my shoulder and teaching me tricks and techniques. I have been particularly inspired by the work of John Busby, Lars Jonsson, Lawrence McQueen, Darren Rees, Keith Brockie, Hannah Hinchman, David Bennett, Chris Rose, Debby Kaspari, Peter Partington, David Sibley, John Gale, Nick Derry, Keith Hansen, Barry van Dusen, Bruce Pearson, John Schmitt, and Tim Wootton. I also study the drawings of the late Eric Ennion, Louis Agassiz Fuertes, and William Berry, from whom I have learned much about nature and drawing.

I also have been inspired by great naturalists who have inspired me to look more carefully at the world, to ask questions, and pay attention. Outstanding birders such as Jon Dunn, Joe Morlan, Rich Stallcup, and Peter Pyle have helped me learn to look more carefully and see more from encounters with wild birds. Some of my greatest mentors have been well-rounded ecologists and old-school natural historians. I am grateful to have had the opportunity to spend time in the field with David Lukas and Kurt Rademacher and Dr. Carl Sharsmith. While I was earning a master's degree in wildlife biology at the University of Montana, my professors Dr. John Kelley, Dr. Kenneth Dial, Dr. Daniel Pletscher, and my thesis advisor, Dr. Erick Greene, helped me bring greater rigor to my nature study.

I am grateful to the master photographer Robert Royse, who gave me permission to use his photographs as reference for this book. I also thank Michael Woodruff for allowing me to use his photos.

I also would like to thank the dear friends and colleagues who have helped me edit this book: my parents, Robert and Beatrice Laws, my wife, Cybèle Renault, Kathy Kleinsteiber, and Barbara Kelley. David Lukas, Joseph Morlan, Rich Stallcup, Alan Hopkins, Dan Murphy, and Jonathan Alderfer reviewed and gave me careful feedback on ornithological content. My teachers Jenny Keller and

Ann Caudle also helped me edit and revise this text. Special thanks to Bruce MacEvoy of Handprint.com for reviewing the color theory and watercolor section. I am deeply honored to have been advised by some of the best bird artists on the planet, who helped me revise and improve this book. I would especially like to thank the great bird artists David Sibley, John Schmitt, Lawrence McQueen, John Busby, Bruce Pearson, Keith Hansen, John Gale, Robert Petty, Ian Lewington, and Nick Derry for their encouragement, extensive notes, and suggested revisions.

The Dean Witter Foundation generously donated funds to support me while working on this project and I am deeply grateful for their patronage.

My ability to make this book is the result of the gifts and opportunities that I have been given, education, the mentorship of great people, and the support of loving friends and family. My artistic style and approach to drawing are inspired by the work of many. It is in thanks to this community that I present this book, which I hope will be of help to you in your discovery of birds, nature, and art. It is also my hope that through this deeper connection, you will be inspired to greater stewardship of the natural world.

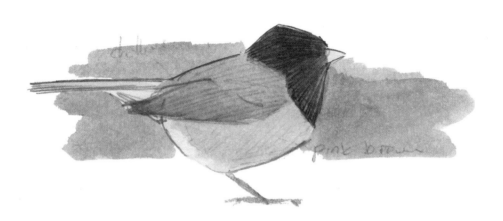

FOREWORD

I have been drawing birds for most of my life. I started almost as soon as I could hold a pencil, around five years old, and I kept at it. Birds have always been my favorite subject and have provided me with a lifetime of challenging and stimulating work.

My father is an ornithologist, so there was no shortage of technical information about birds in our house. Finding instruction on drawing birds was more of a challenge. I watched birds constantly, I studied museum specimens and worked in bird-banding stations where I could hold the birds in my hand, and I sketched them whenever I could. I studied the work of other artists. I took lessons and read books about drawing in general, and I had a short picture book written and illustrated by Lynn Bogue Hunt called *How to Draw and Paint Birds* (published by Walter Foster). That book was big on demonstrations—showing Ms. Hunt's nicely styled sketches—but short on instruction. It didn't offer much more than the self-evident "Try to draw something that looks like this."

Slowly, over years of study and practice, I learned various tricks and details that made my drawings better. I learned about bird anatomy: how the feathers radiate from the base of the bill (page 22 in this book); how the tail pivots from a point far forward of where you would expect (page 37); how the feathers meet to form a crease down the center of the belly (page 24); how the feathers move as a bird "stretches" its neck (page 7). I learned about creating the illusion of form in two dimensions by making the darkest shadows away from the very edge of the bird (page 90), or merely suggesting the arrangement of feathers by outlining a few of them (page 35), and more.

People often ask me if my passion for drawing came first or my interest in watching birds. I have always done both. For me the two are intertwined and mutually supportive in ways that I can't even begin to describe. Since drawing is one of the things I do, whenever I watch birds I am thinking about details of drawing them. I notice the line of the back, the way the bill opens, the interaction of colors and form.

Conversely, when I am drawing I look more closely and ask and answer questions that I would not have considered if I was just watching. In that sense, drawing becomes a way to interact with the birds, and drawing leads to understanding. The simple act of trying to draw something can change the way you look at the world. And that brings me to the underlying message of this book, and one of my favorite things about it: Drawing birds is about so much more than just drawing birds.

Drawing is often misunderstood. Non-artists tend to focus on the end result, and think that the primary purpose of drawing is to produce pretty pictures. For one thing, as this book points out, that's a stress-inducing way to think about the practice of drawing, since by that measure most of your drawings will be failures. More importantly, it misses the deeper and longer-lasting rewards of drawing—the knowledge and understanding that come from the process.

This book is superficially about drawing and painting birds, but it's really a guide to a more thoughtful and inquisitive study of birds, with drawing as the method. As John Muir Laws says in the introduction, "Every drawing is practice for the next one...make it your goal to learn to observe more closely and to remember what you have seen. With these goals, every drawing will be a success."

I wish this book had been available to me when I was starting out, because it is filled with tips and tricks that took me decades to learn. It is detailed and thorough enough to be helpful to an experienced artist, but the explanations are so clear and intuitive, and the text so encouraging, that it should be truly empowering for beginners. Browse this book, try a few drawings, observe, browse some more. Don't worry about how your drawings look; with this book as your guide I guarantee they will get better. Just enjoy the excitement that comes from engaging your curiosity about birds, and the satisfaction of learning.

David Sibley

David Allen Sibley
Concord, Massachusetts

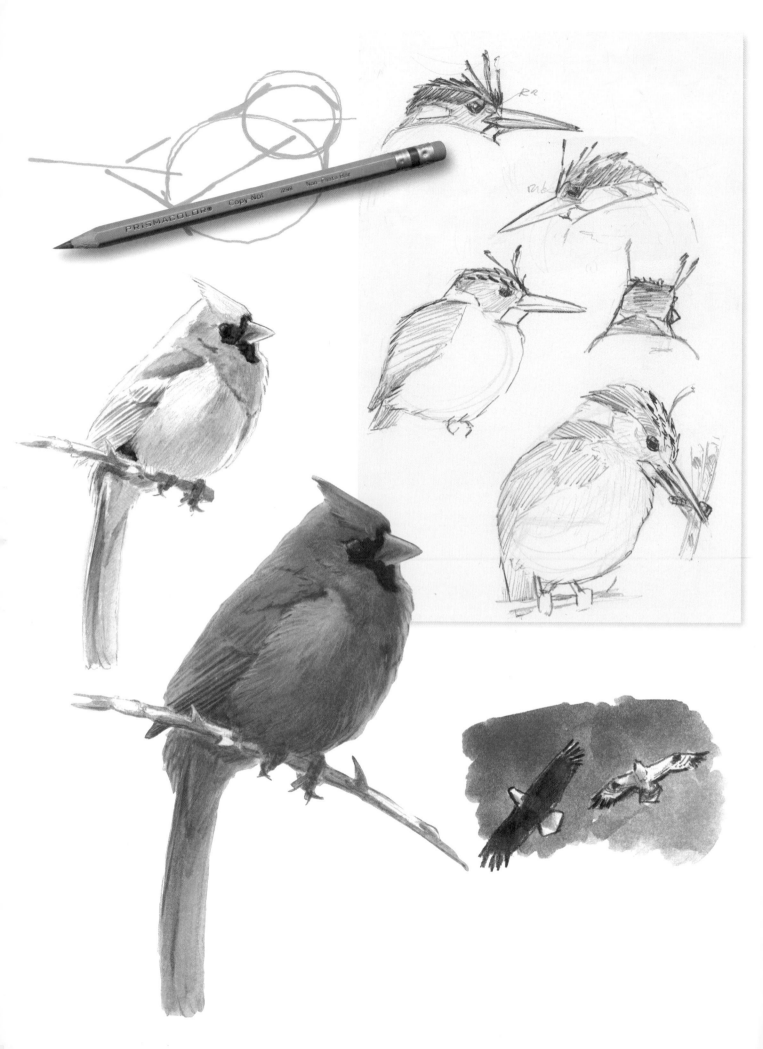

Bird Drawing Basics

To get you started, we are going to take a close look at drawing songbirds and develop a system to quickly get the essential form on paper. This is not a rigid formula to apply to all of your drawings, but a flexible framework that you can adapt and modify. Consider the fundamentals shown here as you develop your own style.

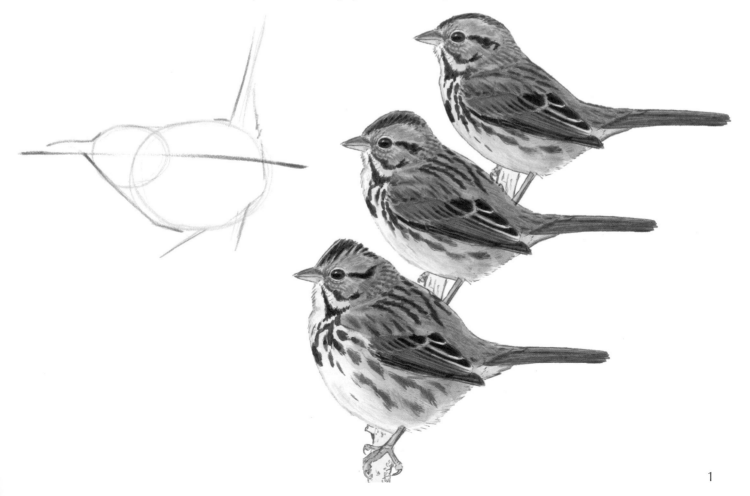

THE JOY OF DRAWING BIRDS

Birds are wonders of flight, beauty, song, and delightful behavior. Drawing them is an invitation to look more deeply at the world around you and will pull you into discovery. The practice of sketching birds will improve your drawing skill and your ability to observe and identify what you see. The greatest reward is not the product or actual drawing but is the process itself. Drawing birds opens you to the beauty of the world.

BEYOND ART

Because birds can escape to the safety of the air, they can afford to expose themselves in open places, singing and wrapped in brilliant feathers. You can easily observe all aspects of their lives and behavior. Watching birds is a window into wildness. Birds are fiercely alive, simultaneously vulnerable and resilient. Study them to quiet your mind. As you grow in patient observation, the world will open and you will be changed forever. The greatest rewards from drawing birds come from opening ourselves to the beauty that is around us every day. The more that you draw, the more you will see and remember. Drawing helps us to look again and again until we discover new subtlety and wonder in the familiar.

> Let me keep my mind on what matters,
> which is my work
> which is mostly standing still and
> learning to be astonished.
> —Mary Oliver

We assume that if we can see, we know how to observe. But true observation is a skill that we must practice and learn. The deeper we look, the more the miracle of being alive opens to our eyes. Every drawing is an investigation and an opportunity to see more details of the world. Drawing makes you look again and again, even at the things that you think you already know. From this exercise, you will discover incredible things about the world around you. The best learning does not come from books. It comes from your own experience. Drawing reinforces the sort of gestalt observations that advanced birders use to identify birds from fleeting glimpses and in poor light.

Another gift of drawing is that you will vividly remember what you have seen. Your brain erases memories that it does not consider vital to your survival. Lost in this are many beautiful and vivid experiences. The reinforcement of drawing locks experiences into your memory.

GIVE YOURSELF PERMISSION TO DRAW

You can do this. Right now, make a resolution to throw yourself into drawing birds for the next year. Let it become a joyful obsession. You will discover that the world opens up to you in ways that you could never have predicted.

There is a powerful myth that drawing is an innate ability that some are lucky enough to be born with, while others do not have the gift. This is utterly false. You are no more a born artist than a chef or mechanic. Drawing is a skill that you develop by practice. If you draw regularly, then you will be able to draw, not the other way around. Many of us remember discouraging words, perhaps in our childhoods, that made us stop drawing, and we have not picked up a pencil since. It is difficult to start again as an adult, because our fragile egos do not give us room to make mistakes and try new things at which we are not already good.

Every drawing is practice for the next one. The more you draw, the more you reinforce the neurological pathways between your eyes, brain, and hand. The greatest secret to drawing well is to make a lot of pictures. Skill is simply a factor of time spent with pencil in hand. Make yourself draw regularly for one year. At the end of the year you will not recognize your work from when you started.

If your goal is to make pretty pictures, then every time a drawing does not work out the way you wanted, you will be disappointed and then less likely to pick up your pencil the next time. Instead, make it your goal to learn to observe more closely and to remember what you have seen. With these goals, every drawing will be a success and you will keep drawing. As an artifact of making more pictures, your ability to draw will grow naturally. The single most important thing you can do to improve your art is draw more often. Your improvement never ends. Draw to observe the world around you, to learn from your observations, and to remember.

Developing any new skill requires practice. The most important thing is to push yourself to draw on a regular basis. Consider drawing a bird a day. Where can you fit it into your routine? Keep a sketchbook with you and draw all the time. The more you draw, the more you develop the neural pathways you are using. As these pathways become well-worn roads, it will become easier to draw what you see.

As you work, you will progress in a series of breakthroughs and plateaus. The more that you draw, the shorter the plateau. As you

progress, you will pass through periods when your drawings come easily and periods when you feel stymied and sense that your drawings just aren't working. This frustration is a part of the process. It comes just before the next breakthrough because you can see where you want your art to go but you are not there yet. In order to jump to the next level you need to see where you are going first, so welcome these bouts of frustration. Keep drawing and ask yourself, "What is it going to be like when I get to the next step?" A few sketches later you will be drawing at a new level.

COMMUNITY AND STEWARDSHIP

Goethe said a joy shared is a joy doubled. Seek out other people who watch birds at a sketcher's pace. Explore and draw together in the field. Encourage each other and share your observations and techniques. Avoid competition and you will all grow together. Our lives may be busy but if you schedule weekly or monthly drawing trips together, it will become a part of your routine. We often excuse ourselves from our adventures outdoors by saying, "I do not have time." May I suggest that you don't have time not to do it? Being awake and outside is one of the most important and pleasurable things we can do in our short lives.

Your relationship with birds and nature will deepen even more if you accept the role of stewardship. Stand up for and protect what you love. Join a local chapter of the Audubon Society or a group working with conservation or nature education in your area. Connect with this strong community and become a voice for the conservation and protection of nature.

DRAW A BIRD IN SIX STEPS

Start with the big picture. Posture, proportion, and angles create the silhouette of the bird. Dark and light values convey its solidity and lighting conditions. Add a little detail at the end, and stop before you overwork it.

1 As you look at the bird, try to feel the life within it. Try to capture its posture and flow with a single line. Block in the proportions of the body, and then the head. Double-check to make sure the proportions are correct before moving on. Carve in the angles, paying particular attention to where the head and tail join the body. You are not committed to these early marks. They serve as your guides.

2 Lightly draw the form of the bird, showing the major feather groups.

3 Block in the major areas of dark and light values. Lighting, color, and pattern all cause value changes.

5 Add details. Accent areas of interest and accentuate the edges. A little goes a long way, so practice restraint.

6 Knowing when to stop drawing is important. As a general rule, stop drawing before the picture is done. It is better for a drawing to be underdeveloped than overworked.

4 If you are working with color, maintain the values you observed in step 3. Remember that in some light, a red bird will not appear red. Add the color you see, not what you think it should be.

POSTURE, THE FIRST LINE

Your bird drawing starts to fly from the first line. Start by capturing the angle of the body.

Think of the first line as a suggestion of the life energy of the bird. Observe the bird carefully, asking yourself, "What is it doing? What is the energy of this bird?" Birds rest at characteristic angles: Scrub Jays sit vertically, while a shrike or kingbird will often sit at a 40° angle. Postures change as birds perform different behaviors, or as they face into the wind. Begin by drawing a faint line that indicates the angle of the head and body. You will build the drawing around this line. If your drawing starts with a proper indication of posture, your completed bird will hold its body at the correct angle. If you just start by drawing a bill and work your way to the tail, it is very unlikely that the resulting drawing will convey the attitude of the live bird. If your subject flies away after you have drawn this first line, you will already have conveyed something important about the subject. Write "jay posture at rest" or a similar note in your sketchbook. This may be useful to you in a subsequent drawing.

Posture (the long axis of the body) changes as the bird engages in different activities.

Capturing the long axis of the body is the first step in drawing a bird. You will construct the rest of the drawing around this line.

The posture of a bird that is facing you is vertical.

Your first line will determine the action, energy, and balance of the bird. Draw it lightly and loosely. Double-check to make sure it is well observed and recorded before continuing.

In a 3/4 view, a bird's posture will appear steeper than it does from the side.

In side view you can see the true angle at which a bird holds its body.

PROPORTION

Proportions change within a species as a bird fluffs its feathers and between species with different-sized bodies. Generally, smaller birds will have proportionately larger heads.

Simplify the bird to an oval for the body and a circle for the head. Draw the body first and then add the head. It is easier to draw the smaller circle proportionate to the larger one. Look carefully at the subject to determine what kind of circle or oval best frames the body shape.

These are the relative proportions of a shrike, chickadee, and magpie drawn so that the body sizes are the same. Compare the head sizes.

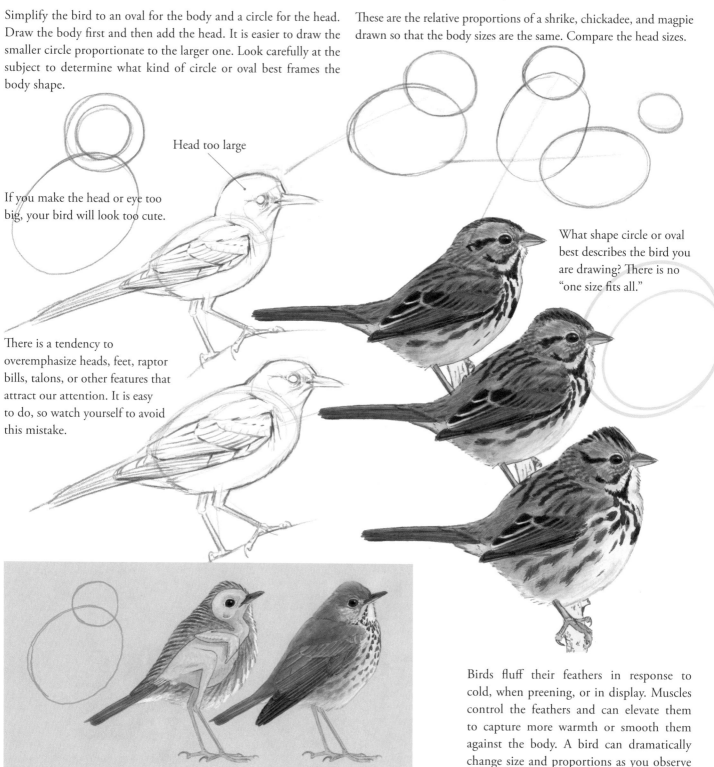

Head too large

If you make the head or eye too big, your bird will look too cute.

What shape circle or oval best describes the bird you are drawing? There is no "one size fits all."

There is a tendency to overemphasize heads, feet, raptor bills, talons, or other features that attract our attention. It is easy to do, so watch yourself to avoid this mistake.

The oval and circle reflect the underlying form of the bird's body as insulated with feathers. The flexible neck can move the head circle up, down, forward, and backward.

Birds fluff their feathers in response to cold, when preening, or in display. Muscles control the feathers and can elevate them to capture more warmth or smooth them against the body. A bird can dramatically change size and proportions as you observe it. When you draw proportions, you are not only drawing that species but that individual bird at that moment.

HEAD POSITION

The head and the body are relatively fixed skeletal structures, but the neck that connects them is extremely flexible. Head position will dramatically change the shape of the bird. Place the head with care.

To draw a bird convincingly, with structure, volume, and life, train yourself to see beyond the surface of the feathers to the underlying structure. Your drawing will look like a pile of feathers rather than a living bird if it is not anatomically correct.

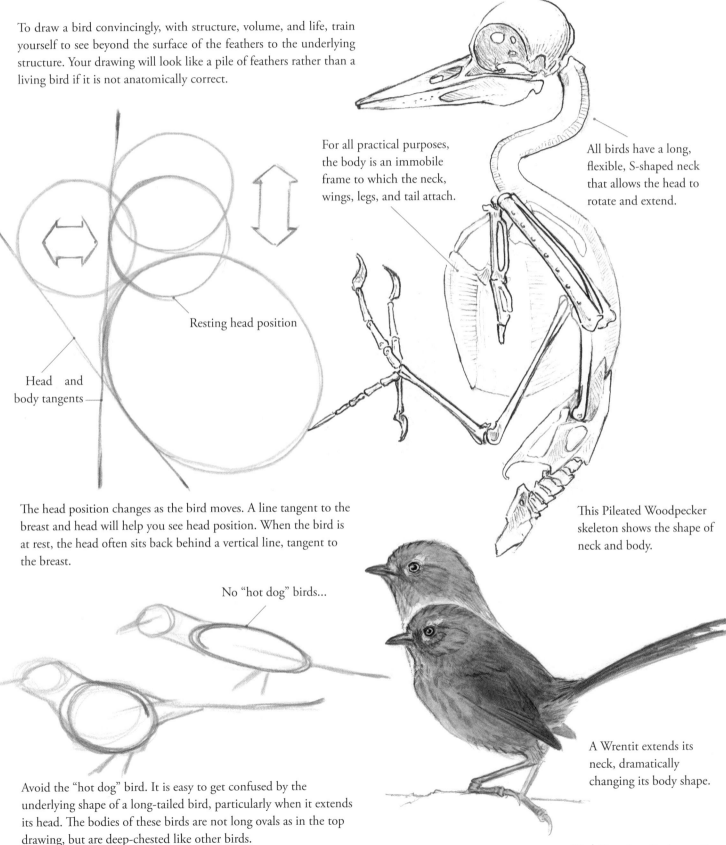

For all practical purposes, the body is an immobile frame to which the neck, wings, legs, and tail attach.

All birds have a long, flexible, S-shaped neck that allows the head to rotate and extend.

Resting head position

Head and body tangents

The head position changes as the bird moves. A line tangent to the breast and head will help you see head position. When the bird is at rest, the head often sits back behind a vertical line, tangent to the breast.

This Pileated Woodpecker skeleton shows the shape of neck and body.

No "hot dog" birds...

Avoid the "hot dog" bird. It is easy to get confused by the underlying shape of a long-tailed bird, particularly when it extends its head. The bodies of these birds are not long ovals as in the top drawing, but are deep-chested like other birds.

A Wrentit extends its neck, dramatically changing its body shape.

ANGLES

Because you build the body with circles, it is easy to over-round your bird. Look for angles where the head meets the body and the tail meets the body. Carve these into the circles with straight lines. This is the point at which your drawing will start to look like a real bird.

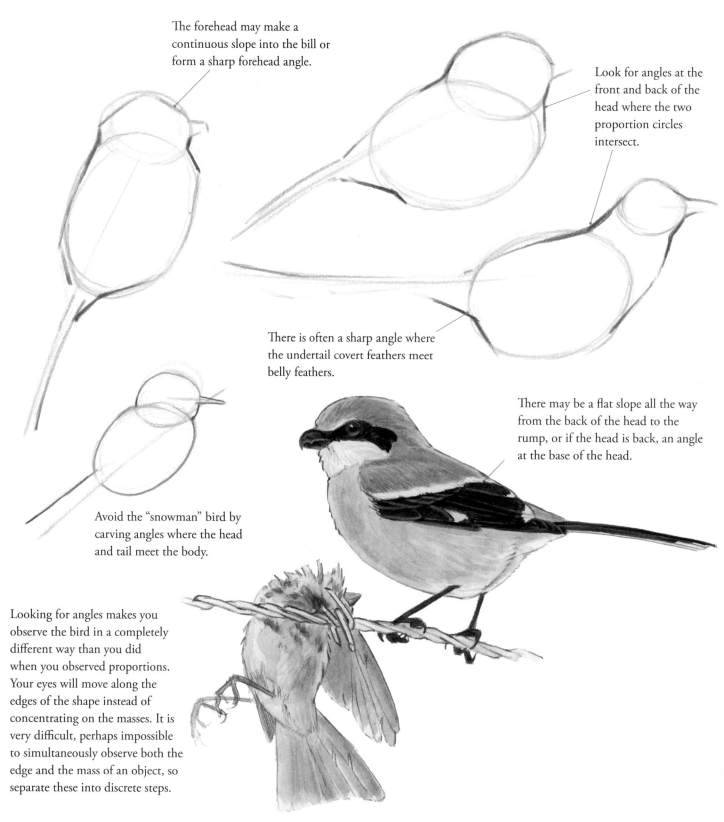

The forehead may make a continuous slope into the bill or form a sharp forehead angle.

Look for angles at the front and back of the head where the two proportion circles intersect.

There is often a sharp angle where the undertail covert feathers meet belly feathers.

There may be a flat slope all the way from the back of the head to the rump, or if the head is back, an angle at the base of the head.

Avoid the "snowman" bird by carving angles where the head and tail meet the body.

Looking for angles makes you observe the bird in a completely different way than you did when you observed proportions. Your eyes will move along the edges of the shape instead of concentrating on the masses. It is very difficult, perhaps impossible to simultaneously observe both the edge and the mass of an object, so separate these into discrete steps.

EVERYTHING FOLLOWS SHAPE

If you have the posture, proportion, and angles, your drawing will capture the gestalt of the living bird. You do not need any details. If the shape is true, your bird will come to life. In the field you often cannot see any details because of lighting or distance. Simply draw what you can see.

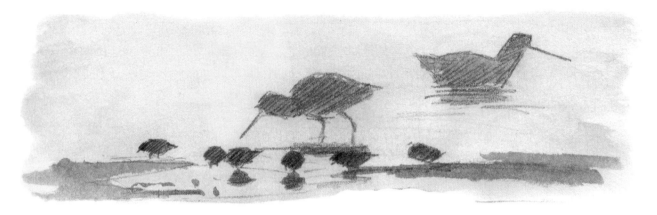

Even with good optics, it can be difficult to discern the details of a bird that is in the distance, but you can still make a successful sketch based on what you actually see. Do not make up anything. If you cannot see the eye, don't draw the eye. If you cannot see feet or feather detail, leave them out. Start to focus on other aspects of what you see, such as the spacing between individual birds.

Backlit birds present their own challenges. Take advantage of the strong contrast to emphasize areas of light and dark. Use negative spaces within the bird to construct its form. Often, dark plumage in full sunlight will look lighter than pale feathers in shadow. Capture the angles and values.

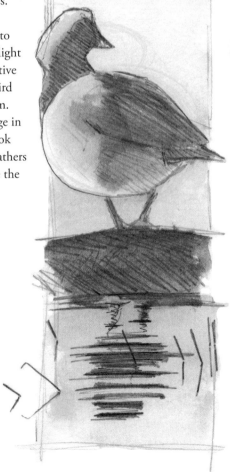

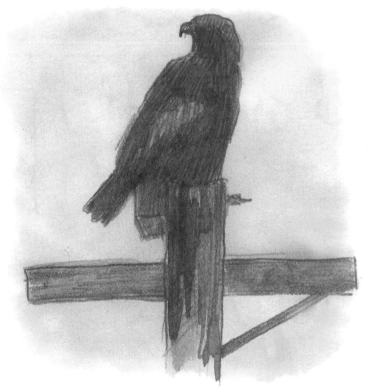

Hazy or foggy conditions also make it difficult to see details. Work with what you have and focus on posture, proportion, and angles. Sketches that emphasize what you really see in the field are the most successful. They train you to focus on the overall impression, or gestalt, of the bird.

STEP BY STEP: WARBLER

The initial strokes of this line drawing are the foundation on which you add detail. Start lightly and loosely.

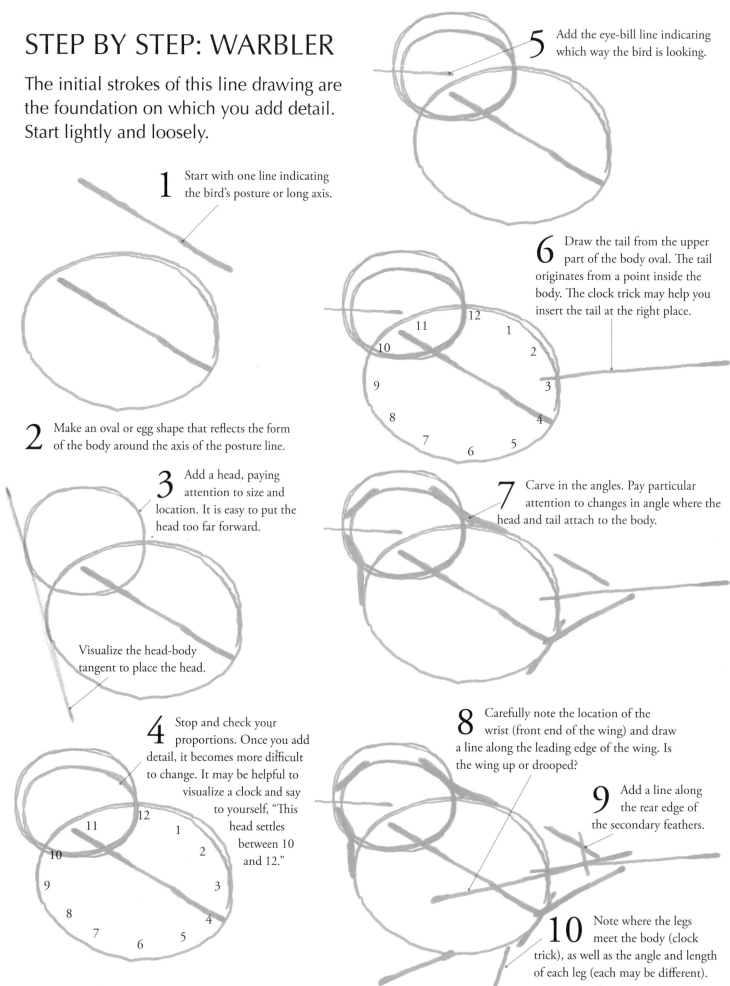

1 Start with one line indicating the bird's posture or long axis.

2 Make an oval or egg shape that reflects the form of the body around the axis of the posture line.

3 Add a head, paying attention to size and location. It is easy to put the head too far forward.

Visualize the head-body tangent to place the head.

4 Stop and check your proportions. Once you add detail, it becomes more difficult to change. It may be helpful to visualize a clock and say to yourself, "This head settles between 10 and 12."

5 Add the eye-bill line indicating which way the bird is looking.

6 Draw the tail from the upper part of the body oval. The tail originates from a point inside the body. The clock trick may help you insert the tail at the right place.

7 Carve in the angles. Pay particular attention to changes in angle where the head and tail attach to the body.

8 Carefully note the location of the wrist (front end of the wing) and draw a line along the leading edge of the wing. Is the wing up or drooped?

9 Add a line along the rear edge of the secondary feathers.

10 Note where the legs meet the body (clock trick), as well as the angle and length of each leg (each may be different).

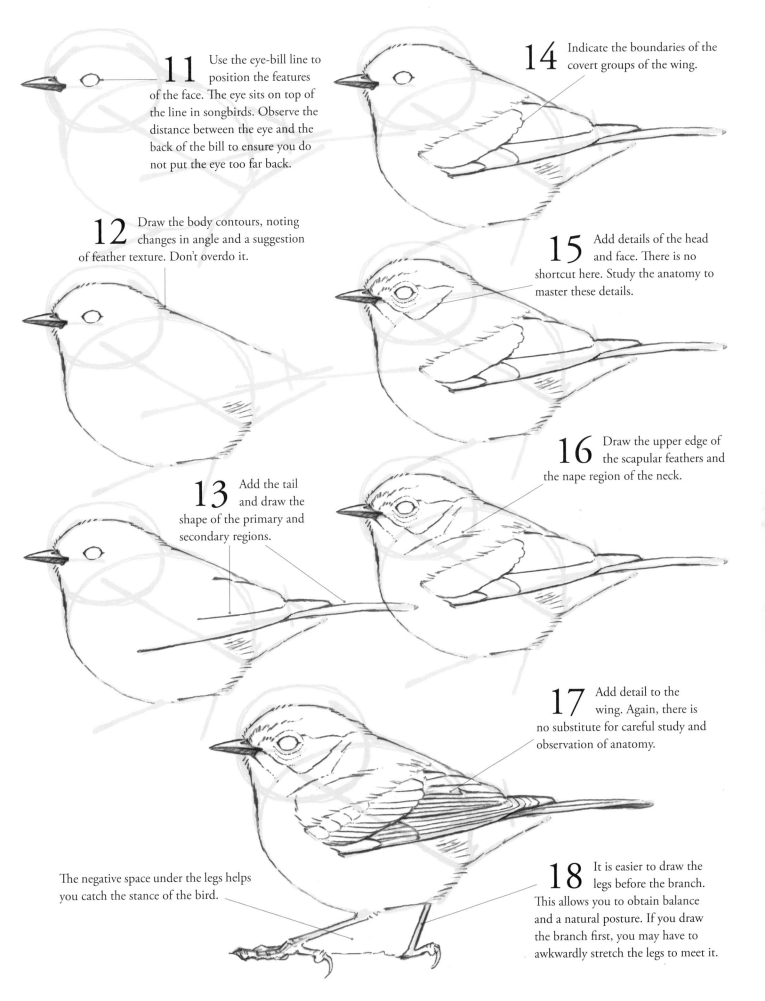

11 Use the eye-bill line to position the features of the face. The eye sits on top of the line in songbirds. Observe the distance between the eye and the back of the bill to ensure you do not put the eye too far back.

12 Draw the body contours, noting changes in angle and a suggestion of feather texture. Don't overdo it.

13 Add the tail and draw the shape of the primary and secondary regions.

14 Indicate the boundaries of the covert groups of the wing.

15 Add details of the head and face. There is no shortcut here. Study the anatomy to master these details.

16 Draw the upper edge of the scapular feathers and the nape region of the neck.

17 Add detail to the wing. Again, there is no substitute for careful study and observation of anatomy.

18 It is easier to draw the legs before the branch. This allows you to obtain balance and a natural posture. If you draw the branch first, you may have to awkwardly stretch the legs to meet it.

The negative space under the legs helps you catch the stance of the bird.

STEP BY STEP: SPARROW

Here are the same steps in the creation of a second bird. This is a flexible process that you can adapt to your subject and style.

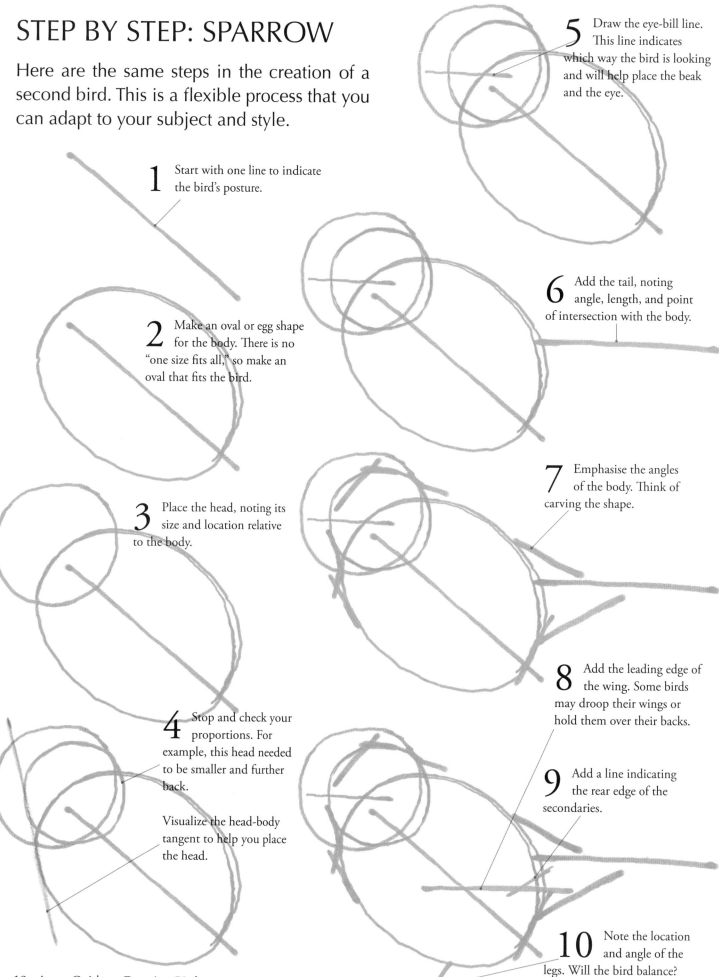

1 Start with one line to indicate the bird's posture.

2 Make an oval or egg shape for the body. There is no "one size fits all," so make an oval that fits the bird.

3 Place the head, noting its size and location relative to the body.

4 Stop and check your proportions. For example, this head needed to be smaller and further back.

Visualize the head-body tangent to help you place the head.

5 Draw the eye-bill line. This line indicates which way the bird is looking and will help place the beak and the eye.

6 Add the tail, noting angle, length, and point of intersection with the body.

7 Emphasise the angles of the body. Think of carving the shape.

8 Add the leading edge of the wing. Some birds may droop their wings or hold them over their backs.

9 Add a line indicating the rear edge of the secondaries.

10 Note the location and angle of the legs. Will the bird balance?

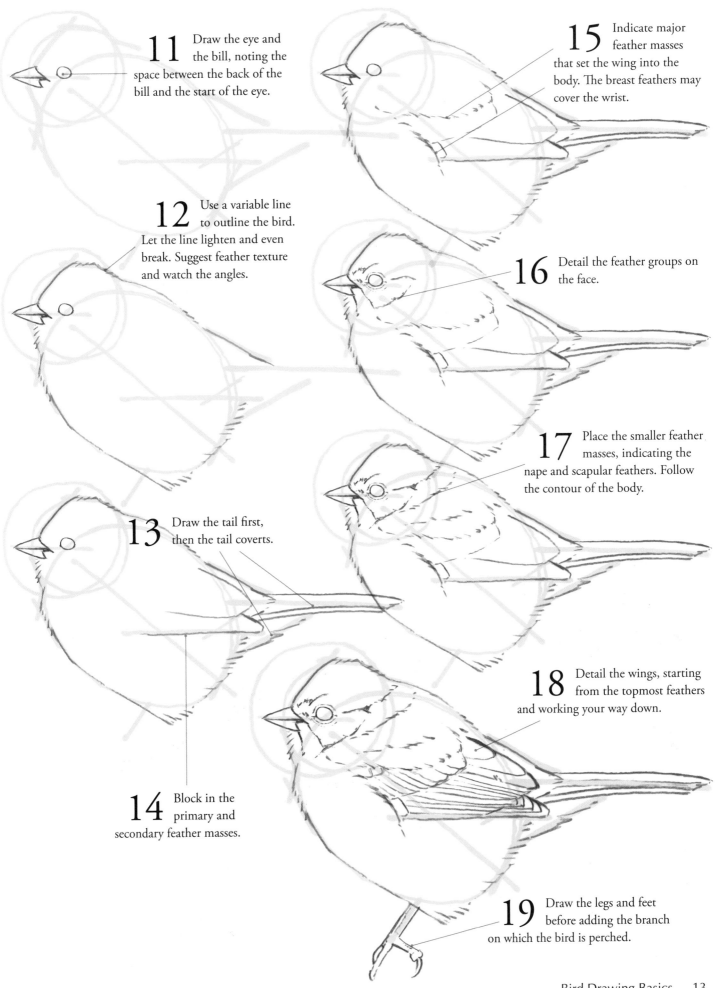

11 Draw the eye and the bill, noting the space between the back of the bill and the start of the eye.

12 Use a variable line to outline the bird. Let the line lighten and even break. Suggest feather texture and watch the angles.

13 Draw the tail first, then the tail coverts.

14 Block in the primary and secondary feather masses.

15 Indicate major feather masses that set the wing into the body. The breast feathers may cover the wrist.

16 Detail the feather groups on the face.

17 Place the smaller feather masses, indicating the nape and scapular feathers. Follow the contour of the body.

18 Detail the wings, starting from the topmost feathers and working your way down.

19 Draw the legs and feet before adding the branch on which the bird is perched.

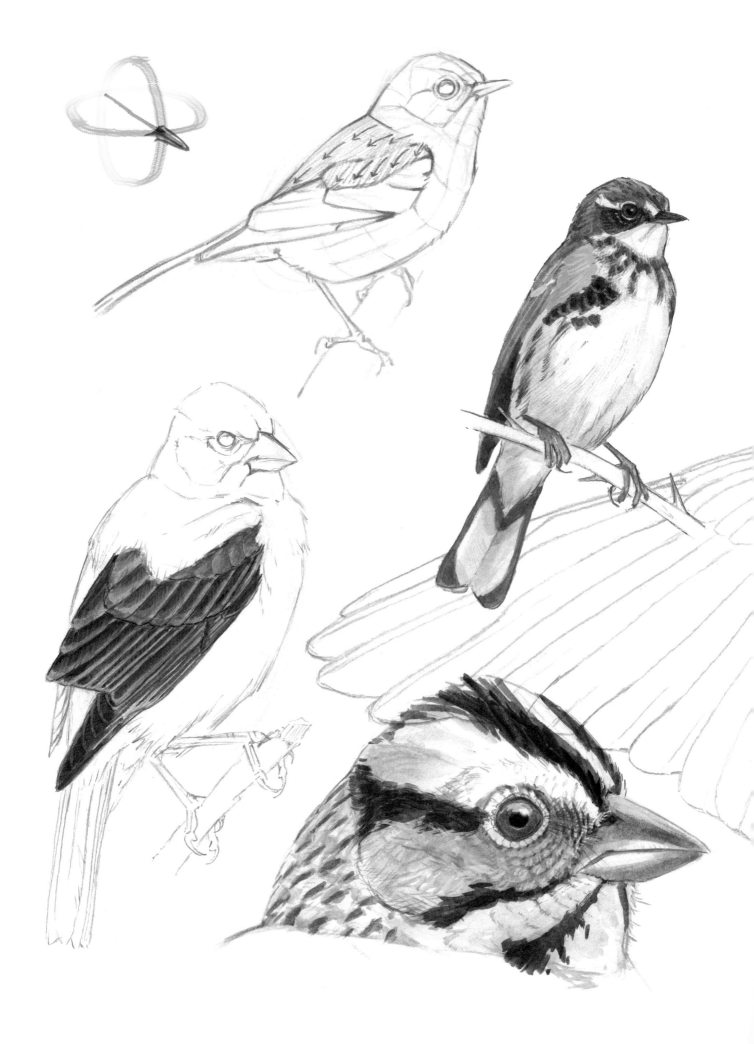

Mastering Bird Anatomy

To convincingly draw birds, you must understand what lies beneath the surface. To draw feathers, you must understand how feathers grow, overlap, and insert into the body. To create the body, you must have an understanding of the bird's skeletal structure. To pose this skeleton, you must be able to perceive the energy, intention, and life of the bird. If you understand more than can be drawn, your sketches and paintings will be informed by energy, solidity, and life.

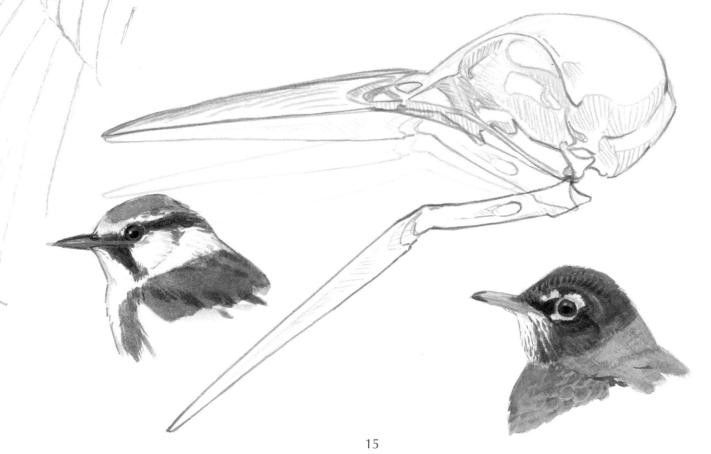

SONGBIRD BILLS

Bills are birds' essential survival tools. Study the variability of bills between species. Learn how bills attach to the head and move.

To make room for the large eye, the lower bill turns down where it meets the skull and hinges behind the eye.

In songbirds, the eye sits on top of the bill line. To place the eye, observe its distance from the front of the head. The distance to the back may change as the bird fluffs its feathers.

When the bill is open, you cannot see its hinge, which is hidden by a stretchy membrane of skin, the rictus.

Some birds show a sharp change in the angle of the cutting edge of the bill (angulated commissure). Technically, this is where the bill edge (tomium) forms a sharp angle where it meets the cheek (rictus). Birds with angulated commissures include meadowlarks and New World blackbirds, seed-cracking finches, sparrows, grosbeaks and buntings, and many groups of nectar-feeding birds, excluding hummingbirds.

The shape of the open bill is formed by the inner edge of the bill and the skin that stretches across the cheek. You may be able to see both in the angles of the open bill.

Upper mandible. Note small nostril (sometimes covered by feathers) and change in angle where the edge of the bill turns down. Feathers of the head curve into the bill from behind.

Lower mandible feathers curve into the base of the bill and extend out underneath the bill.

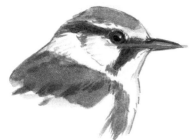

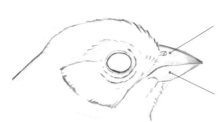

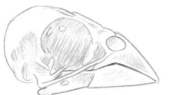

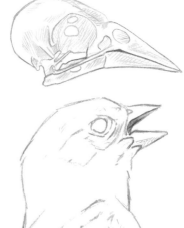

CRANIAL KINESIS

Most bill movement comes from dropping the lower bill. The upper bill can also move independently of the rest of the skull (kinesis), but this movement is usually subtle.

Movement of the upper bill may be subtle. In one study, White-throated Sparrow kinesis was measured using high-speed photography and showed a barely detectable 9.5 degrees of movement in full song. Some birds may show as much as 12 degrees of movement.

It may be hard to detect movement of the upper bill.

Narrow-billed songbirds such as warblers and wrens may show observable movement of the upper mandible. It will be subtle, so be cautious and avoid overdoing it. When birds hold their heads up when they sing, the upper bill appears to flip up more than it actually does.

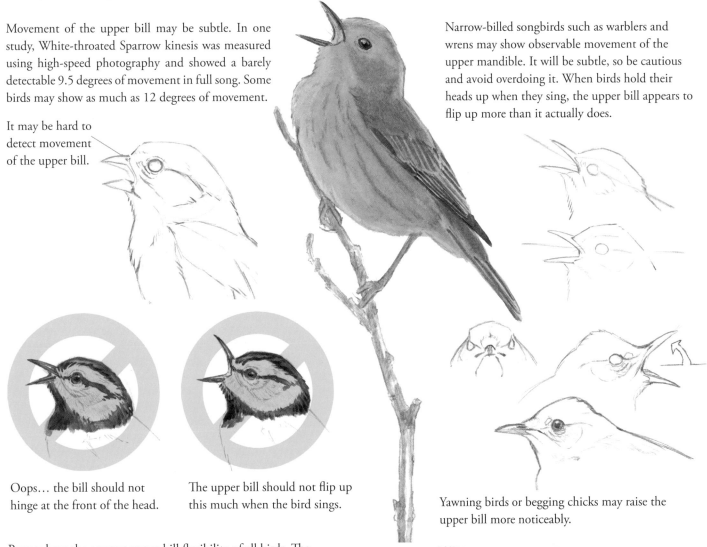

Oops… the bill should not hinge at the front of the head.

The upper bill should not flip up this much when the bird sings.

Yawning birds or begging chicks may raise the upper bill more noticeably.

Parrots have the greatest upper bill flexibility of all birds. The movement of the bill helps them manipulate nuts and seeds. This movement occurs at a hinge between the skull and the bill (prokinesis).

Less common is the ability to move the upper bill from a hinge point within the bill itself (rhynchokinesis).

Woodcocks and long-billed shorebirds can move the tip of the upper bill to grasp worms under the mud.

FEATHER GROUPS VS. MARKINGS

Feather groups are present in all birds and contribute to the bird's shape. Markings are formed by colored feathers within these groups.

Auriculars Stiff feathers that cover the ear and form a triangular patch that extends back from the corner of the opening of the bill and the middle of the eye.

Orbital feathers Tight feathers above and below the eye. Two to four rows of feathers may be seen below the eye. Even without special coloring, you can see the texture of this feather group.

Supraloral feathers arch over the lores at the front of the eyebrow.

Lores Rows of small feathers in front of the eye

Feather Groups

Median crown-stripe

Lateral crown-stripes

Supercilium or eyebrow

Eye-stripe along the upper edge of the auriculars

Feather Markings

Nape feathers cover the back of the neck behind the auriculars.

Throat

Eye-ring and broken eye-ring made by contrasting orbital feathers

Malar A zone of feathers that starts at the curve at the base of the lower bill and covers the bones of the mandible. A small crease is often visible at the bottom edge of the bill, indicating the lower edge of the malar. The distinction between the malar and the throat becomes less clear as you move away from the bill.

Subauricular stripe or mustachial stripe along the lower edge of the auriculars

Lateral throat-stripes

Markings can be made by the coloring of entire feather groups.

Other markings are made by dark feathers along the edges of feather groups.

Some markings are made by a combination of the colors of feather groups and the colors at the edges of groups.

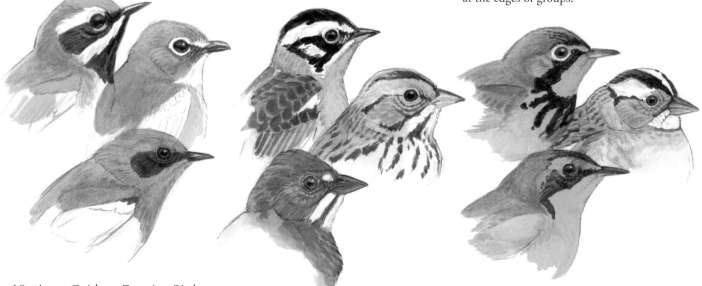

STEP BY STEP: DRAWING HEAD DETAILS

Before drawing head markings, lightly outline the feather groups. These give structure to the face and help you place the markings correctly.

Start by drawing the eye-ring as a zone of tightly packed feathers that circle the eye. You may find it split into two sections, one above and one below the eye. There may be additional rows below the eye.

Draw the ear patch as a triangle of feathers that starts behind the eye. The front edge begins at the rear corner of the bill. This edge may change angle below the rings of feathers that surround the eye. The feathers in front of the eye puff up and out to form the lores.

A small crease drops from the bottom corner of the bill. It will be more clearly defined closer to the bill. The malar region sits between this crease and the ear patch.

The supercilium is the stripe above the eye. The front edge of this stripe makes an arc over the lores called the supraloral region.

Birds' necks are flexible, so the nape feathers that cover the neck will take on a variety of shapes depending on the position of the bird's head. There may be a change in the angle of the head profile where the nape connects to the back of the head. Note that this sparrow's eyeline is raised because the nape and crest feathers are lofted.

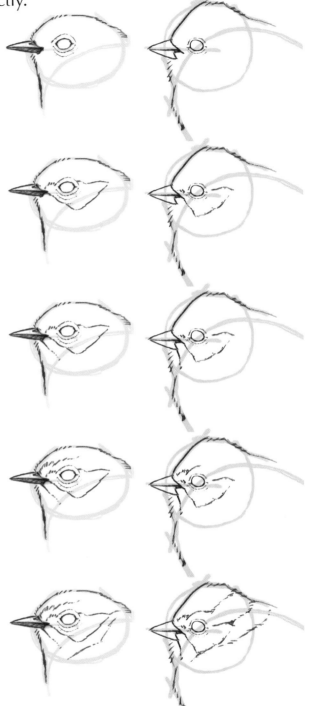

When a bird lifts its nape feathers, the contour of the head, the shape of the feather groups, and the head markings change dramatically. Note how the rear edge of the auriculars and the supercilium broaden and point up.

TURNING HEADS

Crosshairs through the bill and eye and around the head will help you keep track of the alignment of the bill, eye, and feather groups as a bird moves its head.

Visualize and draw the eye-bill line as a circle that wraps all the way around the head. Draw a second circle through the middle of the face and around the back of the head.

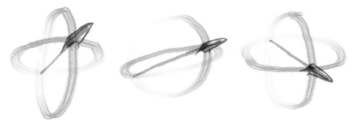

The eye sits on top of the eye-bill line.

The base of the bill fits over the intersection of the crosshairs.

The tip of the bill is aligned with the intersection of the crosshairs.

A line through the intersection of these two circles aligns the bill. Bill length will appear to change with head position. In a side view, you will see the full length of the bill. It appears shorter in 3/4 views.

The symmetry of lines on the head is maintained by keeping track of the center line and the eye-bill line. As the head turns, think of these lines as circles that wrap around the head. Align facial stripes and markings relative to these lines. Pay particular attention to the shapes made by patterns that wrap around the far side of the head. It will help to look at these as negative shapes. Also note that the shape of the eye will be foreshortened. At what point can you no longer see the eye on the far side of the head?

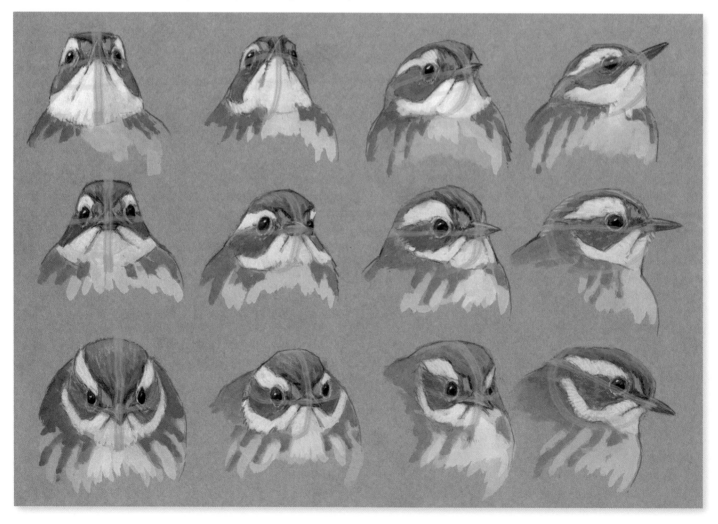

HEAD ANGLES

Bird heads bulge outwards below the eye. Look for this change in angle in front and in 3/4 views. This bulge is more pronounced in some birds, such as the flycatcher genus *Myiarchus* and Vermilion Flycatchers.

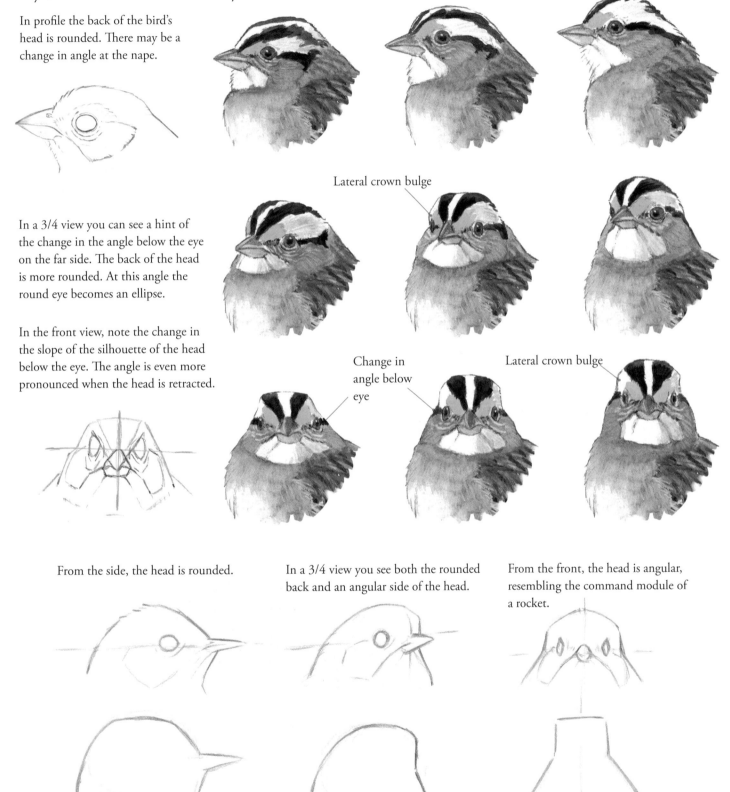

In profile the back of the bird's head is rounded. There may be a change in angle at the nape.

In a 3/4 view you can see a hint of the change in the angle below the eye on the far side. The back of the head is more rounded. At this angle the round eye becomes an ellipse.

In the front view, note the change in the slope of the silhouette of the head below the eye. The angle is even more pronounced when the head is retracted.

Lateral crown bulge

Change in angle below eye

Lateral crown bulge

From the side, the head is rounded.

In a 3/4 view you see both the rounded back and an angular side of the head.

From the front, the head is angular, resembling the command module of a rocket.

BODY FEATHERS

One key to drawing feathers is to understand more of the anatomy than can be drawn. Study feather placement and groups to inform your rendering of the plumage.

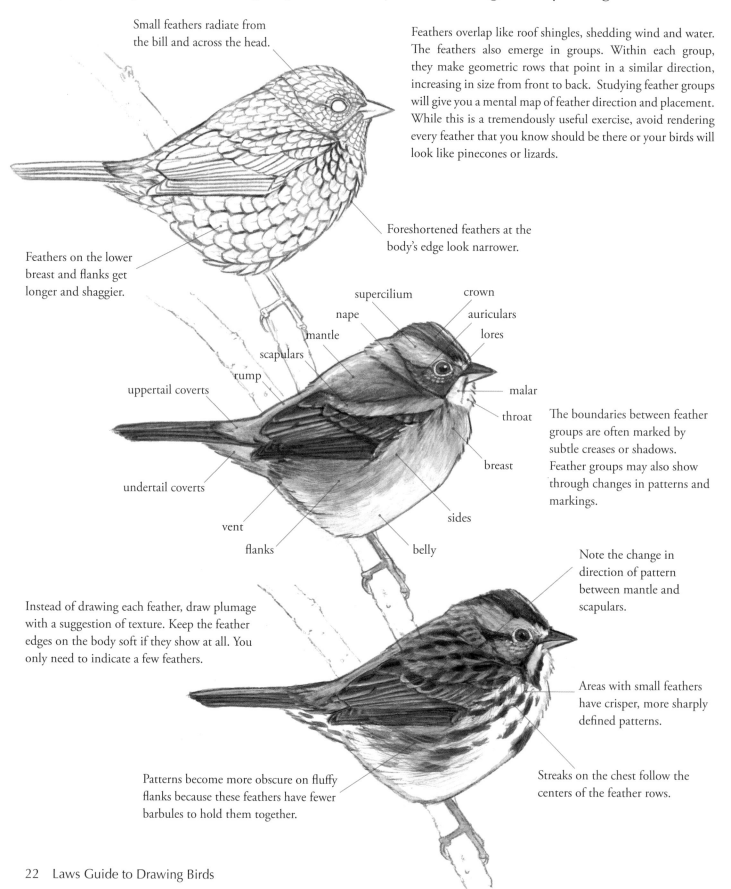

Small feathers radiate from the bill and across the head.

Feathers overlap like roof shingles, shedding wind and water. The feathers also emerge in groups. Within each group, they make geometric rows that point in a similar direction, increasing in size from front to back. Studying feather groups will give you a mental map of feather direction and placement. While this is a tremendously useful exercise, avoid rendering every feather that you know should be there or your birds will look like pinecones or lizards.

Foreshortened feathers at the body's edge look narrower.

Feathers on the lower breast and flanks get longer and shaggier.

supercilium
nape
mantle
scapulars
rump
uppertail coverts

crown
auriculars
lores
malar
throat

The boundaries between feather groups are often marked by subtle creases or shadows. Feather groups may also show through changes in patterns and markings.

breast

undertail coverts

vent

flanks

sides

belly

Note the change in direction of pattern between mantle and scapulars.

Instead of drawing each feather, draw plumage with a suggestion of texture. Keep the feather edges on the body soft if they show at all. You only need to indicate a few feathers.

Areas with small feathers have crisper, more sharply defined patterns.

Patterns become more obscure on fluffy flanks because these feathers have fewer barbules to hold them together.

Streaks on the chest follow the centers of the feather rows.

SUGGESTING FEATHERS

Draw plumage, not individual feathers. You can give the impression of feathers without drawing them. Show shadows where feathers divide at the edges of feather groups or where feathers are slightly fluffed. If you draw every feather the bird will look scaly.

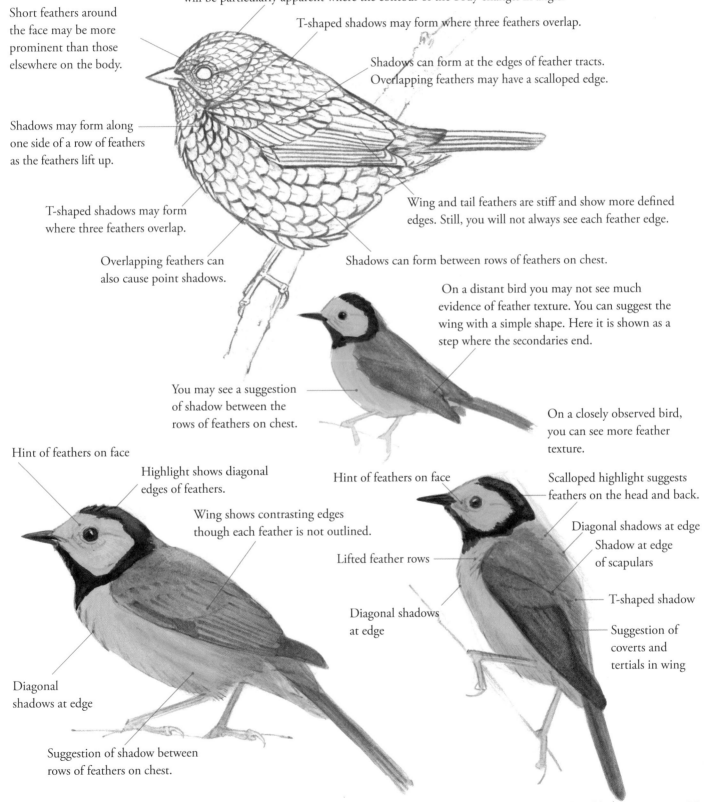

Short feathers around the face may be more prominent than those elsewhere on the body.

Feathers along the outer edge of the body may make diagonal shadows. Such edges will be particularly apparent where the contour of the body changes in angle.

T-shaped shadows may form where three feathers overlap.

Shadows can form at the edges of feather tracts. Overlapping feathers may have a scalloped edge.

Shadows may form along one side of a row of feathers as the feathers lift up.

Wing and tail feathers are stiff and show more defined edges. Still, you will not always see each feather edge.

T-shaped shadows may form where three feathers overlap.

Overlapping feathers can also cause point shadows.

Shadows can form between rows of feathers on chest.

On a distant bird you may not see much evidence of feather texture. You can suggest the wing with a simple shape. Here it is shown as a step where the secondaries end.

You may see a suggestion of shadow between the rows of feathers on chest.

On a closely observed bird, you can see more feather texture.

Hint of feathers on face

Highlight shows diagonal edges of feathers.

Wing shows contrasting edges though each feather is not outlined.

Hint of feathers on face

Lifted feather rows

Scalloped highlight suggests feathers on the head and back.

Diagonal shadows at edge

Shadow at edge of scapulars

Diagonal shadows at edge

T-shaped shadow

Diagonal shadows at edge

Suggestion of coverts and tertials in wing

Suggestion of shadow between rows of feathers on chest.

FEATHERS OF THE CHEST

Chest feathers are not a continuous set of feathers but are composed of groups. Understanding the direction and size of these feathers will help you draw the chest.

FEATHER GROUPS

Breast feathers form a mass across the upper chest. When fluffed, these may protrude from the rest of the chest feathers.

The **sides** connect to the top of the flank feathers and may fluff out over the wrist (front of the wing).

Flank feathers run down the side. The feathers that are higher on the chest are smaller with crisper edges, while the lower feathers are longer and shaggier.

Belly feathers flip inward from the flanks to cover the brood patch (bald spot) in the middle of the belly.

Vent feathers make a small patch that covers the cloaca.

Undertail coverts cover the base of the tail and contribute to the streamlined shape of the bird.

Use the groove between the belly feathers to help establish the direction and curvature of the center line of the breast. The more the bird rotates, the more the center line will curve, much in the same way that longitude lines wrap around a globe. Feather patterns follow the same lines as they wrap around the body.

Breast

Sides

Flanks

Patterns change with angle and perspective.

Belly

Vent

Center line

Undertail coverts

3/4 VIEW

Envision the bird three-dimensionally, with the head and undertail coverts intersecting the body in ellipses. Curve shadows and feather patterns around the form instead of drawing them straight to the edge.

CHEST PATTERNS

To maintain the symmetry of breast feather patterns, draw the center line of the breast and keep track of the patterns along each side.

Establish the center line of the breast (longitude). Patterns on the breast will be roughly symmetrical on either side of this line. Wrap lines at right angles to the center line (latitude) to help maintain the symmetry of the chest patterns. The patterns need not be perfectly symmetrical. There will be variation in the streaking and spotting patterns on either side, but the basic structure will maintain its symmetry.

Note how the block of the wing feathers changes shape and foreshortens as the bird rotates.

Belly feathers make a faint crease where they come together.

Draw a line down the center of the breast and keep breast patterns more or less symmetrical on each side of that line. In a 3/4 view, the breast line is curved.

Feather patterns wrap around the curvature of the chest. Pay particular attention to the change in the angles on the far side of the breast.

Feathers on the upper breast are smaller and make crisp patterns. Feathers on the lower belly are longer and make more diffuse or softer lines.

BACK FEATHERS

The back of the bird is divided into four zones: the mantle, scapular feathers, rump, and uppertail coverts. These areas may have different colors or patterns.

FEATHER GROUPS

The **mantle** feathers occupy the middle of the back and are oriented straight back. Mantle feathers are often streaked, making parallel stripes that run down the back.

Scapular feathers sit on either side of the mantle and cover the space where the wings meet the body, along the top of the folded wing. The scapulars can be slicked back, making tight rows of feathers, or may droop over the wing. The scapular feathers may be streaked like the back but usually point down toward the wing, especially when they are drooped.

Rump feathers sit between the wings and are completely covered when the bird holds its wings over its back. When the wings droop, the rump feathers are visible. They are usually unstreaked, even if the bird's mantle and scapulars have streaks.

Uppertail coverts are stiff overlapping feathers that smooth the contour from rump to tail. They may be streaked or dark-tipped.

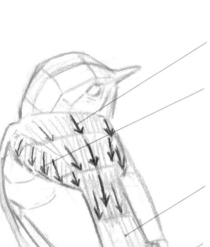

3/4 VIEW

Maintain the geometry of the body by following the center line of the back.

Connect the head and tail with ellipses and wrap shadows and patterns around the curved body.

Mantle feathers lie at a different angle than the scapular feathers. These feathers may be colored in similar ways but you will see a change in the direction of the barring on the back.

The rump feathers are hidden when the wings fold over the back. If the bird droops its wings, this region becomes visible and may reveal colors and patterns otherwise hidden, such as the white patches of Olive-sided Flycatchers or the gray rumps of Chipping Sparrows.

Tuck the wing under the scapulars and into the side of the breast feathers to avoid a wing that feels "pasted" on the side of the bird.

The uppertail coverts may show more pattern and definition of their edges than the softer rump feathers.

TRICKS FOR THE BACK VIEW

Drawing a line down the middle of the back will help you keep the symmetry of stripes on the mantle or patterns in the scapular feathers.

The foreshortened wing that wraps around the far side of the bird can be difficult to draw. Take advantage of photographs and look at the variety of shapes made by the far wings. Keep it simple: using a minimum of detail, block in the wing shape. Learn to trust what you see. Another great way to study this is to make a series of sketches as you slowly rotate a mounted bird.

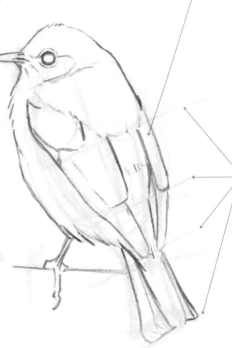

Keep elements of the back and wings symmetrical by aligning them with sets of parallel lines across the back.

Wings that are folded up on the back may sculpt an interesting negative space of rump between them. Look at the shape of this rump wedge to help you place the wings the right distance apart.

SCAPULARS

The distinction between mantle and scapular feathers is often very subtle. On birds with no streaking or patterning on the back, look for a faint seam between the feather groups.

RUMP

Songbirds can loft and deploy their rump feathers. When it gets cold, these elevated rump feathers almost completely cover the wings. Some species, such as Olive-sided Flycatchers, will reveal diagnostic patterns on the rump.

On birds with streaked backs, look for a change in the angle of the feather streaks where the back meets the scapulars.

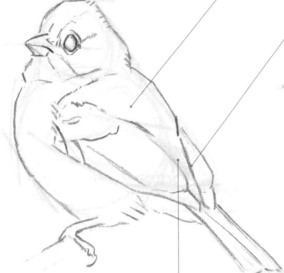

Rump feathers elevated

Carolina or Bewick's Wrens will reveal patterns of spots when the rump feathers are elevated.

WINGS AND THE AUTOMATIC LINKAGE SYSTEM

To reduce the need for heavy muscles in wing operation, the bones of a bird's wing are attached so that moving the elbow automatically moves the wrist.

Birds' arm bones are arranged in a manner homologous to the human arm. From the shoulder there are one upper arm bone (humerus), two forearm bones (radius and ulna), and a hand. The major difference is that the bird's fingers are fused into a solid unit while the thumb remains free. These bones have different proportions in different species. A Calliope Hummingbird has short, strong arm bones to help flap the wing quickly. A Rock Pigeon has mid-size arm bones for a good general-purpose wing. In contrast, a Laysan Albatross has long, light arm bones for a long, gliding wing which is more difficult to flap.

The forearm bones are attached to the hand and upper arm bones in a manner analogous to a parallel ruler, so that moving one joint moves the other. This allows the bird to move its hand by flexing the elbow.

You can make a simple automatic linkage system by connecting two sticks to two sticks. Open and close one joint and watch the other move on its own.

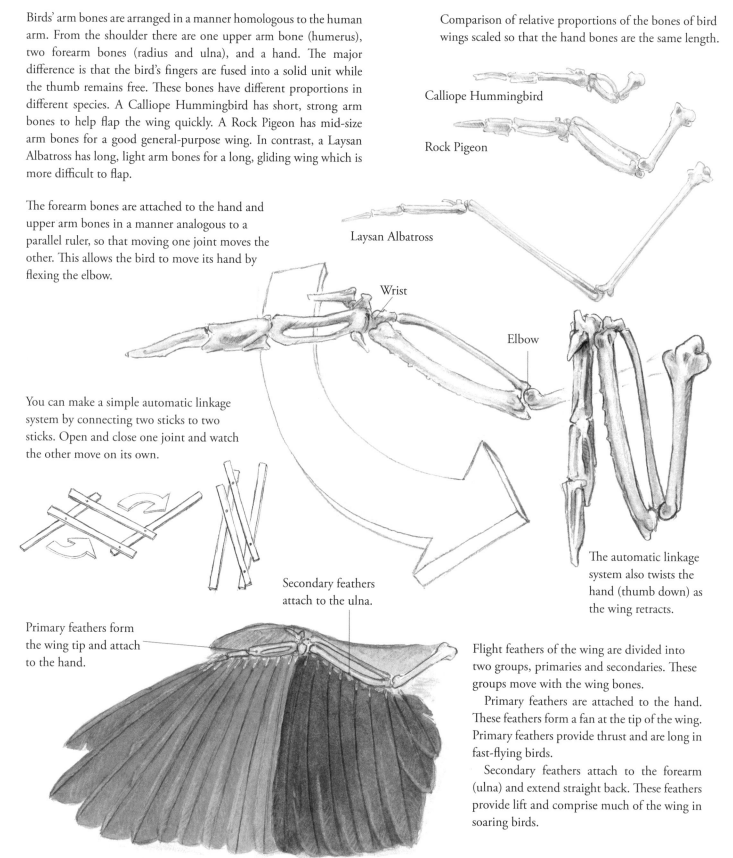

Comparison of relative proportions of the bones of bird wings scaled so that the hand bones are the same length.

Calliope Hummingbird

Rock Pigeon

Laysan Albatross

Wrist

Elbow

The automatic linkage system also twists the hand (thumb down) as the wing retracts.

Secondary feathers attach to the ulna.

Primary feathers form the wing tip and attach to the hand.

Flight feathers of the wing are divided into two groups, primaries and secondaries. These groups move with the wing bones.

Primary feathers are attached to the hand. These feathers form a fan at the tip of the wing. Primary feathers provide thrust and are long in fast-flying birds.

Secondary feathers attach to the forearm (ulna) and extend straight back. These feathers provide lift and comprise much of the wing in soaring birds.

SPREAD YOUR WINGS

As the wing opens and closes, the primary and secondary feathers move in different ways. The primary feathers move like a fan, while the secondary feathers either remain parallel but spread apart or pack together more closely.

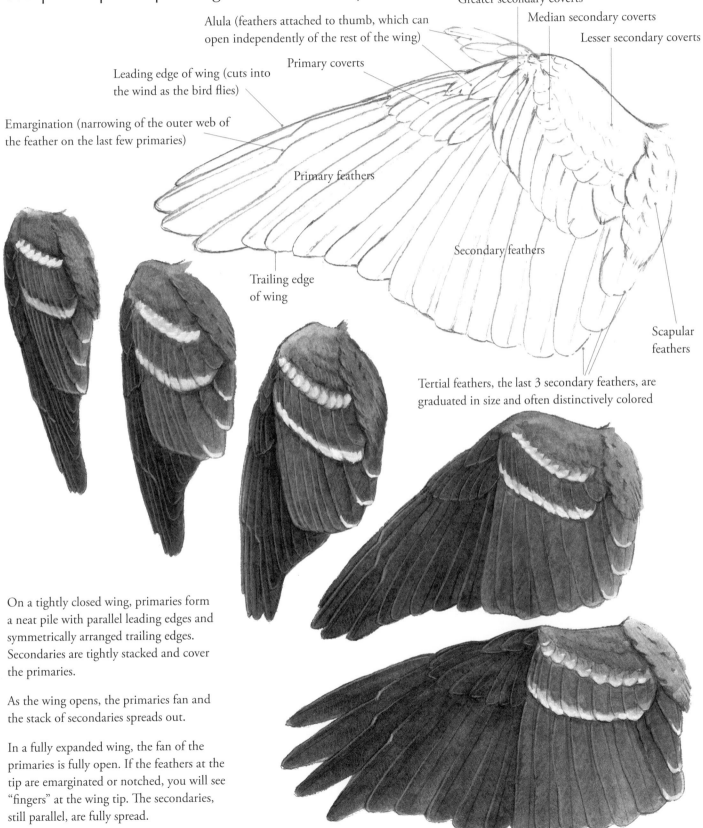

Alula (feathers attached to thumb, which can open independently of the rest of the wing)

Greater secondary coverts

Median secondary coverts

Lesser secondary coverts

Primary coverts

Leading edge of wing (cuts into the wind as the bird flies)

Emargination (narrowing of the outer web of the feather on the last few primaries)

Primary feathers

Secondary feathers

Trailing edge of wing

Scapular feathers

Tertial feathers, the last 3 secondary feathers, are graduated in size and often distinctively colored

On a tightly closed wing, primaries form a neat pile with parallel leading edges and symmetrically arranged trailing edges. Secondaries are tightly stacked and cover the primaries.

As the wing opens, the primaries fan and the stack of secondaries spreads out.

In a fully expanded wing, the fan of the primaries is fully open. If the feathers at the tip are emarginated or notched, you will see "fingers" at the wing tip. The secondaries, still parallel, are fully spread.

WING TRICKS

Get comfortable with drawing wings. If you choose to draw each feather, lay in the sections of the wing, then start with the topmost feather in each section and work down from there.

SECONDARIES

Start drawing secondary feathers with the innermost or smallest tertial feather and then the other two tertials, working your way down.

Add the rest of the secondaries in a pile, parallel to the edge of the largest tertial. Start at the back and work your way to the front.

SCAPULARS COVER THE TOP OF THE WING

Fluff the scapular feathers down over the coverts to form the top edge of the wing.

TUCK THE WING INTO THE BREAST FEATHERS

Tuck the front edge of the wing up under the breast feathers. The scapular feathers cover the top edge of the wing. When it is cold, a bird will bury its wrist deeper into its feathers.

PRIMARY SPACING

Note the number and spacing of the primary feathers. They may be evenly spaced or have irregular lengths. This may be due to molt or a species characteristic. Place a dot at the tip of each feather.

Draw the trailing edges first, then complete each tip before drawing the parallel leading edges. The tips of the primary feathers usually become more pointed as you get to the tip of the wing (exception: some Eurasian warblers).

EMARGINATION LINE

The diagonal emargination line is the result of emargination (narrowing of the outer web of the feather) occurring closer to the feather tip as you move from the leading edge inward. Thus, when the primaries are folded together, the combined locations of the emargination point produce the emargination line.

If the wing shows emargination, draw a diagonal line showing the location, slope, and extent of the steps on the outer feathers. The location and angle of the line will vary between species.

As you draw the leading edge of each feather, show the step at the emargination point.

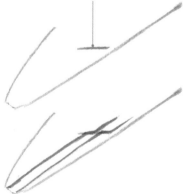

Emargination line

WING PROPORTIONS

The relative proportions of the parts of the wing differ between species. Understand the range of variability and look for these proportions as you draw.

Below, the folded wings of six birds are scaled so that the secondary feathers are the same length. Note how far the primaries extend behind the secondaries. This distance is called the primary projection. It is an important field mark in identifying birds and is important to include in your sketches. If the secondary feathers shorten from the tip of the last tertial to the wrist, the back edge of the secondaries will form an angle. Look through bird photographs and try to pick out birds that show variation in primary projection or the angle of the secondaries.

Where is the point of the wrist? It may be hidden by breast feathers.

How far down do the covert feathers reach?

What is the angle of the bottom edge of the secondaries?

Where on the back do the secondary feathers end?

How far do the primaries extend beyond the secondaries and where do they end relative to the tail?

Pipits and wagtails have very long tertial feathers that cover most of the primary feathers.

What sparrow has the shortest primary projection?

Note the spacing of primary feathers. It may be uneven due to molt or species.

Pewees have a much longer primary projection than *Empidonax* flycatchers.

Falcons have longer primaries and shorter secondaries than buteos.

Swifts, swallows, and hummingbirds have extremely long primary feathers and reduced secondaries.

Primary feathers provide thrust, while secondary feathers provide lift. Birds that do a lot of soaring often have wide secondary feathers. Birds that flap powerfully for speed have long primary feathers. Thus buteos or eagles emphasize secondary feathers, while falcons emphasize primary feathers.

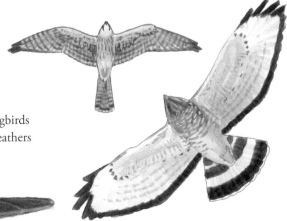

STEP BY STEP: DRAWING WINGS

When drawing the wing, start with the shapes of the feather groups. Then draw the individual feathers, starting with the topmost feather in each group.

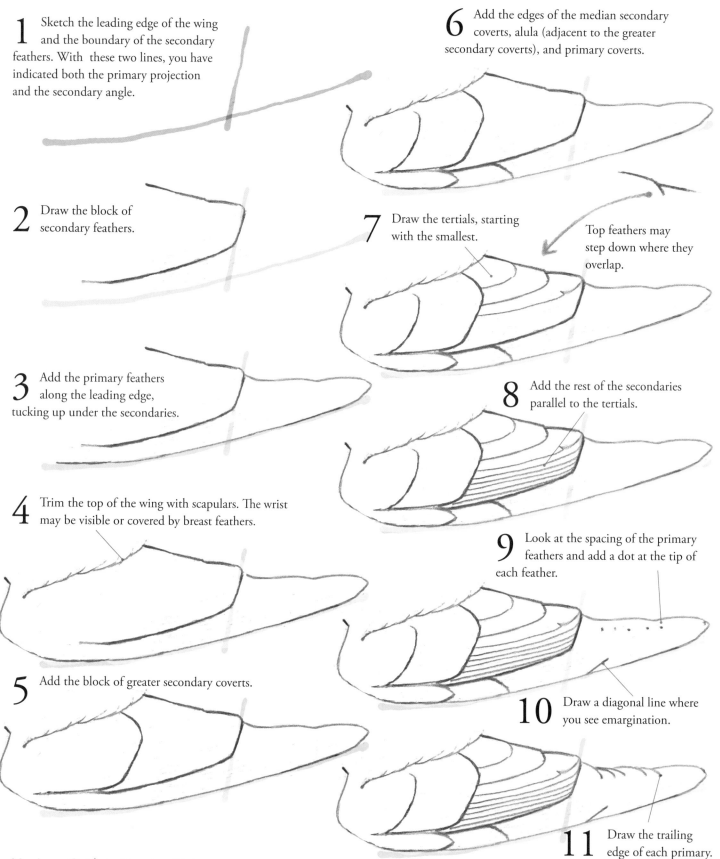

1 Sketch the leading edge of the wing and the boundary of the secondary feathers. With these two lines, you have indicated both the primary projection and the secondary angle.

2 Draw the block of secondary feathers.

3 Add the primary feathers along the leading edge, tucking up under the secondaries.

4 Trim the top of the wing with scapulars. The wrist may be visible or covered by breast feathers.

5 Add the block of greater secondary coverts.

6 Add the edges of the median secondary coverts, alula (adjacent to the greater secondary coverts), and primary coverts.

7 Draw the tertials, starting with the smallest.

Top feathers may step down where they overlap.

8 Add the rest of the secondaries parallel to the tertials.

9 Look at the spacing of the primary feathers and add a dot at the tip of each feather.

10 Draw a diagonal line where you see emargination.

11 Draw the trailing edge of each primary.

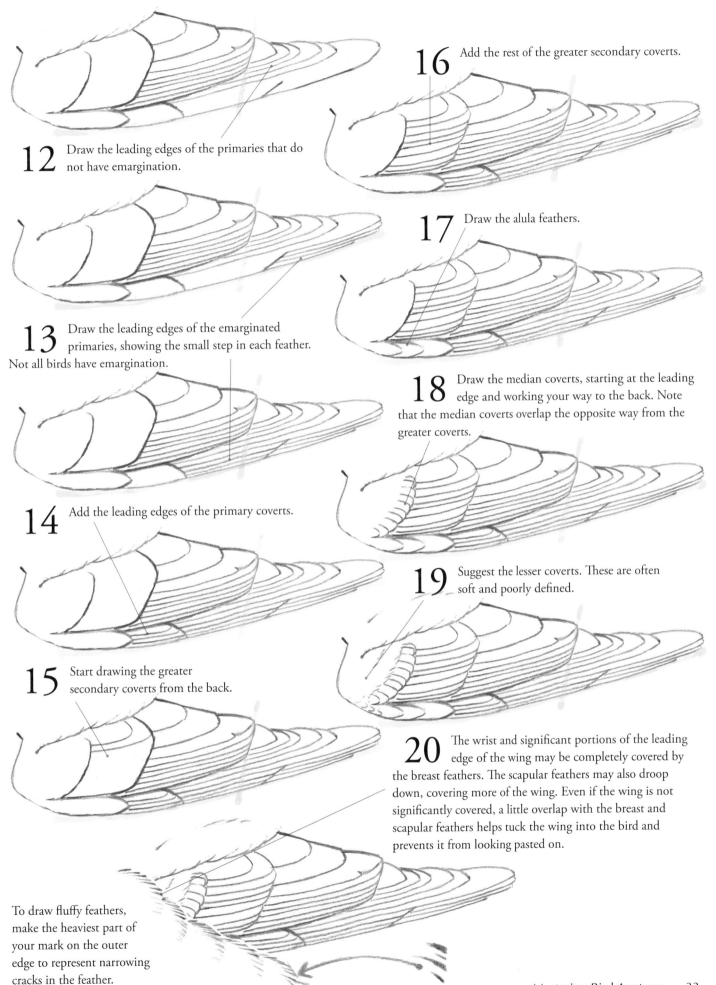

12 Draw the leading edges of the primaries that do not have emargination.

13 Draw the leading edges of the emarginated primaries, showing the small step in each feather. Not all birds have emargination.

14 Add the leading edges of the primary coverts.

15 Start drawing the greater secondary coverts from the back.

16 Add the rest of the greater secondary coverts.

17 Draw the alula feathers.

18 Draw the median coverts, starting at the leading edge and working your way to the back. Note that the median coverts overlap the opposite way from the greater coverts.

19 Suggest the lesser coverts. These are often soft and poorly defined.

20 The wrist and significant portions of the leading edge of the wing may be completely covered by the breast feathers. The scapular feathers may also droop down, covering more of the wing. Even if the wing is not significantly covered, a little overlap with the breast and scapular feathers helps tuck the wing into the bird and prevents it from looking pasted on.

To draw fluffy feathers, make the heaviest part of your mark on the outer edge to represent narrowing cracks in the feather.

TECHNICAL POINTS

Do not be overwhelmed by detail. When you want to draw birds, just do it. If you are making a careful scientific illustration, however, pay attention to the little details. The number of feathers in a wing or the way the feathers overlap will vary between types of birds.

FEATHER OVERLAP

Most feathers overlap so that a feather closer to the bird's back is on top of the next feather toward the wing tip—so if you were to walk out onto a bird's wing, the feathers would form steps going down. In many families of birds, one or more rows of median or lesser coverts are reversed so that the feathers closest to the wrist are above those closer to the body (shown in red below).

All feathers on the wings of **hummingbirds and swifts** have normal overlap and the number of coverts rows is reduced.

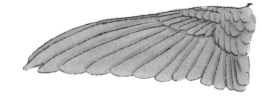

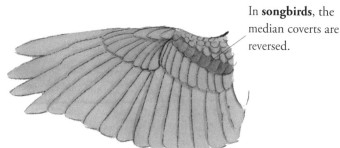

In **songbirds**, the median coverts are reversed.

Note additional short row of coverts.

Hawks, eagles, waterfowl, cormorants, herons, and parrots have a broad patch of reversed coverts.

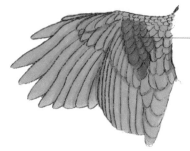

In **upland game birds, rails, and shorebirds**, only the outer 2/3 of coverts are reversed. The proximal half (closer to the body) of the greater secondary coverts are often concealed or overlapped by the median and lesser coverts (not shown).

COUNTING FEATHERS

Although the number of flight feathers in a wing will not be seen in most illustrations, it is useful to learn the feather counts of common orders of birds. You may be able to count individual feathers in birds in flight or with spread wings. (Data from Proctor and Lynch, *Manual of Ornithology*, and Pyle, *Identification Guide to North American Birds*)

	Primaries	Secondaries	Tail
Upland Game Birds	10	12-21	12-22
Ducks, Geese, Swans	11	14-26	14-24
Woodpeckers	10	12	12
Trogons	10	11	12
Kingfishers	10	13-15	12
Parrots, Macaws	10	8-14	12
Swifts	10	7-9	10
Hummingbirds	10	6	10
Owls	10	11-17	12
Nighthawks	10	12-13	10 (12a)
Pigeons, Doves	10	11-12	12 (14b)
Cuckoos, Roadrunners	10	10-11	10 (8c)
Cranes	11	16-18	12
Rails, Gallinules, Coots	10	10-13	12
Shorebirds	10	12-19	12 (10d, 16e)
Gulls, Tern, Alcids	10	16-23	12-18
Hawks, Eagles, Osprey	10	13-19	12
Falcons, Caracaras	10	12-13	12
Grebes	11	17-22	vestigial
Cormorants	10	17-20	12-14
Herons	10	15-19	8-12
Pelicans	10	28-33	20-24
New World Vultures	10	16f or 22g	12-14
Loons	10	22-24	16-20
Perching Birds	9-10	9	12 (13h)

Exceptions: a. Pauraque; b. Mourning Dove; c. Anis; d. Northern Jacana; e. Wilson's Snipe; f. vultures; g. condor; h. meadowlarks

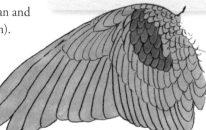

The coverts of **pigeons, terns, and gulls** overlap like those of game birds, except that only the lesser coverts are reversed.

SUGGESTING WING DETAIL

Just because you can draw every feather in the wing does not mean you should. When you are field sketching, draw what you see, instead of drawing what you *think* should be there. If you are too far away to see individual feathers, block in the major feather groups, or just draw the overall wing shape.

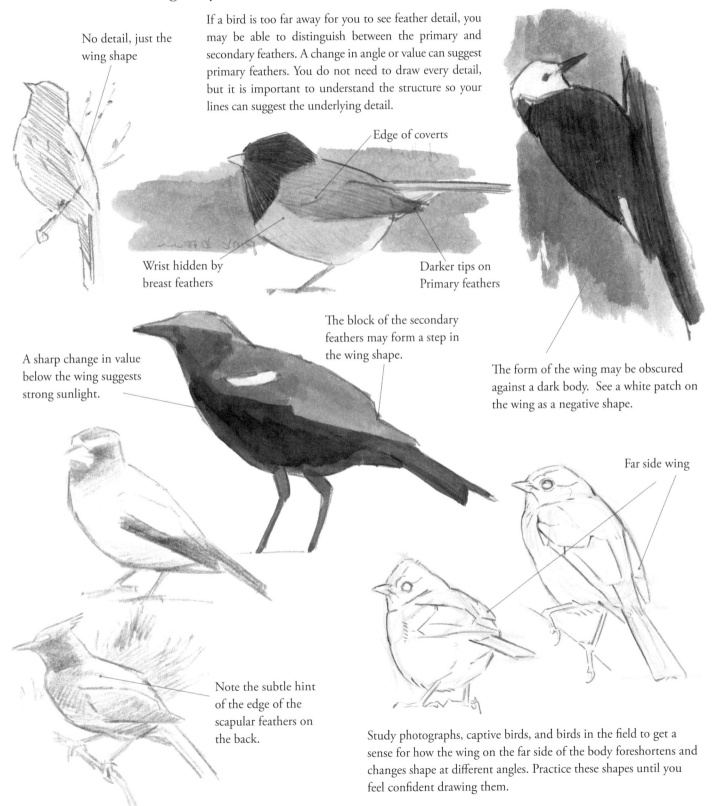

No detail, just the wing shape

If a bird is too far away for you to see feather detail, you may be able to distinguish between the primary and secondary feathers. A change in angle or value can suggest primary feathers. You do not need to draw every detail, but it is important to understand the structure so your lines can suggest the underlying detail.

Edge of coverts

Wrist hidden by breast feathers

Darker tips on Primary feathers

The block of the secondary feathers may form a step in the wing shape.

The form of the wing may be obscured against a dark body. See a white patch on the wing as a negative shape.

A sharp change in value below the wing suggests strong sunlight.

Far side wing

Note the subtle hint of the edge of the scapular feathers on the back.

Study photographs, captive birds, and birds in the field to get a sense for how the wing on the far side of the body foreshortens and changes shape at different angles. Practice these shapes until you feel confident drawing them.

TAIL SHAPE AND STRUCTURE

Tail feathers overlap so that the middle feathers are on the top of the stack of feathers. The relative lengths of the tail feathers make characteristic shapes.

When viewed from above, tail feathers are seen to overlap with the central feathers on top.

When viewed from below, tail feathers are seen to overlap with the outside feathers on top.

Songbirds have 12 tail feathers (6 on each side).

The tail will appear to fan from a point inside the body. This is the location of the stub bone and tissue that supports the tail.

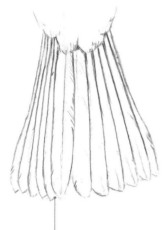

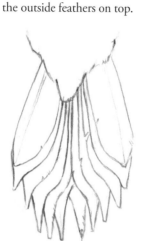

If the feathers are roughly the same length, the tail will be flat or gently curved.

If the central feathers are longer, the tail is rounded or wedge-shaped.

If the outside feathers are longer, the tail is forked. When the tail is folded, it looks pointed.

When the tail closes, the feathers fold into a narrow pile. As the tail opens, it fans from a point within the mass of the body feathers.

Uppertail coverts cover the base of the tail on the top. These feathers may be slightly better defined than the rump feathers and may show as an overlapping row on either side of the tail.

The undertail coverts cover the base of the tail on the underside. Undertail coverts are often longer than the uppertail coverts.

From above, you will see the central feathers on a folded tail.

From below, you will see the outer feathers on a folded tail.

Side view: tail feathers may be held tightly compacted or loosely open.

You can often see the top and the bottom of the tail in the same view.

MOVING AND FORESHORTENING TAILS

Tail feathers attach to a mobile, fleshy stump at the base of the body. The tail feathers may turn, spread, or move up or down as a group. The upper and undertail coverts make a pad above and below the tail, blending the tail insertion into the rest of the body.

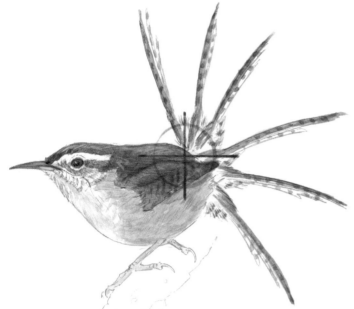

The tail has considerable range of movement. Wrens often cock up the tail.

The axis of rotation of the tail begins inside the body, toward the rear and above the midline. The upper and lower tail coverts move with the tail.

Do not pivot the tail from the tip of the body.

Notched tails, when seen from an angle, have uneven sides because of foreshortening. The back edge of the close side of the notch will appear shorter from above and the base of the far side will appear shorter from below.

You will not always see every feather in a tail, because some feathers may be obscured by the way the tail overlaps. If you have a sense of the overall structure and foreshortened angles, you can accurately suggest the feathers.

Back edges of notched tails appear to be of uneven lengths when viewed from an angle.

Far side narrowed

Far side narrowed

Tails that are slightly tented from feather overlap will appear to be narrow on the far side.

THE THIGH BONE'S CONNECTED TO THE...

Birds have the same basic leg structure as humans. The joints and bones in a bird's leg are arranged the same as in a human leg but most of the limb is hidden by feathers.

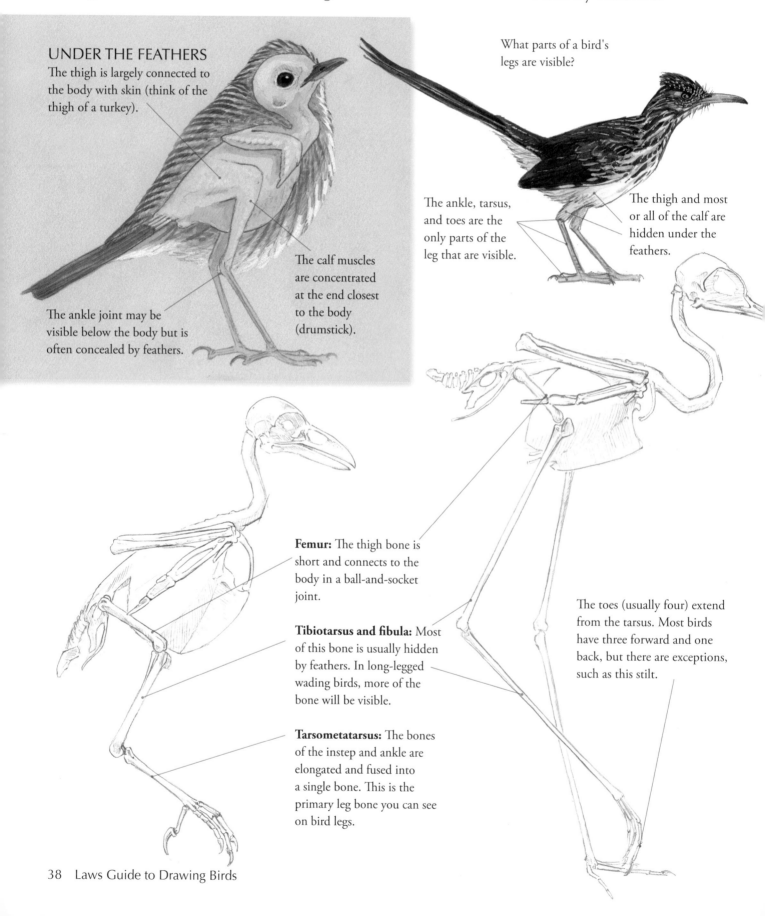

UNDER THE FEATHERS
The thigh is largely connected to the body with skin (think of the thigh of a turkey).

The calf muscles are concentrated at the end closest to the body (drumstick).

The ankle joint may be visible below the body but is often concealed by feathers.

What parts of a bird's legs are visible?

The ankle, tarsus, and toes are the only parts of the leg that are visible.

The thigh and most or all of the calf are hidden under the feathers.

Femur: The thigh bone is short and connects to the body in a ball-and-socket joint.

Tibiotarsus and fibula: Most of this bone is usually hidden by feathers. In long-legged wading birds, more of the bone will be visible.

Tarsometatarsus: The bones of the instep and ankle are elongated and fused into a single bone. This is the primary leg bone you can see on bird legs.

The toes (usually four) extend from the tarsus. Most birds have three forward and one back, but there are exceptions, such as this stilt.

HOW TO BALANCE YOUR BIRDS

Birds at rest center their body weight above their feet.

Visualize the weight of the body and head as if you wanted to balance your illustration on top of a pin. Remember that the tail does not have much weight, as it consists of feathers. Place the center of the feet on a line directly below the balance point.

If you place the feet too far forward, the bird will feel like it is tipping backward. If you place the feet too far back, the bird will seem to be tipping forward.

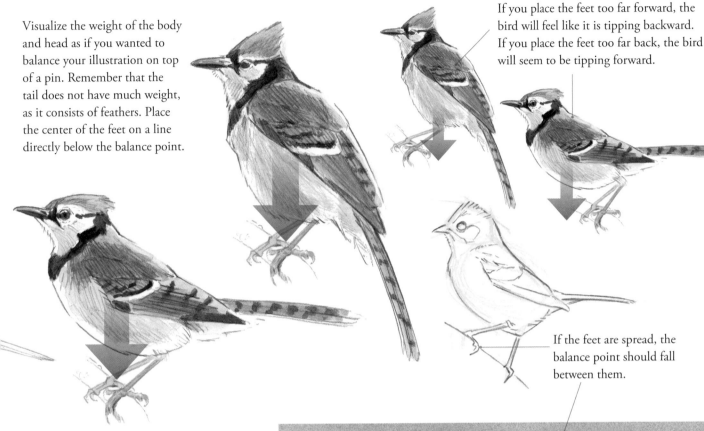

If the feet are spread, the balance point should fall between them.

It may help to draw the bird first, find the balance point, then add the legs and lastly the branch. If you draw the branch first you may have to stretch the legs to an unnatural position for them to reach it.

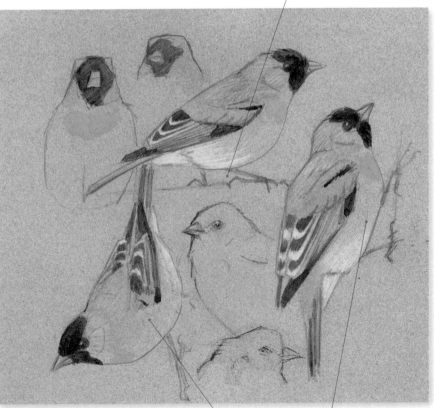

Birds are not always balanced. Some birds may cling to vertical surfaces or even hang upside down as they feed. In these positions birds cling with their strong feet, but when they rest, they center their weight over their feet.

UNDERSTANDING BIRD FEET

Many bird artists are afraid of drawing feet. Some handle this by hiding the feet behind a conveniently placed leaf. Take some time to overcome foot phobia and you will be able to pose birds more easily and draw what you see.

COUNT THE TOE BONES

Each toe in the bird foot has a different number of bones (and consequently joints): one bone in the back toe, and then (from inside out) two, three, and four. How does this look in a drawing? The back toe (one bone) can never curl around a twig. The inner toe has one joint and will not wrap around a branch as closely as the outside toe with three joints.

TOE ORIENTATION

Bird toes can be arranged in different ways. If the detail of individual toes is visible in your drawing, make sure the toes point the right way.

3 forward, 1 back: bitterns, herons, egrets, ibises, vultures, eagles, hawks, falcons, moorhens, doves, flycatchers, shrikes, vireos, jays, nutcrackers, magpies, crows, ravens, larks, swallows, titmice, creepers, nuthatches, wrens, dippers, kinglets, gnatcatchers, thrushes, mimics, thrashers, starlings, pipits, waxwings, warblers, tanagers, towhees, sparrows, longspurs, buntings, cardinals, bobolinks, meadowlarks, blackbirds, grackles, cowbirds, orioles, and finches.

3 forward, 1 back, toes 2 and 3 fused: kingfishers and hornbills.

3 forward, 1 back, webbed: boobies, gannets, pelicans, and cormorants. The fourth toe is long.

3 forward (back toe missing or reduced to a vestigial stub): pheasants, turkeys, grouse, ptarmigan, quail, rails, coots, cranes, plovers, oystercatchers, stilts, sandpipers, phalaropes, and three-toed woodpeckers.

3 forward, webbed (toes 2 and 4 the same length): loons, swans, geese, ducks, avocets, gulls, terns.

Coots and grebes

2 forward, 2 back: ospreys, woodpeckers, cuckoos, roadrunners, parrots, and owls.

4 forward: swifts.

Trogons

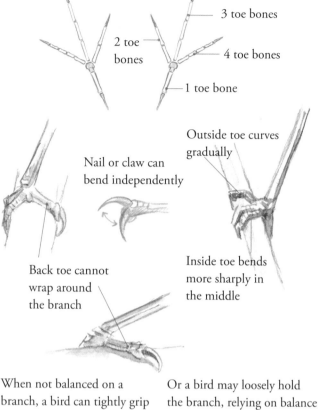

2 toe bones

3 toe bones

4 toe bones

1 toe bone

Nail or claw can bend independently

Outside toe curves gradually

Back toe cannot wrap around the branch

Inside toe bends more sharply in the middle

When not balanced on a branch, a bird can tightly grip it and dig in with its claws.

Or a bird may loosely hold the branch, relying on balance instead of grip. The grip tightens as the bird bends its leg.

Large digital pad at tip of toe

When drawing a foot from the side, avoid splaying the toes. Draw what you see instead of how you know the foot "should" look. As you view the bird's foot closer to eye level, the angles between the toes become narrower.

SIMPLIFYING BIRD FEET

Once you learn the structure of bird feet, it is easy to overwork them. If your sketch is handled lightly and loosely, draw the feet the same way. If your drawing is highly detailed, then add more detail to the feet. Familiarity with the structure of the foot will allow you to simplify the shape in a way that still reads "bird's foot."

50 BIRD FEET

A good way to get comfortable with bird feet is to find pictures of bird feet online and draw 50 bird feet. In the first drawings, add as much detail as you can. As you get further along, start to simplify the feet, seeking to capture the feel of bird feet with a minimum of line and fuss.

Always keep the back toe straight.

The back foot may be hidden by the body. Even if you cannot see it, visualize where it would be and how it would connect to the body.

Learn to draw a simple side view.

Angular toes suggest the joints of the foot.

Instead of drawing each toe separately, you can draw adjacent toes as one shape.

Although the back toe does not curl around the branch, the claw can pivot forward.

The middle toe is the longest. Suggest claws at the tips of the toes without drawing too much detail.

Now take your new understanding of bird feet into the field. If you cannot see a bird's foot, do not draw it. However, when the foot is in sight, look at it carefully and simplify the shape. If certain details are not visible from this range, leave them out of your picture. Let your lines suggest your understanding of the structure without the need to show everything you know.

LEG POSITION AND ANGLE

The lower leg bones emerge at a forward angle. Each leg may be held at a different angle.

BIRD ON A HORIZONTAL SURFACE

From the front, songbird legs are slightly splayed. When viewed from the side, the legs are parallel. However, if the bird perches at an angle to the viewer, the legs appear to be at different angles.

BIRD ON AN ANGLED SURFACE

If a bird is perched on an angled branch or rock, the higher leg will be held more horizontally and the lower leg more vertically.

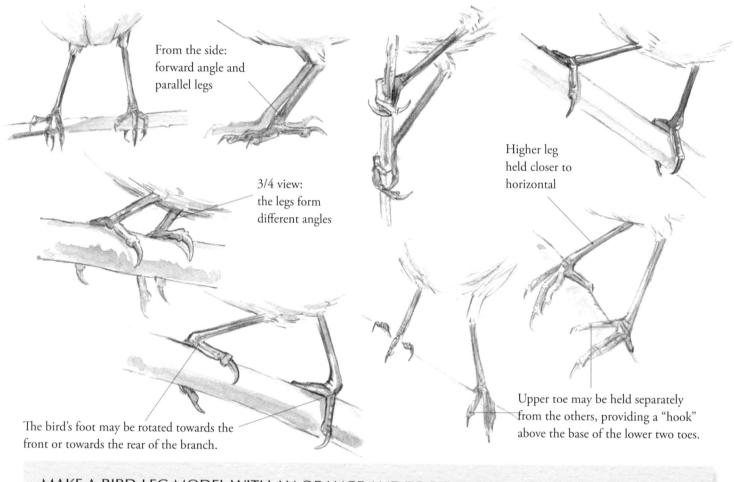

From the side: forward angle and parallel legs

3/4 view: the legs form different angles

Higher leg held closer to horizontal

The bird's foot may be rotated towards the front or towards the rear of the branch.

Upper toe may be held separately from the others, providing a "hook" above the base of the lower two toes.

MAKE A BIRD-LEG MODEL WITH AN ORANGE AND TOOTHPICKS

To help develop an intuitive sense of leg foreshortening, push two toothpicks at a steep angle into an orange so that they make a V-shaped angle between them. Now rotate the orange and watch how foreshortening appears on bird legs.

From the side: the legs point forward

From a 3/4 angle: one leg is vertical, the other angled

From the front: the legs are splayed

BIRD LEG DETAILS

Just as birds' feet show tremendous variation, so does the visible part of the leg (tarsus). If your drawing is detailed enough to show details of the feet, consideration of the legs is warranted as well.

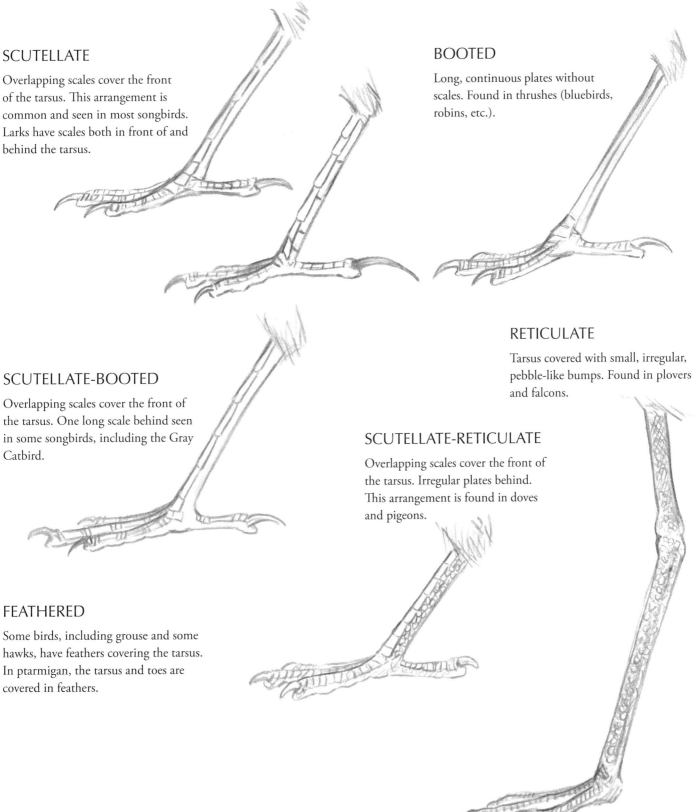

SCUTELLATE

Overlapping scales cover the front of the tarsus. This arrangement is common and seen in most songbirds. Larks have scales both in front of and behind the tarsus.

BOOTED

Long, continuous plates without scales. Found in thrushes (bluebirds, robins, etc.).

SCUTELLATE-BOOTED

Overlapping scales cover the front of the tarsus. One long scale behind seen in some songbirds, including the Gray Catbird.

RETICULATE

Tarsus covered with small, irregular, pebble-like bumps. Found in plovers and falcons.

SCUTELLATE-RETICULATE

Overlapping scales cover the front of the tarsus. Irregular plates behind. This arrangement is found in doves and pigeons.

FEATHERED

Some birds, including grouse and some hawks, have feathers covering the tarsus. In ptarmigan, the tarsus and toes are covered in feathers.

WINDOWS OF THE SOUL

Eyes are one of the first things people notice when they scan an illustration. Giving a little extra attention here will pay off. But beware of overemphasizing the eyes. Sometimes a suggestion is all you need.

The shape of the eye will change as a bird turns its head. Sparrow eyes look round from the side and elliptical from the front. The opposite is true of owls. Hawks are somewhere in between. The plane of the cheek also varies in the same way.

Think of the eye as three parts: the colored iris, the pupil, and a small highlight that makes the eye look wet and alive.

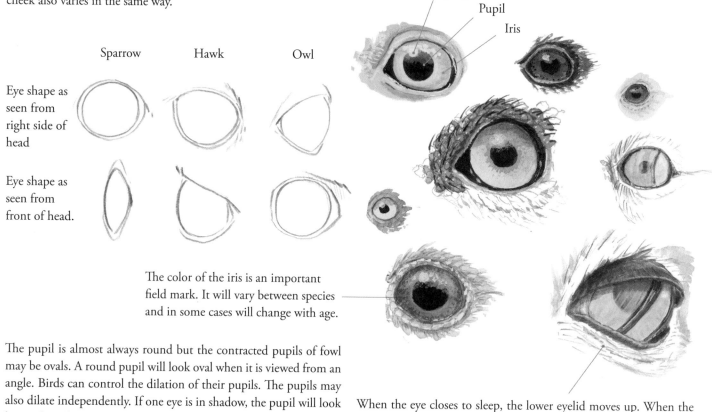

Highlight
Pupil
Iris

Sparrow Hawk Owl

Eye shape as seen from right side of head

Eye shape as seen from front of head.

The color of the iris is an important field mark. It will vary between species and in some cases will change with age.

The pupil is almost always round but the contracted pupils of fowl may be ovals. A round pupil will look oval when it is viewed from an angle. Birds can control the dilation of their pupils. The pupils may also dilate independently. If one eye is in shadow, the pupil will look larger than the one in direct light.

Eyes reflect the light source that illuminates them. An eye in direct sunlight will reflect the sun and the sky above. Be sure to draw the highlight on the correct side of the eye, so that it is oriented with the rest of the light and shadows in the picture.

If the day is overcast or the bird is in shadow, as in a deep forest, the reflected light on the eye will be reduced or absent.

When the eye closes to sleep, the lower eyelid moves up. When the bird blinks, the upper lid moves. Bird eyes are also protected by a transparent nictitating membrane that can flick across the eye from the inside corner, moving upwards and back.

Because our attention is so drawn to the eyes, we easily exaggerate them in our sketches, making them either too large or overworked and prominent. Keep it simple and lively.

Sometimes it is difficult to see the eye. You can leave it out if you cannot see it.

IRIDESCENCE

Feathers iridesce because of the microscopic structure of feather barbules. When a feather is not angled toward a viewer to reflect light, it appears dark. The secret to painting iridescence is to put pure color adjacent to black.

Undercoat of bright Phthalo Blue that blends into a strong purple.

Undercoat of green that blends into yellow-green on the breast

Topcoat of Payne's Gray, applied with a dry-brush to suggest feather edges and fluffiness

When painting iridescence, start with a base layer of the bright iridescent color. Let it change to another high-intensity color in the highlighted area. Iridescent highlights do not lighten but rather blend to a different brilliant hue. Once this coat is dry, start to cover it with dark paint, leaving a fairly abrupt edge between the color and the shadow (instead of a gradual transition). Another way to handle iridescence is to paint a dark undercoat and highlight it with bright colored pencils once the paint is completely dry.

Shadows carefully drawn in with Payne's Grey (a deep black-blue color) using a pointed brush

Texture and pale feather edges added by applying white colored pencil

Light and dark areas will change depending on how the feathers are oriented to the viewer. Even a gorget (the iridescent patch on a hummingbird's throat) that reflects back light will often look dark in some areas. You often see shadows of individual feathers adjacent to the darkest shadow areas. A change in light direction, viewer angle, or the position of the bird will dramatically change how you see the iridescence. To see the brightest colors, position yourself so that the sun is at your back as you look at the bird.

Green areas may shade to coppery yellow

Color shifts immediately to black without intermediate grays.

Reflection of sky

Sharp color change from bright red to bright orange

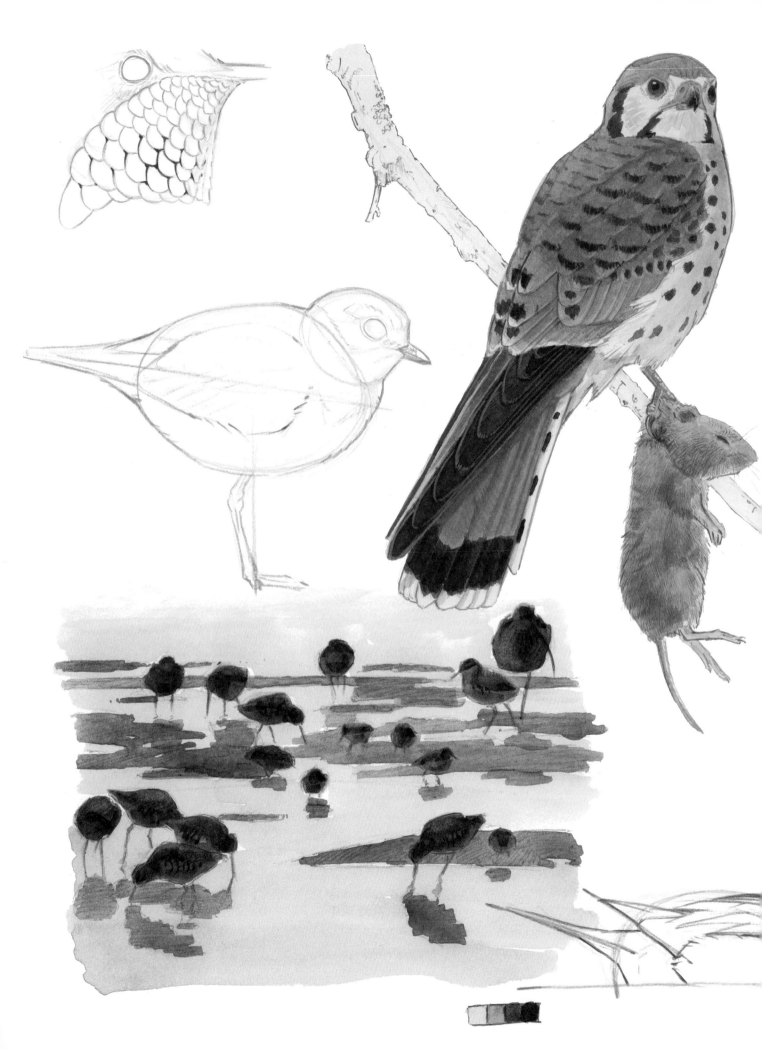

Details and Tips for Common Birds

BIRDS OF PREY

Birds of prey, or raptors, have distinctive facial and body features. The prominent bill and ridge over the eye give an intensity to their expression.

Raptor eyes are set far forward and are often located under a prominent supraorbital ridge that gives the bird a fierce expression (absent in Ospreys and some kites). Eye color can change with age.

Proportions are important. Kestrels, hawks, and eagles have different relative head sizes. Also note that the proportions of the bill relative to the head are different among these species. The kestrel has a big head and small bill, while the Golden Eagle has a small head and large bill. Generally, raptors with small bodies will have proportionately large heads.

Hawks and eagles have strongly hooked bills for tearing flesh. The cere (back of the bill and gape) is covered with tissue and is often bright yellow. This region can change color as the bird ages.

Your attention will be drawn to and held by the hooked bill, hooded eye, and strong talons. Consequently, it is easy to exaggerate these features in your drawing. This will make your drawing cartoonish. Some raptors (such as Bald Eagles) do have large bills, but I find I often need to pause and make raptor bills smaller.

Raptor heads are often blocky and angular. Look for the angles on the side of the head turned away from you.

Raptor eyes face forward. Owl eyes are more forward-directed than hawk eyes. Forward-facing eyes are rounder from the front and more elliptical from the side. Carefully examine the shape of the eye as the head rotates. Crosshairs on the face can help you keep the bill and eye aligned.

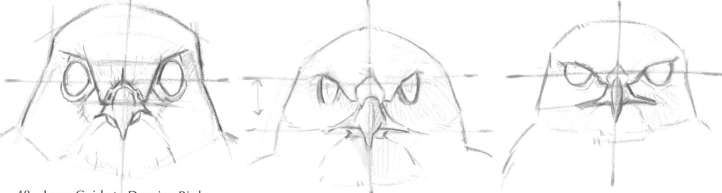

RAPTOR ANATOMY

While raptors are structurally very similar to each other, the proportions of heads, wings, and tails vary between species and even vary between age classes.

The length of the primary feathers varies between species. They are very long in falcons and shorter in buteos. Even among buteos there is considerable variation in feather length.

Raptors have strong skeletons with sturdy legs and feet. The curved beak is also characteristic of birds of prey, an adaptation for tearing meat.

Wrist

Elbow

The primaries can tuck back under the secondaries. Notice how the leading edge of the wing (dashed line) intersects the wrist.

The length of the secondaries is also variable. Look carefully. There is no generic raptor wing.

Pay attention to the length of the projection of the primary feathers beyond the block of secondaries. Also note where the wings stop relative to the tip of the tail.

Large talons are used for killing and holding prey. Owls have two toes facing forward and two oriented back. Hawks have three toes forward and one back. The back claw is the largest.

Unlike songbirds, raptors have prominent thighs. This is visible when they drop the legs in flight or when they prepare to land.

The heavily feathered thigh adds a sense of power to the raptor's stance. The thigh may be hidden when the bird is in an upright posture, but it becomes increasingly visible as the bird leans forward.

RAPTOR BODY FEATHERS

Feather groups are often clearly defined on birds of prey. Look for shifts in feather size and pattern.

THE CHEST

Breast feathers form a distinctive patch on the upper chest. These may be more tightly patterned than on the sides. In birds that have recently eaten and have a full crop, you will see a prominent bulge in this area. The breast sometimes has a seam in the middle, giving the bird a double-breasted appearance.

Look carefully for patterns on the large lower **flank** feathers.

The **belly** may have long shaggy feathers.

THE BACK

The **mantle** makes a small triangle above the scapulars. Note how the feathers change size from small on the mantle to large on the scapulars.

The enlarged **scapular feathers** contrast with the smaller covert feathers of the wing and are a prominent feature of the back.

Let's take a look at how some of these proportion and feather group details play out in a Red-tailed Hawk.

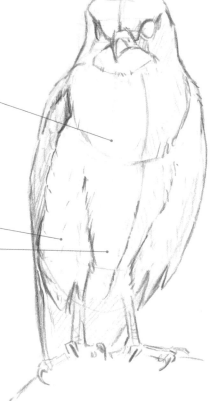

Mantle

Pale scapular feathers make a "V" across the back of a Red-tailed Hawk.

The length of the wing tips varies widely. There is even variation within morphs of Red-tailed Hawk. The wing tips reach the end of the tail (shown) in western, Fuertes', dark, rufous, and Harlan's morphs, but they are shorter than the tail in eastern and Krider's morphs.

STEP BY STEP: PEREGRINE WATERCOLOR

Unlike those of songbirds, body feathers of hawks are stiff and well defined. You will often be able to pick out individual feathers on the back and chest, especially when a perched bird fluffs its feathers.

Make a light drawing of the posture, proportions, and angles.

Block in feather groups. Note double-breasted look.

Indicate individual feathers to show their overlap and increase in size.

Fill in patterns on individual feathers. The lower flanks can have distinct patterns.

Paint areas of shadow, giving volume to different groups of feathers.

Paint dark patterns. Usually dark comes last but do not risk losing the details of feather markings.

Once your work is completely dry, paint the breast with a quick coat of warm brown. Paint a dark wash on the back.

Reinforce shadows and work details around the face. Do not overwork it; stop before you think you are done.

DRAWING WATERFOWL

Proportions are critical for accurate waterfowl illustrations. Start with a carefully observed shape and use negative shapes to place patterns of light and dark.

Proportions of the head relative to the body and neck length will vary among species. Look carefully and use head length as a measurement tool. Even if you have the right bill, your merganser will not look right if it has Ruddy Duck proportions. The head will sit above the body instead of in front of it.

Scaup have proportionately large heads and short necks. Buffleheads have the largest head proportions of all.

Pintails have proportionately small heads and long necks.

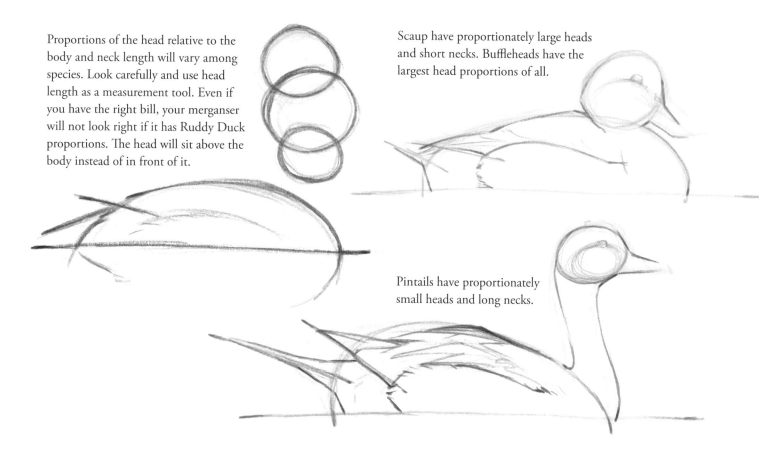

Recheck proportions and neck length before continuing a waterfowl drawing. Subtle shifts in these factors will radically change the silhouette. Smaller ducks tend to have proportionately large heads. Does the body sit high in the water like a Ruddy Duck or low like a merganser?

Use negative shapes to help block in plumage patterns.

As a duck extends or retracts its S-shaped neck, the head moves up and down. When fully retracted, the head sits back from the front of the breast with the neck folded in front of it. This pushes the chest out. When the neck straightens, the head moves up and forward and the line of the chest comes in.

THE ANGLES OF HEADS AND TAILS

Look for important angles on the forehead, chest, and tail. Visualizing negative shapes can help you see the angles more clearly. Note that raising and lowering the head or tail changes the shape.

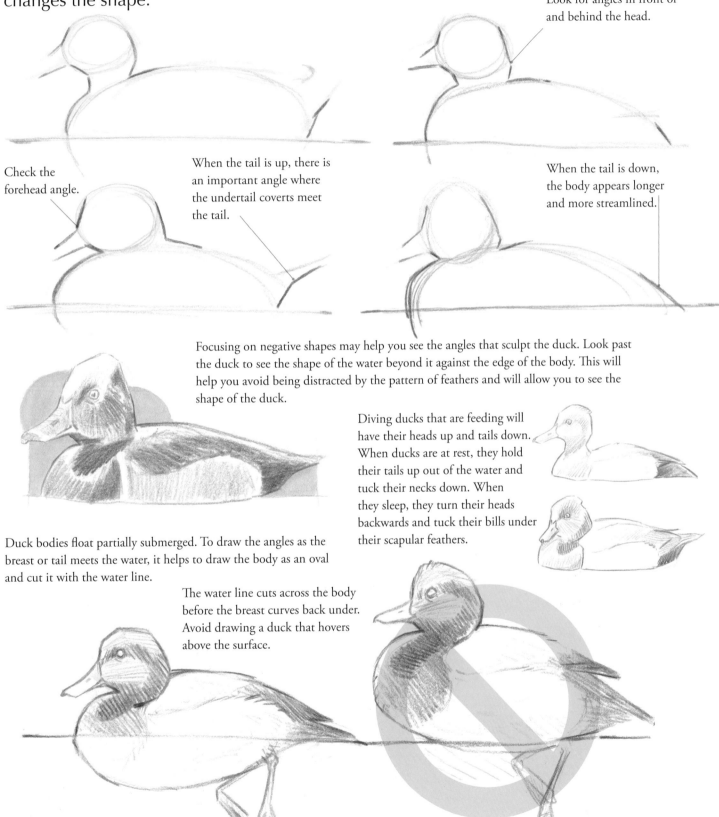

Look for angles in front of and behind the head.

Check the forehead angle.

When the tail is up, there is an important angle where the undertail coverts meet the tail.

When the tail is down, the body appears longer and more streamlined.

Focusing on negative shapes may help you see the angles that sculpt the duck. Look past the duck to see the shape of the water beyond it against the edge of the body. This will help you avoid being distracted by the pattern of feathers and will allow you to see the shape of the duck.

Diving ducks that are feeding will have their heads up and tails down. When ducks are at rest, they hold their tails up out of the water and tuck their necks down. When they sleep, they turn their heads backwards and tuck their bills under their scapular feathers.

Duck bodies float partially submerged. To draw the angles as the breast or tail meets the water, it helps to draw the body as an oval and cut it with the water line.

The water line cuts across the body before the breast curves back under. Avoid drawing a duck that hovers above the surface.

DUCK DETAILS

To accurately draw plumage you must understand the underlying feather topography. Do not draw every feather. Often the edges of individual feathers will not be distinct. Instead, it is the feather groups that make patterns. Let your understanding of the feathers show through as you draw and paint the plumage.

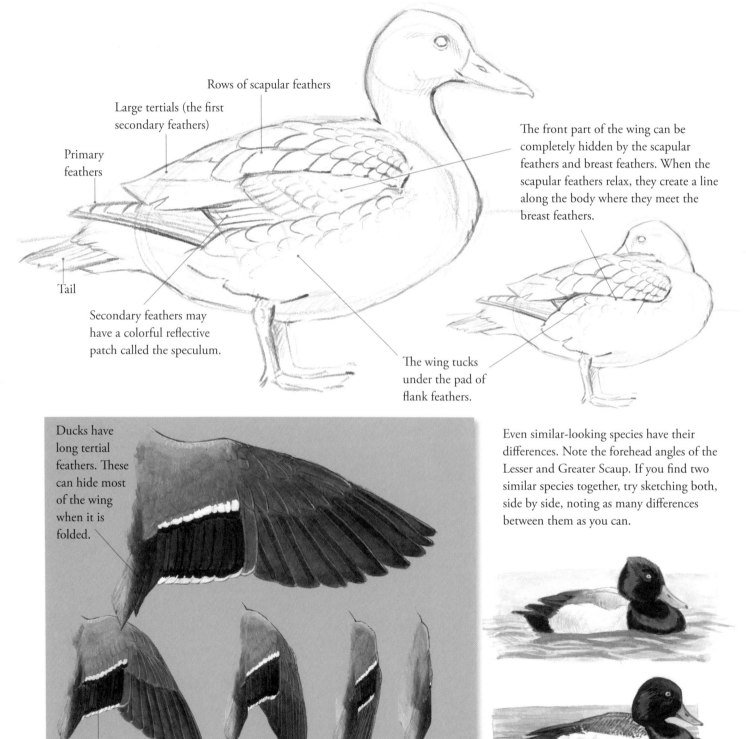

Rows of scapular feathers

Large tertials (the first secondary feathers)

Primary feathers

Tail

Secondary feathers may have a colorful reflective patch called the speculum.

The front part of the wing can be completely hidden by the scapular feathers and breast feathers. When the scapular feathers relax, they create a line along the body where they meet the breast feathers.

The wing tucks under the pad of flank feathers.

Ducks have long tertial feathers. These can hide most of the wing when it is folded.

Speculum of secondary feathers

Even similar-looking species have their differences. Note the forehead angles of the Lesser and Greater Scaup. If you find two similar species together, try sketching both, side by side, noting as many differences between them as you can.

DUCK HEADS

Accurate placement and shape of the bill will make your duck look like a duck. The bill emerges near the base of the head circle (instead of the middle of the head) and then slopes up to the forehead.

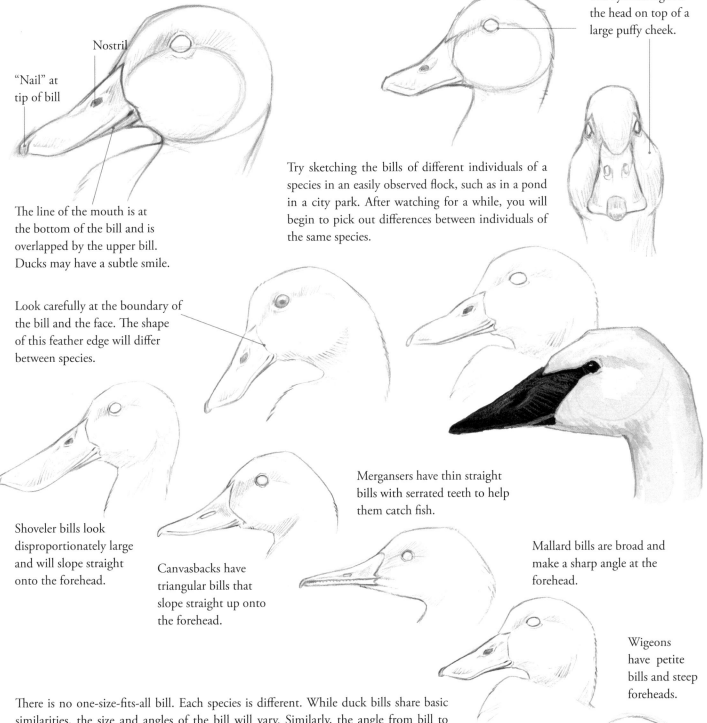

Nostril

"Nail" at tip of bill

The eye sits high in the head on top of a large puffy cheek.

The line of the mouth is at the bottom of the bill and is overlapped by the upper bill. Ducks may have a subtle smile.

Try sketching the bills of different individuals of a species in an easily observed flock, such as in a pond in a city park. After watching for a while, you will begin to pick out differences between individuals of the same species.

Look carefully at the boundary of the bill and the face. The shape of this feather edge will differ between species.

Mergansers have thin straight bills with serrated teeth to help them catch fish.

Mallard bills are broad and make a sharp angle at the forehead.

Shoveler bills look disproportionately large and will slope straight onto the forehead.

Canvasbacks have triangular bills that slope straight up onto the forehead.

Wigeons have petite bills and steep foreheads.

There is no one-size-fits-all bill. Each species is different. While duck bills share basic similarities, the size and angles of the bill will vary. Similarly, the angle from bill to forehead can be dramatically different between species. Start with a basic round head and check your proportions, carefully observing the proportions of the bill. Then study the angles on the head. You do not need to memorize these differences, but appreciate the variation among species and carefully observe the subject that you are drawing.

WATERFOWL IN MOTION

As the duck moves, use the location of the eye and the shoulder as reference points. Envision a vertical line through each point. What do they intersect?

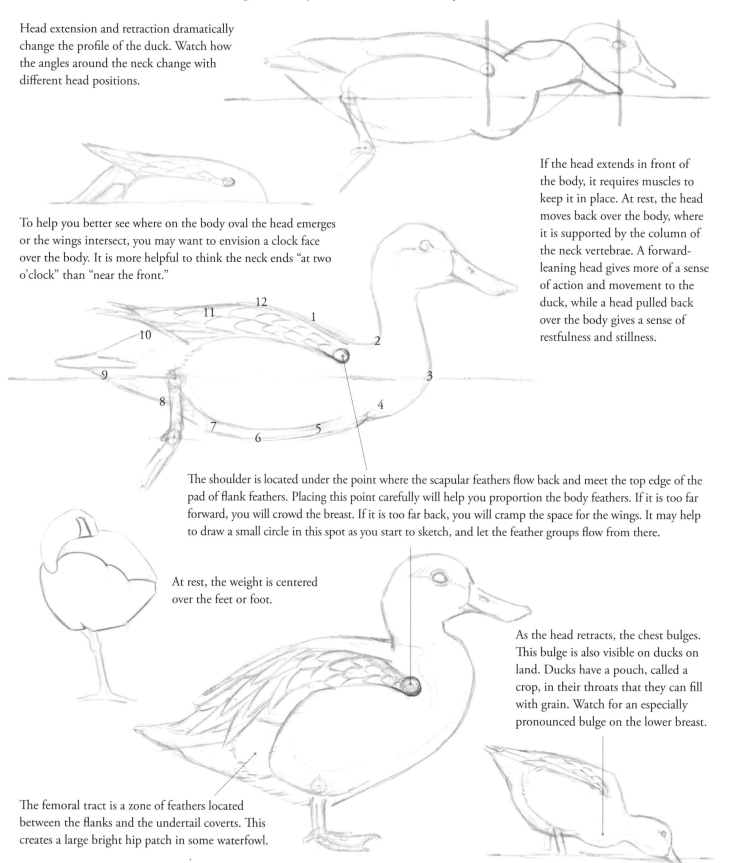

Head extension and retraction dramatically change the profile of the duck. Watch how the angles around the neck change with different head positions.

To help you better see where on the body oval the head emerges or the wings intersect, you may want to envision a clock face over the body. It is more helpful to think the neck ends "at two o'clock" than "near the front."

If the head extends in front of the body, it requires muscles to keep it in place. At rest, the head moves back over the body, where it is supported by the column of the neck vertebrae. A forward-leaning head gives more of a sense of action and movement to the duck, while a head pulled back over the body gives a sense of restfulness and stillness.

The shoulder is located under the point where the scapular feathers flow back and meet the top edge of the pad of flank feathers. Placing this point carefully will help you proportion the body feathers. If it is too far forward, you will crowd the breast. If it is too far back, you will cramp the space for the wings. It may help to draw a small circle in this spot as you start to sketch, and let the feather groups flow from there.

At rest, the weight is centered over the feet or foot.

As the head retracts, the chest bulges. This bulge is also visible on ducks on land. Ducks have a pouch, called a crop, in their throats that they can fill with grain. Watch for an especially pronounced bulge on the lower breast.

The femoral tract is a zone of feathers located between the flanks and the undertail coverts. This creates a large bright hip patch in some waterfowl.

STEP BY STEP: RUDDY DUCK

Do not think of these step-by-step birds as the only formula to follow, but as one example of how one artist approaches the subject. Absorb what is useful from such demonstrations and discard what does not work with your way of drawing or looking at birds.

1 Draw the form of the duck, noting the proportions and angles. Double-check your proportions. The Ruddy Duck has a surprisingly large head. Use negative spaces to see the form more accurately.

2 Add texture and value with graphite. Pay attention to the way that the markings follow the contours of the body, giving it volume.

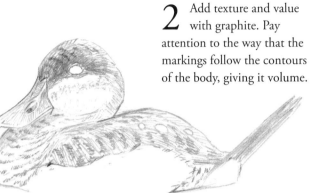

3 Paint a light base layer to establish the colors. Keep your palette small to help your colors harmonize with each other.

4 Paint subtle shadows under the head and bill and at the edge of the breast and flank feathers.

As you add detail, show the contours of the body. Think of wrapping the markings around a three-dimensional form.

I love the muted browns and dappled patterns of female birds. Painting the transitions between brown and gray will help you appreciate the subtle changes in color.

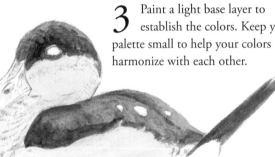

5 Final detail added with a splayed brush to achieve textured feathers. White pencil adds pale specks in the feathers.

Keep reflections simple. Remember that they are cast directly below the subject. The subject and the reflection are not mirror images of each other. Note that more of the back of the duck is visible on the actual bird than you see in the reflection.

If you find painting reflections challenging, study the work of other artists. I had a very hard time with this reflection until I spent about an hour studying how J. F. Lansdowne handled a similar subject. As an exercise, try copying the work of your favorite artists, line for line. Studying the masters will not turn your style into a clone of someone else's. You will discover new ways of drawing and seeing.

WORKING WITH WADERS

Shorebirds are cooperative models as they forage along open beaches and marshes. Do not be intimidated by their intricate markings. At most distances, these patterns blend into smooth tones.

Posture will change as the bird feeds, walks, or rests. You will notice subtle changes in posture even among similar species. Start with the posture line and build the rest of the drawing around it.

A bird resting on one leg will position that leg at an angle so that the foot rests on the ground directly below the bird's center of gravity. This is seen from both the front and the side view.

Proportions are critical here. A subtle shift in head size will make a drawing look like a different species. Smaller birds tend to have larger heads. Triple-check before continuing. This curlew and sandpiper have been scaled so that the ovals that form their bodies are the same size. Note the difference in the relative sizes of their heads.

Carefully observe the proportion of the eye relative to the rest of the head. The eye will be relatively larger in smaller birds.

Look for the angle of the forehead. This will dramatically change the expression and feeling of your illustration.

Leg length will also vary among species, as will the amount of the tibia exposed below the breast. Place the ankle joint carefully.

The greater secondary coverts and the tertials cover most of the wing. You rarely see the tip of the primary feathers.

Tertials

Lesser and median coverts

Greater coverts

Five rows of scapular feathers are prominent on the back of a shorebird. The two rows above the wing are larger and contrast with the smaller covert feathers directly below them.

The neck is a flexible S-shaped curve. It can extend or contract but it will bend at predictable locations, often making a "shelf" on the front of the neck of an egret or heron. The folded neck piles up in front of the breast.

Relaxed scapulars

Compressed scapulars

Tertial feathers

Primary feathers

The scapular feathers droop when the wing is relaxed, or they can form a sleek pad on top of the wing when the feathers are compressed.

ORDER OF OPERATIONS

Try this trick to help you draw long-necked birds. It will help you locate and capture the dynamic angles.

1 Start by drawing the head. Then draw the front of the neck using negative space. Concentrate on where the neck changes angles and the length of each line segment between the turns.

2 Place a series of dots behind the neck indicating the approximate thickness of the neck.

3 Now, using the dots as a guide, use negative space again to draw the back of the neck. Note that you are not just connecting the dots. They are only guides to help keep the neck from getting too thick or thin. It is the negative shape that will carve the angles of the neck. Finally, add the body.

Tangent lines between body and head help you place the head and visualize the negative space.

WADER HEADS

Pay attention to the proportions of bill lengths and the degree of curvature of the bill. Your brain exaggerates any feature that draws your attention, so it is easy to make wader bills too long and to exaggerate the curve of the bill.

Heron and egret eyes are aligned with the upper bill. There are no feathers between the eye and the bill.

Pay attention to eye size and placement. The eye may sit higher in the head (above the bill line) than you are used to if you have been drawing a lot of songbirds. The eye may also be farther back on the head than you expect. The extreme of this case is the woodcock, in which the eye is closer to the back of the head than the front.

The size of the eye is also variable. As with songbirds, smaller waders have proportionately larger eyes. This gives them a "cute" expression.

Look for steep foreheads on many waders. The angle from the bill to the crown of the head will make a strong negative shape.

Bill length and curvature differ between species, and females often have longer and more strongly curved bills. Use the head as a measuring tool. How many head lengths is the bill? For shorter bills, imagine flipping the bill back into the head. Would it reach the eye, the back of the head, or further? Does the bill curve? If so, how far down the bill is the flexion point? Is it a steady curve from the head, or does it come out straight and curve at the end?

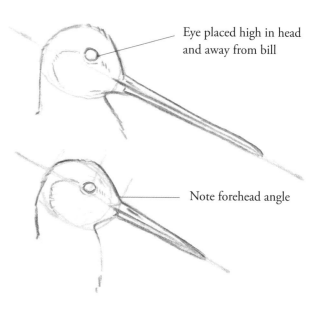

Eye placed high in head and away from bill

Note forehead angle

STEP BY STEP: SHOREBIRD VALUE STUDY

As with songbirds, start with posture, proportion, and angles. A useful next step is to lay in the values (areas of dark and light). Value is often overlooked as artists race to throw in local colors or add detail, but value is a critical part of what we see. Look for it in nature. If you squint your eyes to blur the detail, you will see value better.

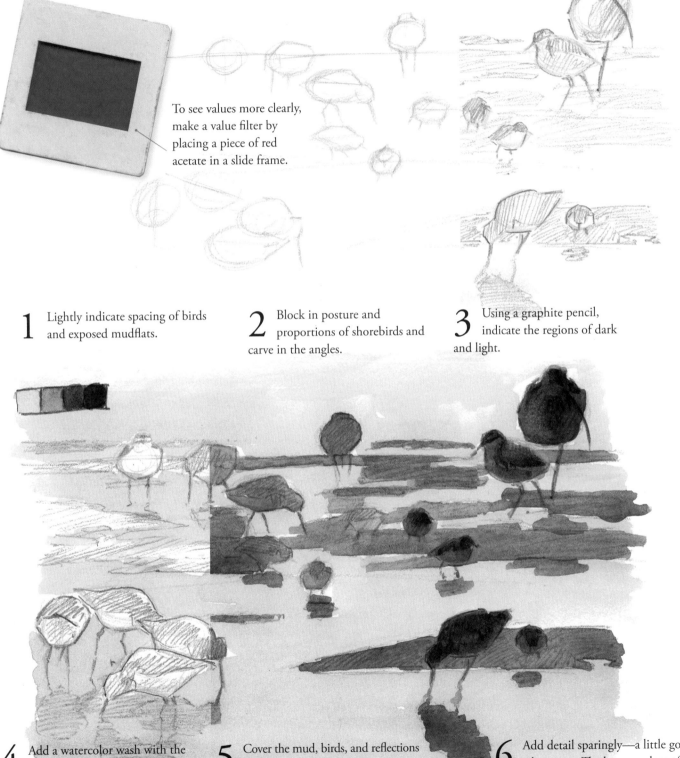

To see values more clearly, make a value filter by placing a piece of red acetate in a slide frame.

1 Lightly indicate spacing of birds and exposed mudflats.

2 Block in posture and proportions of shorebirds and carve in the angles.

3 Using a graphite pencil, indicate the regions of dark and light.

4 Add a watercolor wash with the lightest color, the water. Note that water can be many colors, not just blue. Let it dry.

5 Cover the mud, birds, and reflections with a dark wash. When this is dry, paint the birds with a second wash.

6 Add detail sparingly—a little goes a long way. The brown colors of the birds' backs are lost in dim light.

HUMMINGBIRD HELPER

Hummingbirds can be very cooperative subjects to sketch. Prop your sketchbook at the window near the feeder and they will come to you!

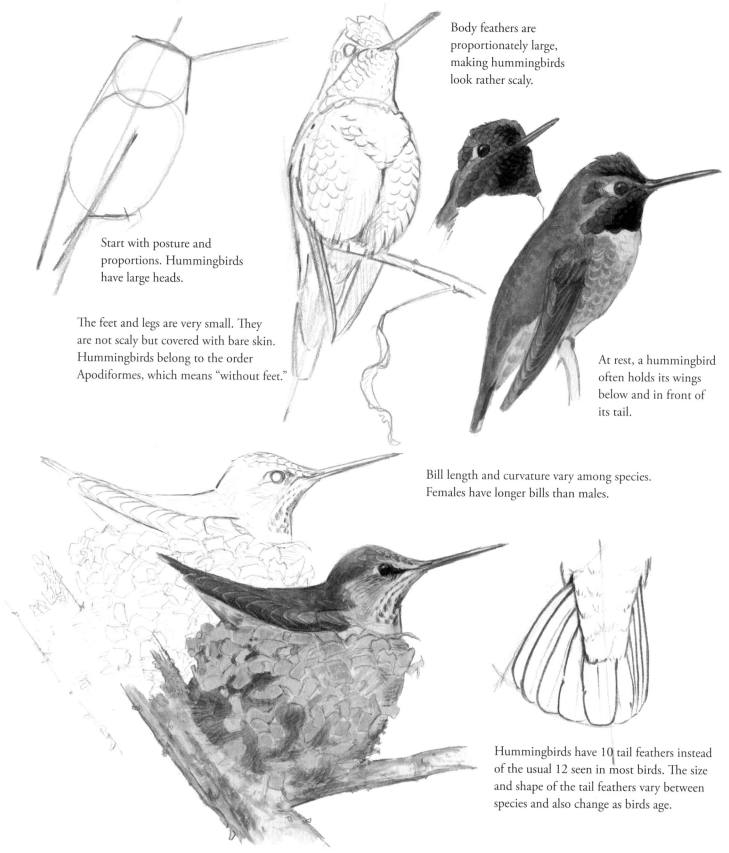

Body feathers are proportionately large, making hummingbirds look rather scaly.

Start with posture and proportions. Hummingbirds have large heads.

The feet and legs are very small. They are not scaly but covered with bare skin. Hummingbirds belong to the order Apodiformes, which means "without feet."

At rest, a hummingbird often holds its wings below and in front of its tail.

Bill length and curvature vary among species. Females have longer bills than males.

Hummingbirds have 10 tail feathers instead of the usual 12 seen in most birds. The size and shape of the tail feathers vary between species and also change as birds age.

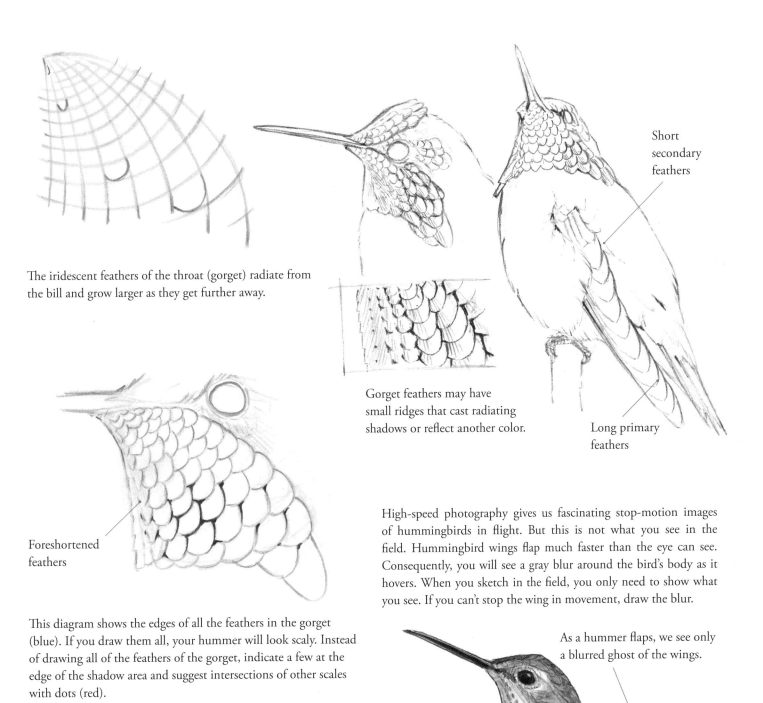

The iridescent feathers of the throat (gorget) radiate from the bill and grow larger as they get further away.

Short secondary feathers

Gorget feathers may have small ridges that cast radiating shadows or reflect another color.

Long primary feathers

Foreshortened feathers

This diagram shows the edges of all the feathers in the gorget (blue). If you draw them all, your hummer will look scaly. Instead of drawing all of the feathers of the gorget, indicate a few at the edge of the shadow area and suggest intersections of other scales with dots (red).

High-speed photography gives us fascinating stop-motion images of hummingbirds in flight. But this is not what you see in the field. Hummingbird wings flap much faster than the eye can see. Consequently, you will see a gray blur around the bird's body as it hovers. When you sketch in the field, you only need to show what you see. If you can't stop the wing in movement, draw the blur.

As a hummer flaps, we see only a blurred ghost of the wings.

Note how shifting from green to yellow suggests iridescence. Hummingbirds often pump their tails as they hover. The tail can be spread or closed in flight.

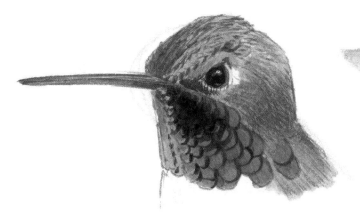

To suggest iridescence, vary the reflective color without blending (here from red to orange) and transition quickly to black shadow.

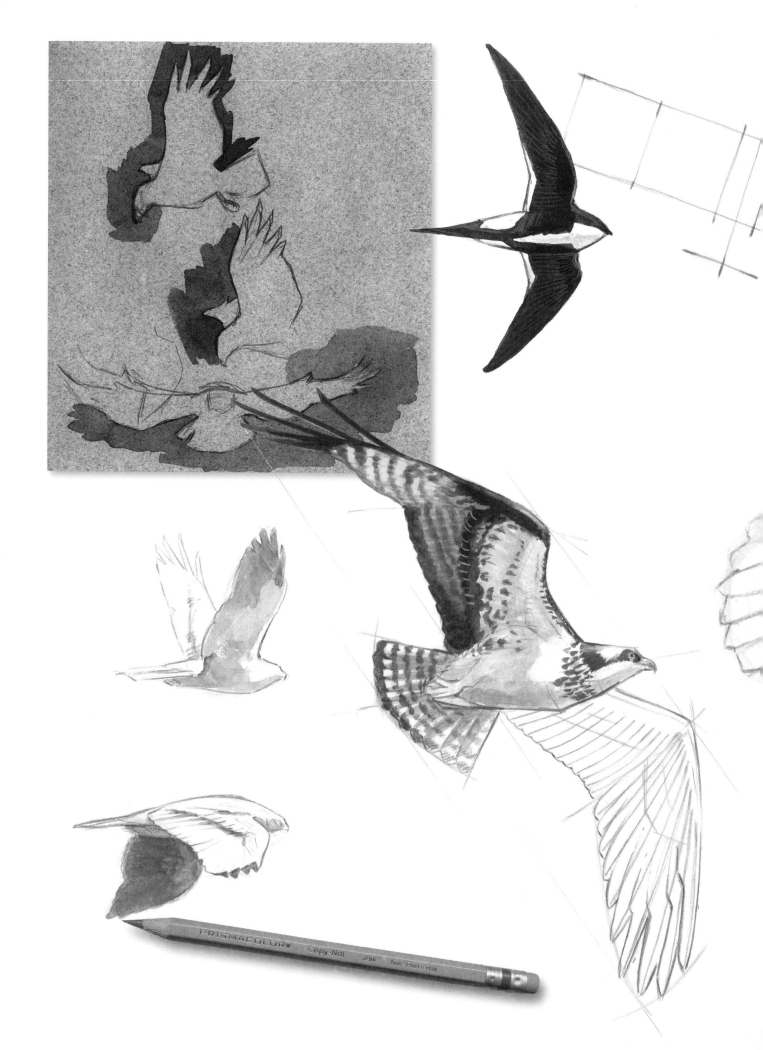

Birds in Flight

Drawing birds in flight requires an understanding of anatomy and the basic foreshortening principles that come into play as a bird moves through the air. As you draw, imagine that you can feel the air beneath the wings, suspending the bird in the air.

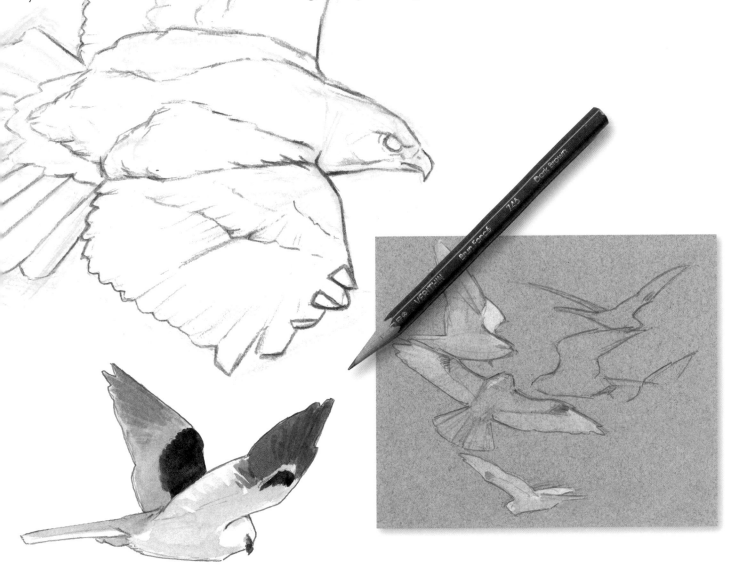

BUILD A FLIGHT FRAME

Simplify the shape of a flying bird with a frame to align the axis of the body and the plane of the wings. Rotate and foreshorten the frame to draw a flying bird in different positions. As before, capture the posture, proportions, and angles.

DRAW THE WING-BODY POSTURE

Start by drawing a bird stick figure to record the angles of the wings relative to the body.

BLOCK IN THE PROPORTIONS

Construct a flight frame over the posture. Watch the relative sizes of the wings and body as well as the proportions of the primaries to the secondary feathers. If the wings are held symmetrically, all points of the wing will stay parallel with the lines of the flight frame, including the wrists, the wing tips, the backs of the wings, and even the tail (unless it is being used to turn).

1 Create the wing-body posture by drawing the axis of the body, head to tail. Add a wing line, noting the angle at which the wings cross the body.

3 Place a set of lines above and below the body axis to show the width of the body at the plane of the wings.

4 Finally, add parallel lines across the wings to show the length of the secondaries and primaries. These proportions will change on different species.

The proportions of wing and tail will change between species. Buteos have broad wings with prominent secondary feathers and short tails. Falcons have narrow wings with long primary feathers and long tails.

2 Place a line along the back edge of the wings and a short line parallel to the wings to show the length and width of the tail.

You will not observe extreme perspective distortion on distant birds. Avoid this comic book "zoom" effect.

CUT IN ANGLES

Train yourself to watch the negative spaces around the head, tail, and wings. Carve these angles into the flight frame.

Look past the bird to the negative space beyond it. See the angles that carve the shape of the head. Compare the angles of the shapes you see on either side of the tail.

The same flight frame and silhouette can be used to draw either the top or the underside of a bird in flight.

ANGLED FLIGHT FRAMES

If a bird is approaching or receding at an angle to the viewer, the wing-body posture will not be perpendicular. The wings will cross the body at an angle.

Angle the wings forward or backward relative to the body line to frame a bird that is approaching or departing from the viewer at an angle. The same flight frame and silhouette can be used in either case, but one bird will be observed from the top and the other from below. In birds observed from below, the body will block some of the wing that is farther away from the viewer.

Parallel lines help keep structures and markings on both wings symmetrical.

Wings are not perpendicular to the body line.

Drop a box from the shoulders to show the depth of the body.

Belly blocks the view of the insertion of the far wing.

This angle is more acute compared to the opposite side.

This side of the tail looks longer.

Approaching As a soaring bird approaches you, the wing that is closest to you will be held at an angle, so that it appears behind the head. When viewed from the back, this is the lower wing. When viewed from below this is the upper wing.

Note that these birds have the same silhouette

As do these two

This side of the tail looks shorter.

Far wing tips appear stunted because they curve up and away from your line of sight.

FORESHORTENING TAILS

Departing As a soaring bird flies away from you, the wing that is closest to the viewer will be held at an angle so that it appears forward of the head. When seen from below, this is the upper wing. When seen from the back, this is the lower wing.

Simplify the tail to a triangle whose tip is inside the frame of the wings. As the frame and the tail tilt, the sides of the triangle become uneven. Note how the lengths of the sides and the angles between the wing and tail both change.

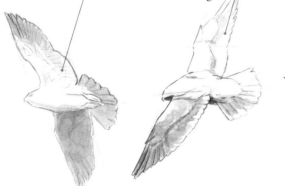

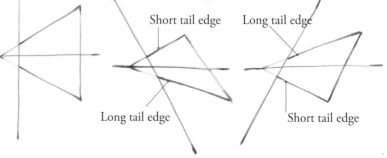

Short tail edge Long tail edge

Long tail edge Short tail edge

ANOTHER ANGLE ON WINGS

If a bird holds its wings up at an angle (dihedral) or down while flapping, each wing may be foreshortened to a different degree.

As birds flap their wings, the wing-body posture changes, creating a V that may be upside-down or asymmetrical.

The shape of the flight frame changes accordingly.

As a bird rotates its body with wings held at either an up or down angle, differences in foreshortening become apparent. As you see more of the breast or the back, one wing may appear longer as well.

Flying birds constantly make micro-corrections in wing position to adjust for changes in updrafts and wind as they fly. This gives you leeway to slightly alter a bird's wing position and stay true to the physics of flight and the bird's flight profile. Observe soaring birds in the field. A bird surfing the updraft of wind at a cliff face is a perfect subject.

From above, we see less foreshortening on the far wing, so it looks longer. However, the close wing is strongly foreshortened because it points toward the viewer.

When one wing is extremely foreshortened, the other may be seen at its full length.

The amount of foreshortening depends on the angle of the wings and the rotation of the body.

The angle of the shoulders and wing base will be roughly parallel to the angle of the tail tip.

WING TIP TIPS

The tips of the wings of a large soaring bird, or those of a smaller bird in a powerful downstroke, are pushed upwards by the air beneath them. When these curving wing tips point toward the viewer, they are foreshortened. The effect is that the longest primary feathers appear stunted.

Cut and fold a stiff piece of cardboard to make a wing platform with tips that curve upward. Spin the cardboard in your hands and notice how the lower wing tip becomes foreshortened, while the upper tip remains clearly in view.

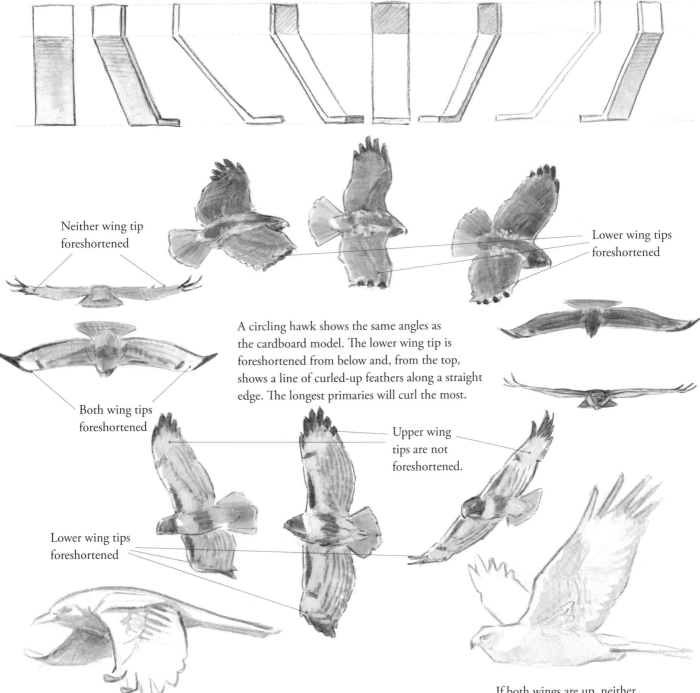

Neither wing tip foreshortened

Lower wing tips foreshortened

Both wing tips foreshortened

A circling hawk shows the same angles as the cardboard model. The lower wing tip is foreshortened from below and, from the top, shows a line of curled-up feathers along a straight edge. The longest primaries will curl the most.

Upper wing tips are not foreshortened.

Lower wing tips foreshortened

If both wings are down, the wing tips of both wings may curl up.

If both wings are up, neither wing tip will be foreshortened.

MAKE A FLIGHT MODEL

Use this page to create bird-in-flight models. By rotating the models in your hands, you will develop an intuitive understanding of the perspective and angles of soaring birds.

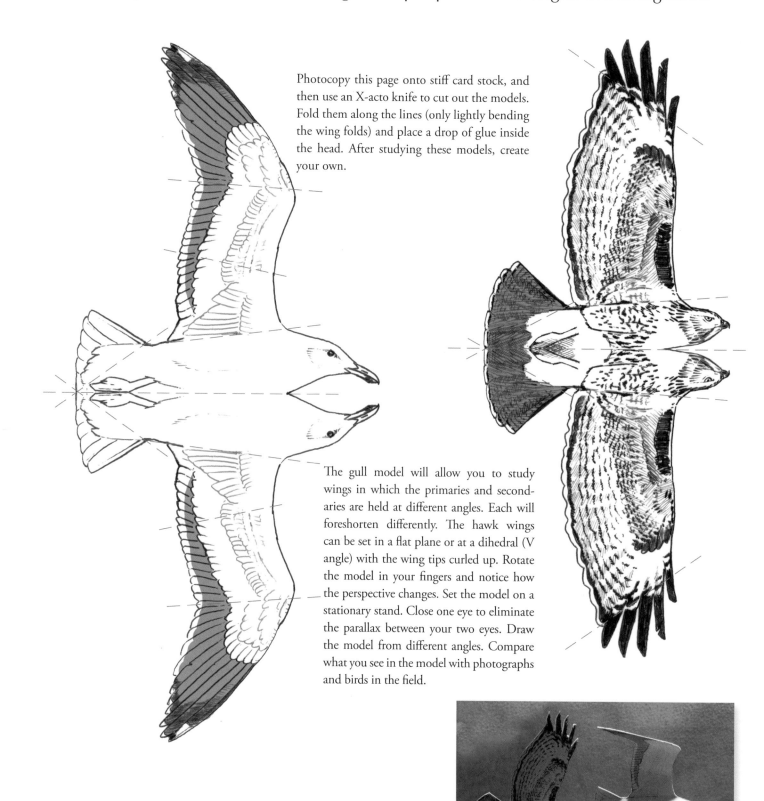

Photocopy this page onto stiff card stock, and then use an X-acto knife to cut out the models. Fold them along the lines (only lightly bending the wing folds) and place a drop of glue inside the head. After studying these models, create your own.

The gull model will allow you to study wings in which the primaries and secondaries are held at different angles. Each will foreshorten differently. The hawk wings can be set in a flat plane or at a dihedral (V angle) with the wing tips curled up. Rotate the model in your fingers and notice how the perspective changes. Set the model on a stationary stand. Close one eye to eliminate the parallax between your two eyes. Draw the model from different angles. Compare what you see in the model with photographs and birds in the field.

SKETCHING SMALL BIRDS IN FLIGHT

Large birds flap slowly and soar more frequently. The wings of small birds flap so quickly that they often blur. Even so, there are tricks that can help you draw fast-flapping birds in the field.

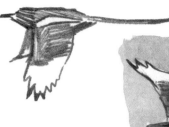

There is no way to freeze-frame a bird rushing past you without the use of high-speed film. In the studio, it is interesting to copy wings in action from high-speed photographs. In the field, draw what you see. A blur is a blur. Don't expect intricate detail in your field notes. You may be able to capture the shape of the bird body and perhaps the amplitude of the wing beats.

If a bird holds a brief glide, you may see the full spread of the wings. Distinguish the jagged fan of the outer primaries from the smooth body of the secondaries.

If you just see a blur of wings, draw the blur. You will not see distinct edges or detail on quickly beating wings.

Because the wing slows and reverses at the top and bottom of the stroke, you may see a ghost image of the wing in both positions.

Watch gulls from the back of a boat and fill your sketchbook with impressions of what you see. The birds will be constantly in motion but will return again and again to familiar angles. Try closing your eyes to clear your brain, then open them for a moment like the shutter of a camera, and then close your eyes once again. A moment in flight will be briefly etched into your vision. Make a fast sketch of what you saw, and then try it again. Quickly jot down the angle of the leading edge of the wing and the contour of the belly.

If the wing is bent, the primaries and secondaries will foreshorten differently.

Foreshorten the triangle of the primaries and the rectangle of the secondaries separately.

UNDERWING ANATOMY

The feathers that cover the undersurface of the wing are similar to the upper wing in songbirds. More primitive groups of birds, such as ducks, herons, or raptors, have more complex patterns of feathers on the underwing.

The underside of songbird wings is similar to the top. Covert feathers cover the leading edge of the wing. The primary and secondary feathers are reversed in their stacking order so that the primary feather is on top.

Vestigial tenth primary feather, seen from below

Outer primaries may have a **notch**, which is a narrower section on the inner web of the feather. Similar to emargination, the length and depth of the notch decreases as you move from the wing tip toward the secondaries.

Most non-songbirds have a set of axillary feathers in the armpit. This is analogous to the scapular feathers on top of the wing. These feathers cover the area where the wing attaches to the body.

Long-winged seabirds, such as the albatross, have an additional set of flight feathers that attach to the humerus. These **humeral feathers** give the wing an extra bend that is prominent when the wing is slightly bent.

Dark pigment in feathers gives them extra strength; because of this, the wing tips and feather edges are often heavily pigmented.

Axillary feathers

Look for a pale zone in the middle of the primary feathers.

It is difficult to see individual feathers from a distance, but the patterns on the wing are easily seen. The primary and secondary coverts often contrast with the wings. Bars on individual feathers create stripes across the wing. These stripes curve through the primaries and are straight in the secondaries.

A shadow can help depict the relationship between a bird and the ground.

When you observe a wing from below, you can see how the stepwise notches and emargination of the primary feathers work to create the slotted appearance of the wing tips. The long, slotted primary feathers help reduce drag with each wing beat.

STEP BY STEP: RAVEN IN FLIGHT

Start with basic shape and proportion. Pay special attention to how foreshortening affects your subject.

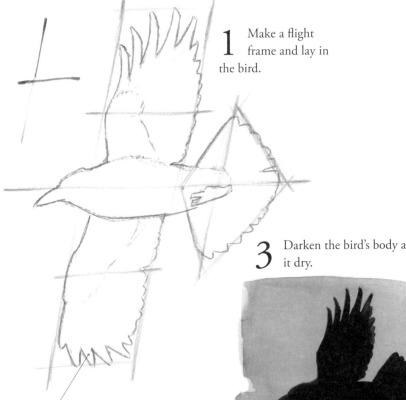

1 Make a flight frame and lay in the bird.

The tip of the lower wing is foreshortened.

2 Paint a cyan wash over the bird.

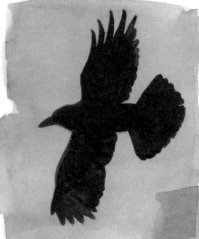

3 Darken the bird's body and let it dry.

5 Play with the values, lifting out paint and adding it back in once the paper dries. Try to suggest detail rather than showing it explicitly. As a last step, crisp up the highlights with a white colored pencil.

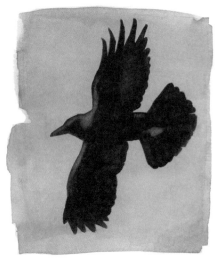

4 Lift out highlights with a damp brush.

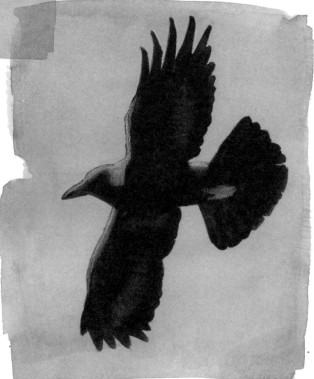

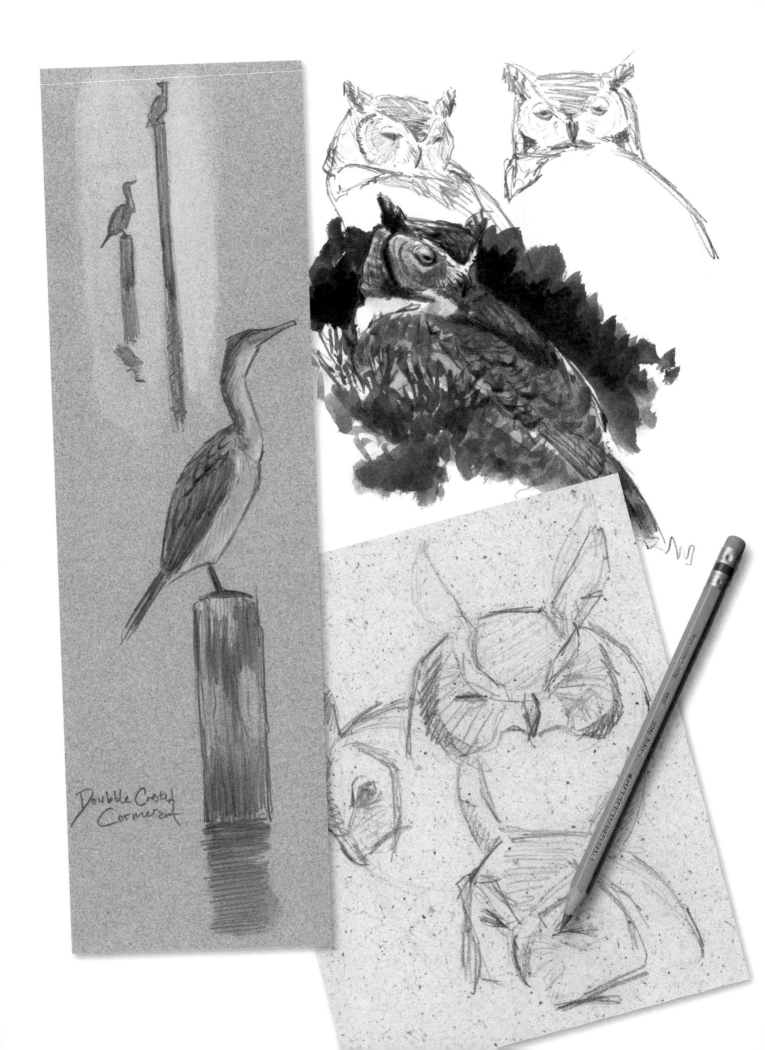

Double Crested
Cormorant

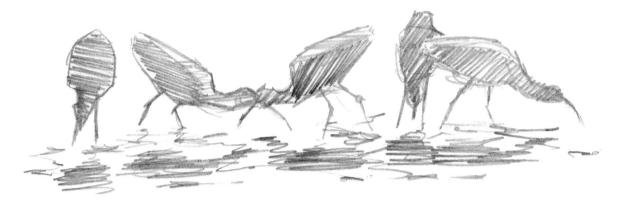

Field Sketching

Field sketching is the most important and perhaps the most enjoyable part of becoming a good observer and a bird artist. Spending time with living birds in natural conditions will help you develop an intuitive feeling for and kinship with the living animal that you cannot get from photographs alone.

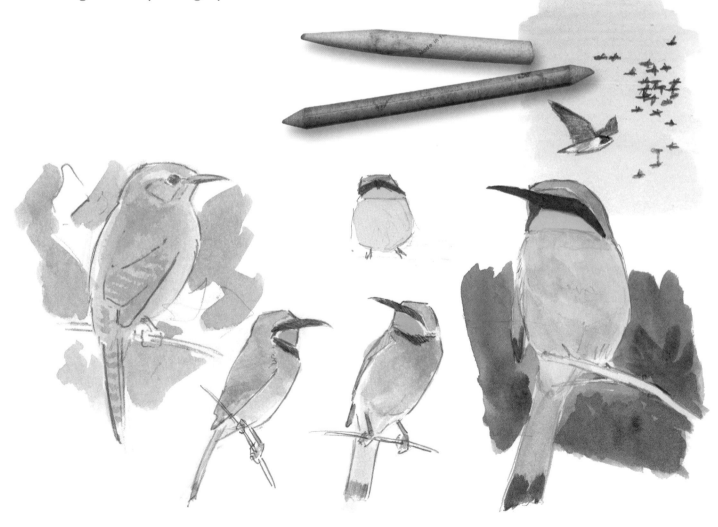

GO OUTSIDE AND DRAW

The purpose of field sketching is to learn from nature. Train yourself to look and look again until you see. Do not worry about making pretty pictures; instead, focus on documenting what you learn during a direct encounter with nature.

Field sketching is the most important practice in understanding and being able to draw birds. Time spent outdoors watching real birds will help you understand the essence of birds. You will encounter their fierce, fragile wildness. There is a tremendous difference between the drawings of someone who has spent time in the field and the drawings of those who work from photographs alone.

Do not be afraid of blank paper. If you have trouble starting, write the date, location, and weather on the page right off the bat. This "opens the page" and makes it easier for other marks to follow. Keep lists and written notes adjacent to your sketches. This makes your journal feel less like a precious art project and more like a tool for recording what you see.

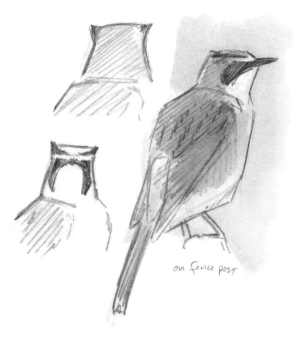

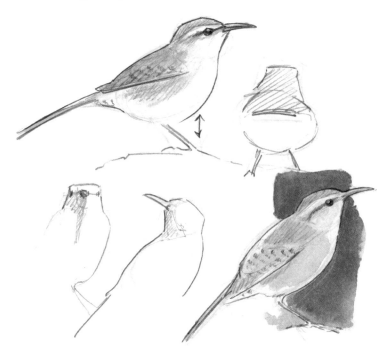

on fence post

Draw what you see. If a bird is too far away for you to see details, just draw the shape. You do not have to make up where the eye, or any other parts you cannot see "should" be. If you draw only what you see, your field sketches will have a sense of what you are truly experiencing rather than a mix of reality and what you think should be there.

Try to avoid "correcting" your field sketches by copying over them with details from a field guide. What you record in your field notes has special value. These are your best field observations. Sure, there will be mistakes in them; you did not see exactly where that white stripe started or how far the brown extended on the back. Some of your drawings will have gaps and incomplete sections because you were not able to see those details. This is to be expected in field work.

Do your best to be true to nature, not true to some book. Later, if you choose to draw portraits of birds based on your sketches, you will have a rich primary source of what you really saw, rather than a hybrid of observation and copied details. You can use your sketches along with photographs, other drawings, or stuffed birds as sources of information for other drawings.

When you first step into the field, many animals, disturbed by your presence, will drop into the underbrush and hide. You will be surrounded by a sphere of silence and inactivity. The longer you sit quietly, the more you will be accepted by the animals around you. Your sphere of disturbance will shrink as birds begin to come out of hiding and go about their business, accepting you as part of the environment. Sitting still takes patience, and drawing is a good way to occupy yourself while you wait. Try starting by drawing a flower growing next to you or a thumbnail landscape while you wait. As birds expose themselves near you, begin drawing them, and if they move off you can return to the other sketch.

By spending time with animals in their natural habitats we come to understand them deeply and sympathetically. We feel the cold of the morning or the hour of the day. This sense of time and place can be suggested in simple sketches.

Sketching also improves your memory. When you draw, the doors of your perception are wide open. The sketching process cements memories in your mind. You will find that you not only remember what you were drawing but also details of the day that you did not even record.

FIELD SKETCHING IS NOT FIELD GUIDE ART

Field guide illustrators often paint birds in a soft neutral light to emphasize the local color of the feathers without the distraction of strong shadows and highlights. This is good if you are painting for field guides, but when sketching birds from life, draw what you see.

You have seen thousands of bird illustrations in field guides. As a result, you may try to make your field sketches look like the bird in the guidebook. But what you see in books is different from the actual bird that you encounter outside. Field guide art is intended to facilitate bird identification. This goal is vastly different from learning while sketching in the field.

In field sketches, body position is whatever you find, not just a profile. The bird may fluff or compress its feathers in response to temperature.

Body may glow with reflected colors from the environment.

Shadows and highlights may make stronger patterns than local color.

In a field guide, lighting is usually from the upper left with the subject facing into the light (turned left).

Distinguishing characteristics are emphasized.

WAXWING AS SEEN IN A FIELD GUIDE

WAXWING AS SEEN IN THE FIELD

Local color of feathers is prominent.

Subtle shadows and highlights give form and dimension.

Body in typical posture but still showing plumage details. Here the wing position allows you to see both the uppertail and undertail coverts.

Key field marks may be obscured by foliage or body position.

You do not need better binoculars or a different view of the bird. Work with what you see. Try to record your experience of that ephemeral encounter with the animal. How does this bird look on this evening, in this place? There is no generic waxwing. The platonic ideal shown in the field guide does not exist.

Birds drawn in the field may show harsh, hard-edged highlights and shadows. Look for these features and do your best to capture the feel of the real bird as you see it in that moment.

Think of both shadows and highlights as shapes. Block in these shapes and apply tone. Even a simple three-step value scale (highlight, mid-tone, and shadow) will work.

Can't see the feet or the eye? Then don't draw them. Go with what you actually experience.

WORKING IN THE FIELD

Drawing live birds in their natural habitat is the best way to get to know them. There are some challenges in doing this but if you anticipate them and are prepared, you will minimize the difficulties and maximize the advantages.

WILL IT STAY OR WILL IT GO?

If you suspect the bird will fly away quickly, don't fumble with your gear, but look intensely at the bird while it is in front of you. Start with posture, proportions, and angles, and then focus on how the bird looks in this particular light. Where is the shadow? Does it have a sharp edge? Can you see a highlight or rim light? Also, note plumage patterns and interesting negative shapes created by the feathers from the angle at which you are viewing it. If the bird flies away, quickly jot down what you saw in simple sketches. If the bird is cooperative enough to stay in one place, start a series of drawings noting different postures. When you look up at a bird, you will be able to hold a small piece of information in your mind for a few seconds. Sketch this down and then look again. If you spend most of your time looking at your paper, you may not be taking full advantage of opportunities to watch the bird itself.

TALKING TO YOURSELF

As I watch the bird, I softly (but out loud) mumble discreet observations to myself: "dark bill tip, sharp angle between nape and crown, thin lateral throat stripe…" I know, it sounds crazy. You will feel self-conscious at first, but you will quickly discover that by verbalizing your observations, you will be able to hold them in your memory longer, making it easier to get them down on paper.

Find that bird! Don't bring your binoculars up to your eyes and then hunt for the bird. Instead, lock your head and eyes on the bird, bring your binoculars up in line with the bird to cover it from your view, and then bring your binoculars straight back to your eyes.

USE BOTH WRITING AND DRAWING

Some observations are easier to write than to draw. Include both writing and drawing in your field notes. This has the added advantage of making your sketchbook feel less like an art project than a place to record your notes and observations. In field notes, just as you avoid being fussy trying to make pretty drawings, do not worry about using perfect grammar and spelling. Simply get the notes on paper. Make sure to include date, time, location, and weather as a regular part of your field notes.

FIELD EQUIPMENT

There are three guidelines to keep in mind when selecting field equipment: simple, light, and portable. Hold all of your materials to these standards. Keep your field sketching kit stocked and ready to go. Everything should fit in a portable bag that you can throw over your shoulder so you are ready to hit the trail. A shoulder bag is better than burying your drawing materials in your backpack. The longer it takes to get out your sketchbook and put it away, the less likely you will be to use it. Keep your sketching kit accessible. Store it with your binoculars and you will be much more likely to take it with you when you step outside. Include a plastic bag in your kit to use as a seat on a wet day or for collecting trash.

Good optics will bring a bird into your lap. Lightweight binoculars can be held in one hand as you sketch. If your binocular hand shakes, stabilize it by pressing your forefinger against your brow. If your binoculars are too heavy, you will need both hands to support them. If you are right-handed, train yourself to hold the binoculars in your left hand so that you can work your pencil with your right hand. If a bird is sitting still, you can watch it for long periods through a spotting scope. This is ideal for shorebirds, waterfowl, or perched hawks. If your scope has a zoom eyepiece, start with the lowest magnification (largest field of view) and then zoom in once you find the bird. You can also adjust the size and viewing area to create different compositions. You only see in two dimensions when you look through the single eyepiece of a telescope. It is easier to translate this view to the paper surface (which also is two-dimensional).

To avoid accidentally stabbing yourself in the eye, never hold your pencil in your binoculars hand!

How you hold your gear makes a difference. To make a stable drawing platform, tuck your arm under your journal with your fingers looped over the top and firmly press the book into your body.

If you are sketching through lightweight binoculars, hold them in your non-dominant hand and brace your arm on your knee. Drawing through a spotting scope is easier, as it frees up both hands to hold your sketchbook and brush.

ZOOM IN AND OUT

It is easy to get stuck in a rut of always drawing birds at the same size or scale. Experiment with zooming in to look at detail. Then zoom out to observe the bird in its habitat. You will observe and learn different things at each scale. What do you notice with your naked eye, your binoculars, a spotting scope?

lil coot

FIELD SKETCHING ZEN

The most important part of field sketching is not the drawing itself, but the focus that it brings to your observations and the strengthened memories that emerge from drawing what you see.

When you discover a bird in the field, start by carefully observing it. It may fly away, so take advantage of the chance to observe. What is its posture? What are its proportions of head to body? Look for the angles. Note the bill length, the tail length, and the primary projection. Mumble your observations softly. If you say what you see, it will stick in your brain a little longer. Then grab your sketchbook (which you keep in that accessible shoulder bag) and get to work.

Draw without fear. If you are afraid of making a mistake, you will prevent yourself from getting anything down on paper. Just do your best with what you see. Of course there will be mistakes. You can correct these errors in a second sketch or simply by adding written notes alongside your drawing. Use writing and sketching together to document as much information as you can in the easiest way possible. Some things are easier to write, others are easier to draw. Remember that these are field notes, not art projects.

Look for postures, variations in plumage, angles, or other aspects of the bird that are not depicted in the field guide. You are not trying to draw a generic bird, but the individual in front of you. You do not have to complete any of the drawings. You can also collect bits and pieces of what you see rather than drawing several complete birds. If you notice an interesting angle of the head, simply draw those lines. If you notice that the legs take a striking stance, sketch that detail. If you notice that part of the head pattern takes a surprising shape at a certain angle, make a quick sketch of what you see. These bits and pieces can come together later in a more comprehensive drawing.

If you feel overwhelmed by a complex subject, make your job easier by focusing on a small part of the larger subject. You can focus on understanding how the bill attaches to the head, or make thumbnail sketches of postures showing the variation in tail positions. Ignore the pattern and just draw how shadows and highlights are cast on the bird. Or you can focus on the proportions and silhouette. A field sketch does not need to be a head-to-toe portrait.

You will meet birders along the way who will look at your sketches and take perverse glee in finding something to correct. They may say something like "No, no, no, the median coverts should be tan…" These people miss the point. A field sketch is not about making a perfect illustration; instead it is a tool that allows you to look more closely. Just smile and say thank you—you just made their day.

Most of all, enjoy your field work. Drawing birds is a great excuse to spend quiet time in nature. At the end of the day, your field notes tell the story of what you observed.

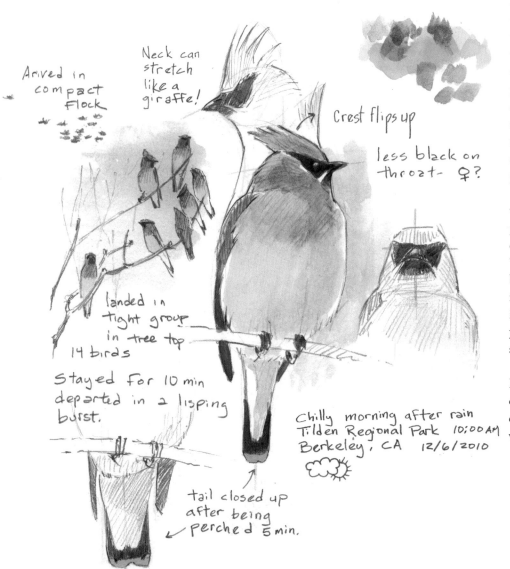

Arrived in compact flock

Neck can stretch like a giraffe!

Crest flips up

less black on throat- ♀?

landed in tight group in tree top
14 birds

Stayed for 10 min departed in a lisping burst.

Chilly morning after rain
Tilden Regional Park 10:00 AM
Berkeley, CA 12/6/2010

tail closed up after being perched 5 min.

DRAWING MOVING BIRDS

Birds do not hold still and pose for your drawings. There are ways to take advantage of quick glimpses of moving birds and make the most out of encounters with cooperative ones.

Birds will change position. Count on it. Anticipate and welcome the new head position, body angle, wing droop, or fluffing feathers. These are opportunities to learn something new. Even a bird that is sitting still will rotate its head. Start drawing the first position that the bird takes. If it moves, start a second drawing on the same page, next to the first drawing. If the bird moves another time, begin a third drawing. It is easier to draw both a right-side and left-side view than it is to flip the bird over in your mind. Light will also fall differently on the right side and the left. When you wait for the bird to come back to a pose that you started in your first sketch, somehow the bird can tell, and it will never come back to that posture. The solution is to keep drawing. If the bird comes back to a pose you have already begun, jump back to that drawing and continue. The most developed drawing will be the most characteristic posture of the bird! You can also give one bird multiple heads, tails, or wings, showing its movement in one sketch. Do not worry about finishing any of the drawings that you start. This is not bird portraiture—it is field sketching. You are learning from nature.

Test colors before applying them to the bird.

Each time the bird moves, start a new drawing. How do the posture and angles change with each pose?

As you sketch, look for field marks or postures that are not in your bird book.

If you are sketching birds in a flock, you can jump from bird to bird to assemble one drawing depicting one pose. If you sketch the flock showing multiple poses, you can switch between the sketches as your subjects move. As you draw, observe and represent the spacing between the individual birds and the common light source.

How does light fall on the bird?

The drawing on which you get the farthest will be the most common posture of the bird.

What shapes do the highlights make?

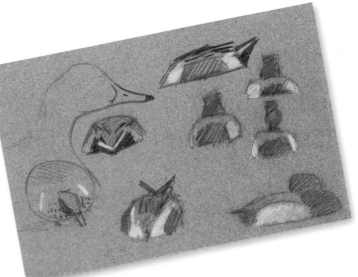

BIRDS IN HABITAT

A bird on its own is lost on a sea of white paper. A flock of birds begins to show size and behavior relationships between birds. Observing and drawing birds in their own habitat or as part of a scene will allow you to tell an even richer story.

A sketch of a single bird floating on white paper gives some information: pattern, shape, or posture

Showing a group of birds also communicates relationships between them, how close they cluster together or what species associate with each other.

Just adding a hint of habitat or a mini-landscape behind the birds puts them in a deeper context. A background does not need to be detailed or extensive to tell a story.

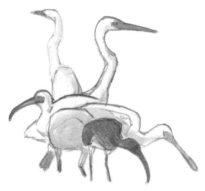

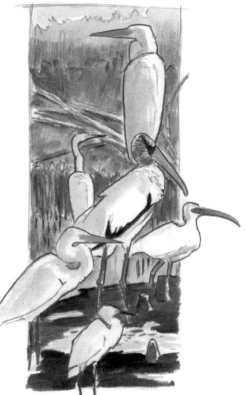

Do not think of it as adding "background," which can feel like an afterthought. A little bit of habitat gives meaningful context to the birds. One way of doing this is to place a box or a circle behind the birds. Draw your habitat within this frame. Habitat images do not need to be elaborate nor take a lot of time to create. The bodies of the birds may even block most of the scene.

Your birds may feel claustrophobic if they are completely encased in the habitat box, so play with "breaking the box." Place the habitat sketch so that it does not completely enclose the birds.

Make sure that the bird and the habitat scene are lit from the same light source. Consider incorporating some of the background color into the bird and vice versa to achieve color harmony. Highlights and shadows may show some of the same warm or cool colors.

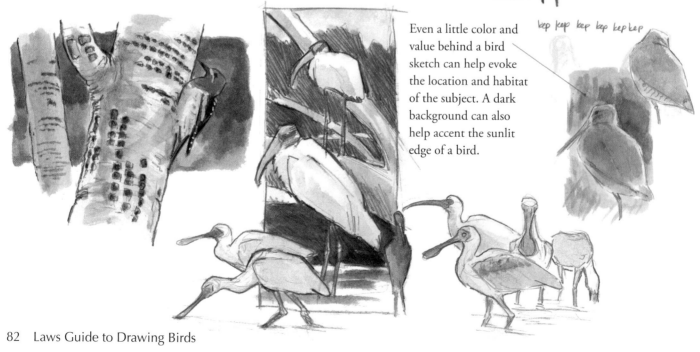

Even a little color and value behind a bird sketch can help evoke the location and habitat of the subject. A dark background can also help accent the sunlit edge of a bird.

kep kep kep kep kep kep

TRAVEL SKETCHING

Sketching unfamiliar birds is a powerful exercise to train yourself to draw what you see instead of what you think "should" be there.

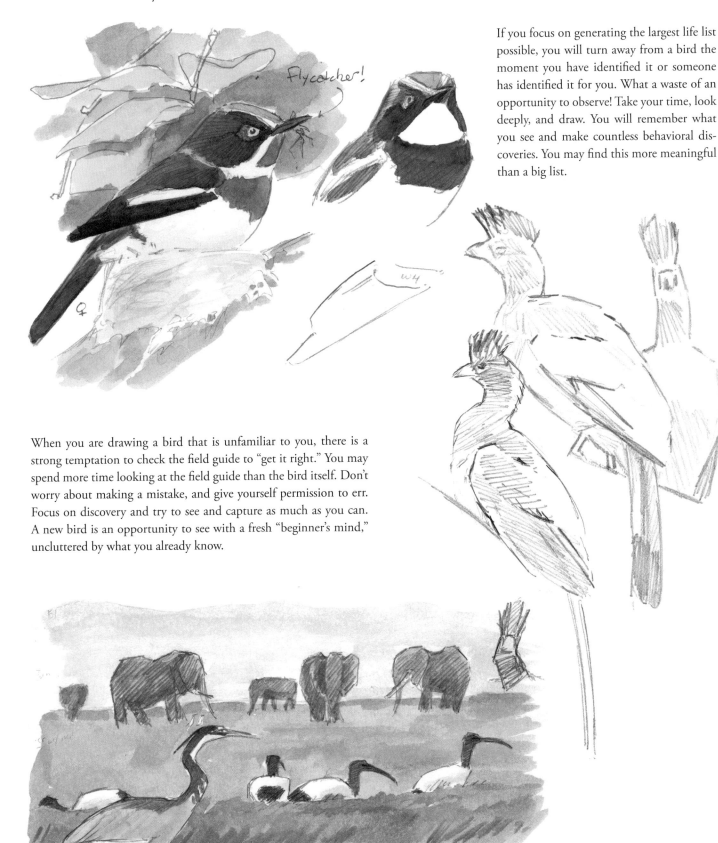

If you focus on generating the largest life list possible, you will turn away from a bird the moment you have identified it or someone has identified it for you. What a waste of an opportunity to observe! Take your time, look deeply, and draw. You will remember what you see and make countless behavioral discoveries. You may find this more meaningful than a big list.

When you are drawing a bird that is unfamiliar to you, there is a strong temptation to check the field guide to "get it right." You may spend more time looking at the field guide than the bird itself. Don't worry about making a mistake, and give yourself permission to err. Focus on discovery and try to see and capture as much as you can. A new bird is an opportunity to see with a fresh "beginner's mind," uncluttered by what you already know.

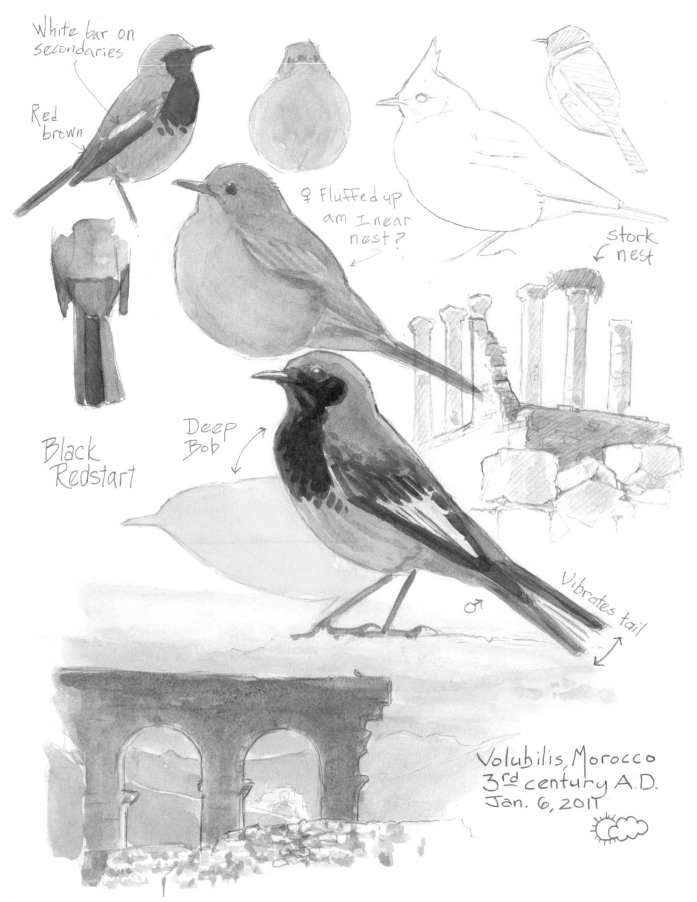

White bar on secondaries

Red brown

Black Redstart

♀ Fluffed up am I near nest?

stork nest

Deep Bob

♂

Vibrates tail

Volubilis, Morocco
3rd century A.D.
Jan. 6, 2011

Birding as you travel helps you notice aspects of a new landscape that you might otherwise miss. The birds you encounter have evolved in and with the conditions of this foreign place. How are they similar to or different from birds that you are used to seeing? Why? What new bird songs fill the air? Be wary of birding to the exclusion of taking in the rest of the landscape.

DOCUMENTING RARE SPECIES

Field notes are very useful for recording observations of rare species or birds that are outside their usual range. Take rigorous and specific notes to document a rare species.

MAKING A FIELD DESCRIPTION

Field notes and sketches made while actually observing the bird and before referencing field guides are your most critical primary source. When you find a bird that you think may be a rarity, make annotated sketches from multiple views documenting what you see. It is easy to miss parts of a bird, and for these notes you must be thorough, not just noting key field marks. Work systematically and describe the head, back, wings, rump, and tail. Then flip over to the front and describe it from chin to the undertail coverts. Finally, describe the soft parts, eyes, bill, and legs. Make size comparisons with other birds nearby. Note feather wear. If the bird makes any sounds, describe them as best you can. (Sometimes birds will make distinctive sounds just as they fly away.) How many birds were seen? Were they keeping to themselves or were they associating with other species in a mixed flock? Describe any behavior that you see, and make gesture sketches of these postures. If it is possible, call in other birders to observe the bird and take photographs to supplement your sketches.

If the bird leaves before you have completed your notes, write down how much time you were able to actually observe the bird. Then write down everything in your short-term memory in a different section of your notes, still without referencing a field guide. To keep memory sketches separate from those drawn from life, write "life" next to the life sketches and "memory" next to the sketches done after the bird flew away.

Once you have recorded everything you remember, or finished your notes while the bird is still in view, open your field guide and compare it with your observations. Be careful, because the book may suggest details that you did not actually see. Do not modify any of the original drawings based on what you see in the guide. It is common for a bird in the field to look substantially different than the illustration in a field guide. Trust what you observed. If the bird is still visible, look for characteristics depicted in the book that you did not initially observe. Then make new sketches that include these details as you notice them on the actual bird. If you make any new drawings, label them "life and reference" or "memory and reference." This practice maintains the integrity of the primary source of your field notes.

REPORTING RARE BIRDS

Different states and provinces have slightly different processes for reporting rare birds to a regional rare birds records committee. Check online to obtain the reporting forms for your area. At a minimum, the reviewing committee will request this basic information:

Date and time: Include both the time that you saw the bird and the duration of the observation.

Location: Go from general (state, county) to specific. Include a drawn map if necessary. Note the environmental conditions, such as habitat, weather, temperature, and light levels.

Observers and equipment: Names and experience level of observers present. Include the distance from bird and the optics used. Also describe what resources (field guides, etc.) you used to identify the bird.

Description of the bird: This is where your field notes really come into use. Document everything you saw and include copies of sketches, original field notes, and photographs. Explain why you would eliminate similar species from your identification. Discuss discrepancies in the observations of different observers.

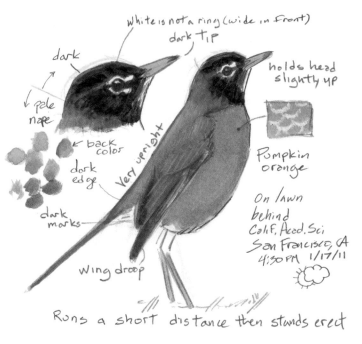

Practice making careful documentations on common bird species. This will help you observe those species more carefully and will train you to look at the same level of detail when observing rare or out-of-range species. Your drawings do not have to be pretty, but your observations must be rich, clear, and specific.

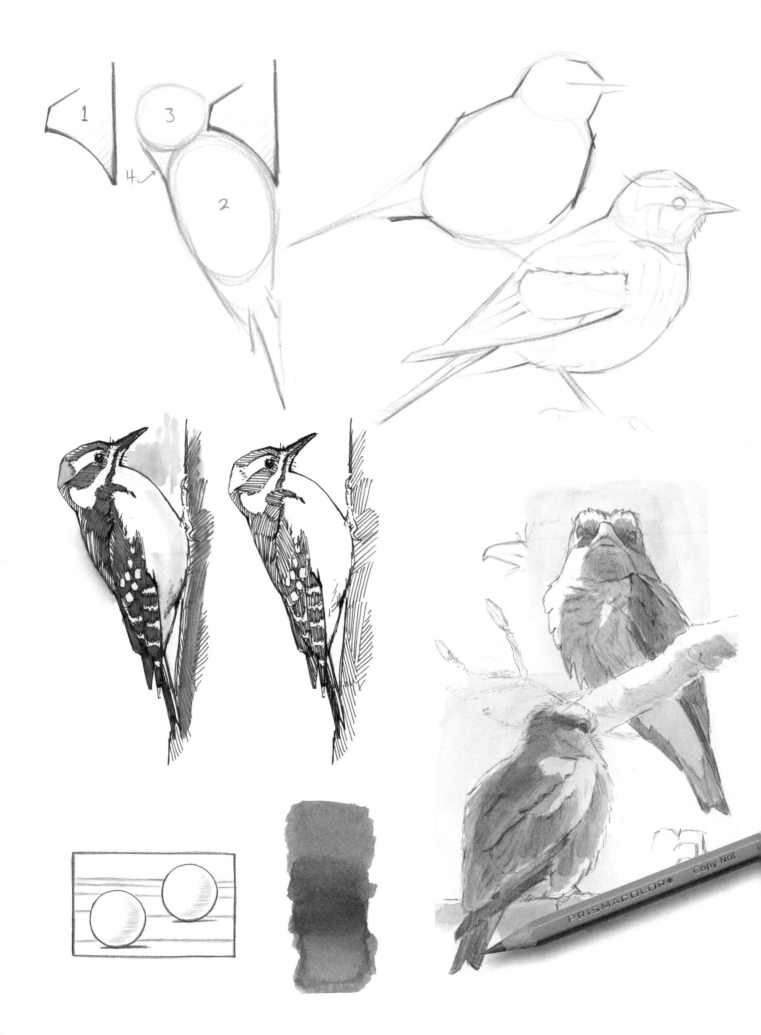

Materials and Techniques

KEYS TO BETTER DRAWING

Here are some concepts that you can apply across your drawings. Experiment with them and adapt them to your own drawing style.

SHAPE BEFORE DETAIL

First things first. Don't get bogged down in detail at the start of a drawing. Focus on capturing the basic shape: posture, proportions, and angles. Use negative shapes to check your form before starting to add details. Once you add detail, it becomes difficult to see errors in your original shape, because you can be distracted by the details and you will not want to change proportions on any part of the drawing that you have "finished."

MAKE DECISIONS WITH ANGLES

Use circles and ovals to approximate the basic shapes. Although this is a great way to start, these shapes lead to a tendency to over-round the drawing. There are subtle contour shifts along the edges of most objects in nature. Look for these angles and carve them into your drawing. Each angle marks a decision: this contour bends to this degree at this point. Carve in the angles and watch your drawing come to life.

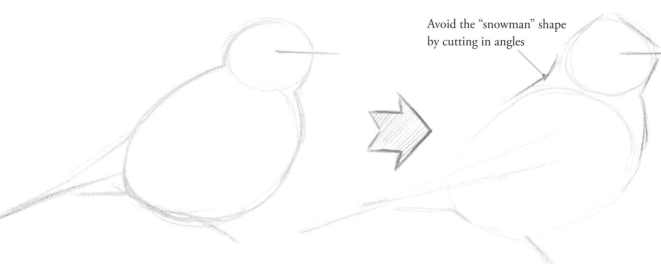

Avoid the "snowman" shape by cutting in angles

USE A VARIABLE LINE

Your pencil is a very flexible tool. It can create thin or thick lines and dark or light lines. If you vary the pressure and angle of the pencil, you will achieve a variable stroke. This is more visually interesting than a line produced by one level of pressure throughout the entire drawing.

SHOW PLANES WITH PENCIL STROKES

If your pencil shading lines show through in your final illustration, you can use them to describe the form of the object. Let the angle of your pencil strokes change to follow the contour of the body. If there is a sharp change in angle, your pencil lines can change direction at the edge of the planes. Pencil strokes can wrap around a curved object like contour lines on a topo map, they can flow down the planes of the subject like water, or they can indicate the direction that the feathers lie on the body. You can darken areas by cross-hatching, adding additional sets of lines at acute angles to the first. Make sets of cross-hatched lines at an angle close to the first set (making spaces that look like small diamonds). Avoid cross-hatching at 90° angles or the pattern will make a mechanical checkerboard.

Hatching changes direction as the contour of the body changes.

Crosshatching lines do not cross at a right angles.

Variable line disappears to "let light into the back."

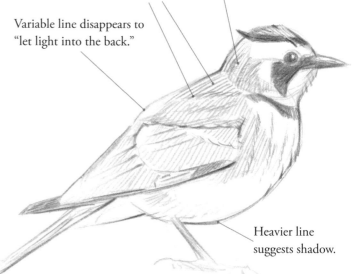

Heavier line suggests shadow.

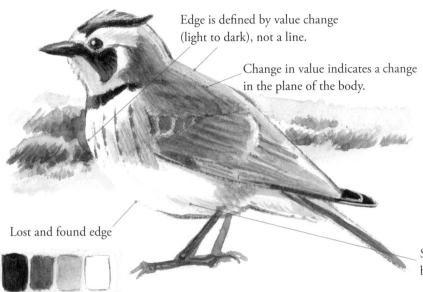

Edge is defined by value change (light to dark), not a line.

Change in value indicates a change in the plane of the body.

Lost and found edge

Shadow area does not reach edge of body because of reflected light.

PLAY WITH THE EDGE

You do not need to encase your illustration in a solid line. Create "lost and found" edges, leaving gaps in the line, perhaps suggesting sunlight dancing on the object. Not all edges need to be defined by a line. Value shifts, either dark against light or light against dark, can also indicate the edge of an object. Use a contrasting background to create an edge with a change in value.

SIMPLIFY YOUR VALUES

Instead of a continuous range, the drawing above uses only four discrete values. A simplified system like this is easier for the artist to visualize while drawing. It also will help you to consider the boundaries of each value area as an artistic decision, in contrast to the default view of shading that gradually fades into white. A drawing can have a simplified value range and simultaneously can use the full range of values.

CONSIDER THE FULL VALUE RANGE

Using the full range of dark-to-light values can introduce depth and interest into a drawing or painting. Look for ways to increase contrast in your drawings while staying true to the subject. Highlights are only bright in comparison to the dark values in your picture. Can you push your darks darker or crisp up the highlights? After carefully painting a bird, I often discover that the whole picture is too pale because I have not incorporated the full range of value that is in front of me.

To help you learn to focus on value, try monochromatic painting, using only one color (like a black-and-white photograph). You can also see value by looking at your subject through a red acetate filter as a means of seeing a monochromatic world. Without a filter, you can see value contrast by squinting at your subject, which will blur details and emphasize value changes.

If your paintings are too pale, put in your darkest values early (even though this goes against the traditional watercolor wisdom of working from light to dark). This will force you to adjust the painting to match the darks. At the other end of the spectrum, leave your white areas white. If you are using watercolor, leave those areas that you wish to be bright white untouched. You cannot achieve a white brighter than white paper. A successful painting can also have a limited value range, but be intentional about the decision to limit the values. Remember that colors also have values. Yellows tend to be light values, blues dark.

TRY A LIMITED COLOR PALETTE

A painting that uses too many colors may look like a calico patchwork instead of a unified piece. A more limited palette brings unity and a sense that the painting is illuminated from a single light source. Try painting with a small set of adjacent colors on the color wheel and perhaps use a touch of a color from the opposite side of the color wheel as an accent.

COLOR TEMPERATURE OVER LOCAL COLOR

Beginning artists often focus on painting the overall or local color (this tree is green, this fire engine is red). Natural shadows change the way we perceive colors. Instead of trying to match local color, pay attention to the color temperature. Does the sun cast a "warm" yellow or orange glow over the subject, or do you see "cool" blues or purples in the shadow areas? These sorts of color shifts are generally ignored in field guide art but are an important part of drawing in the field. Look for and respect color changes and your bird will feel like it is integrated into its environment. Observe how colors shift in light and shade, at different times of the day, and beneath sunny or overcast skies.

Background purple brought into shadow color

Foreground color brought into body to unify drawing

OBSERVING LIGHT AND SHADOW

Light and shadow describe the form and structure of your subject and give drawings dimension. But be careful; shadow can also quickly dominate a drawing.

THE CONVENTIONS OF SHADOW AND LIGHT

Light and shadow are handled in predictable ways in most scientific illustrations. Shadows are usually deemphasized so as not to be confused with plumage patterns. The light source is typically located in the top left-hand side of the drawing. It helps to learn these conventions to convey light, but do not be trapped by them. Become an observer of light. Note how it changes and diverges from this simple model. Be consistent about how you handle light or shadow. If you bring a warm ochre into one highlight, look for that same warm glow in other highlights. If you add a touch of violet to one shadow, you may also find it in other shadow areas in the painting.

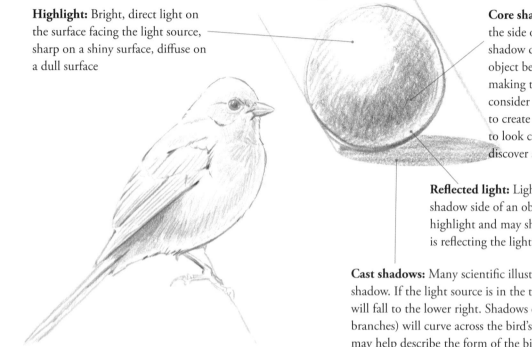

Highlight: Bright, direct light on the surface facing the light source, sharp on a shiny surface, diffuse on a dull surface

Core shadow: Deepening value on the side opposite the light source. The shadow does not reach the edge of the object because of reflected light. Avoid making the core shadow too dark, and consider using colors other than black to create your shadows. If you start to look carefully at shadows, you will discover subtle colors within them.

Reflected light: Light that bounces back onto the shadow side of an object is not as bright as the highlight and may show the color of the object that is reflecting the light.

Cast shadows: Many scientific illustrations do not include the cast shadow. If the light source is in the top left corner, the cast shadow will fall to the lower right. Shadows of other objects (such as branches) will curve across the bird's rounded body. These shadows may help describe the form of the bird but may also be confused with plumage patterns.

SPECIAL LIGHTING SITUATIONS

Strong sunlight: Direct sunlight can cause bright highlights and deep shadows. A sunlit back may appear to be brighter than the shadowed belly, even if the bird has a white breast and a black back.

Backlighting: A bird that is between you and a bright light source will show a halo of light transmitted and reflected from the bird's edge with deep shadows in its core. You may not be able to see the local color.

Overcast skies: Cloudy weather will soften shadows, making it easier to appreciate the patterns and colors of a bird's feathers.

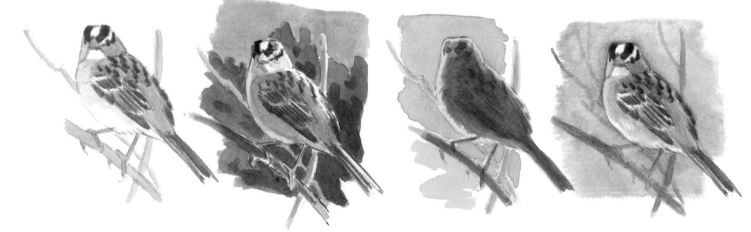

PLANES AND TEXTURE

Just as angles in the silhouette define body shape, changes in shadow values show changes in planes on the surface of the body. Define these planes first; then add a little texture.

SHOW PLANES WITH CHANGES IN VALUE

Most objects in nature are not evenly rounded. Do not think of shading as making a smooth blend of shadow tone from a dark core shadow to a highlight. These gradual shadows end up over-rounding the subject. Most real objects in nature have angles and planes (surfaces) that catch light or that cast shadows with defined edges. Changes in value indicate where planes meet and where the body surface changes angles. Changes in value turn a form.

To capture these planes, draw a light line along the edge of the shadow's shape and fill it with tone. Trace a faint line along the edge of the highlight and fill in the remaining area with a mid-tone (don't let those guidelines show). The trick is that the shadows and highlights are defined shapes, not just blended areas of tone. If you try to incorporate too many shades of gray or concentrate on blending the values, you will lose track of these planes. Therefore, keep your value scale simple. Rounded forms turn gradually and show gradual value change; angled forms turn abruptly and show sharp changes in value.

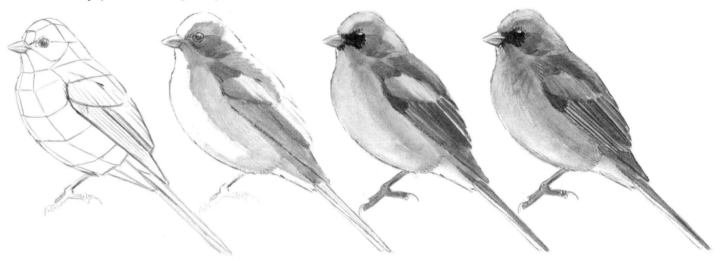

A LITTLE BIT OF TEXTURE GOES A LONG WAY

The texture of feathers will show most prominently when they are ruffled where the body makes a sharp angle beneath them. Texture also shows at the point where the shadow rolls into the highlight. Oblique light in this transition area will highlight the feather detail. Do not overdo it with feather texture. A little bit and your bird has soft feathers. Push it a little further and your bird becomes scruffy. Try adding highlights with a white colored pencil and then crisping up the details and adding a hint of texture with a dark brown colored pencil. Compare the last three stages of the illustration below. The results are subtle but effective.

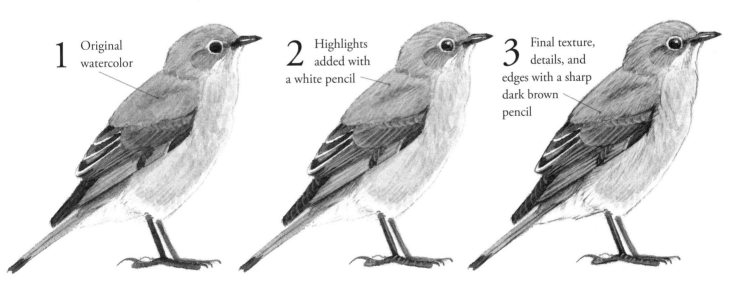

1 Original watercolor

2 Highlights added with a white pencil

3 Final texture, details, and edges with a sharp dark brown pencil

USING NEGATIVE SPACE

When you focus on a bird, your attention can get lost in the details. Instead of looking at the bird itself, look past it, and study the shape of its background. This will help you focus less on the detail and concentrate on the shape.

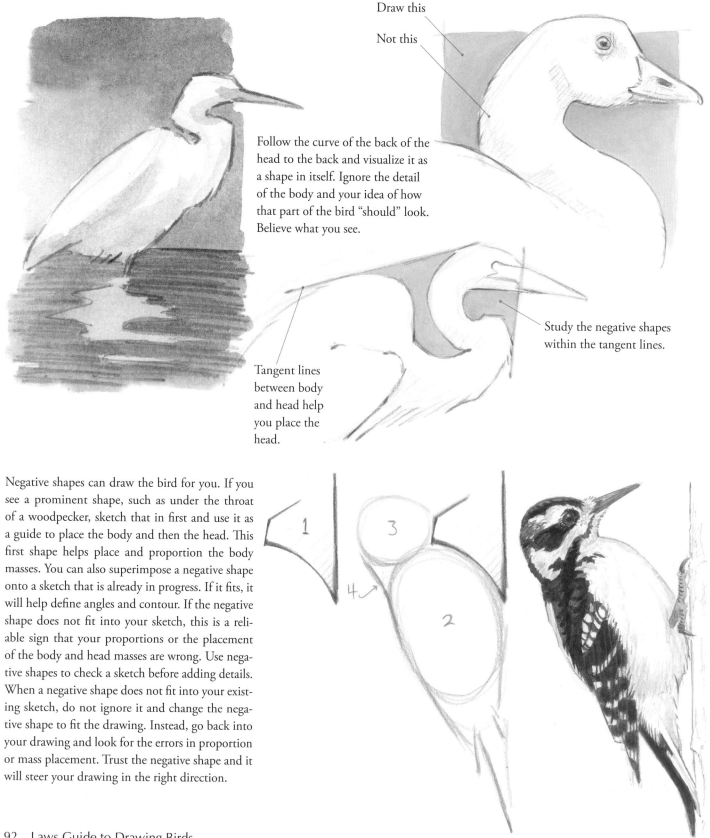

Draw this

Not this

Follow the curve of the back of the head to the back and visualize it as a shape in itself. Ignore the detail of the body and your idea of how that part of the bird "should" look. Believe what you see.

Study the negative shapes within the tangent lines.

Tangent lines between body and head help you place the head.

Negative shapes can draw the bird for you. If you see a prominent shape, such as under the throat of a woodpecker, sketch that in first and use it as a guide to place the body and then the head. This first shape helps place and proportion the body masses. You can also superimpose a negative shape onto a sketch that is already in progress. If it fits, it will help define angles and contour. If the negative shape does not fit into your sketch, this is a reliable sign that your proportions or the placement of the body and head masses are wrong. Use negative shapes to check a sketch before adding details. When a negative shape does not fit into your existing sketch, do not ignore it and change the negative shape to fit the drawing. Instead, go back into your drawing and look for the errors in proportion or mass placement. Trust the negative shape and it will steer your drawing in the right direction.

COMBINING SHAPES

Negative shapes can also be useful to define the sections of bird bodies that are contorted into poses that make them difficult to understand. You can work your way around a sleeping duck by adding one shape at a time.

Look for negative shapes within the body to help you place parts of a complex subject. Look for boundaries where color or value change sharply.

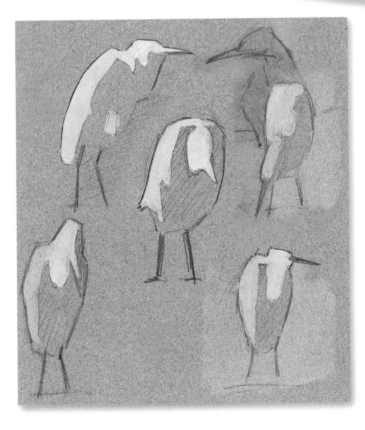

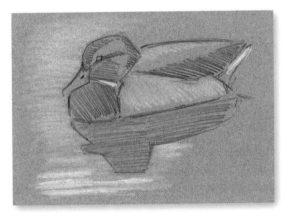

SHADOWS AND HIGHLIGHTS ARE SHAPES TOO

Don't draw shadows as continuous gray zones on one side of the bird that fade as you reach the top of the bird. Direct sunlight and sharp changes in body contours create bold highlight and shadow zones that are crisply defined. Shadows are muted on cloudy days and under the canopy.

HOW TO SHOW DEPTH

Here is your depth tool kit. You do not need to use every technique in every drawing, but if your illustration looks flat you can use this as a checklist to see how to bring out a sense of space.

Size: Objects that are closer to you will look larger than objects of the same size that are further away. A small tree in the foreground can be visually confusing, so if you include it in your drawing, be sure to use some of the other techniques to compensate.

Overlap: Objects that are further away will be partially obscured by objects that are in front of them. Intentionally overlapping objects in a picture will add more depth. Beware of line adjacencies that occur when the edge of a background object lines up with the edge of a foreground object, making them read as one continuous shape. Do not let the edge of a background object intersect a foreground object at the point where the foreground object changes angle.

Height in picture plane: Objects that are higher in the picture plane will appear farther away than objects that are lower in the picture plane if both objects are perceived to be on the ground.

Line: Darker or thicker lines pop forward, while narrow or light lines recede. You can reinforce a foreground line at the point where it overlaps a background object.

Detail: Objects that are closer to you will be more detailed than objects that are further away. If you add too much detail to a background element, you will flatten your picture.

Breaking the picture plane: If part of your subject overlaps the frame of the illustration (breaking the box), it will appear to be in front of all of the objects within the frame.

Value: Objects become increasingly pale as they recede into the distance and are obscured by scattered light in the atmosphere.

Contrast: Objects that are closer to you show a wider range of values (dark to light) than objects that are far from you. The darks are darker and the lights are lighter in foreground elements. Objects in the background are seen through a hazy filter of air that scatters light, making the overall object more pale, and making the light areas less brilliant.

Color purity: Objects closer to the observer will appear in their true colors. Colors observed in the distance will lose their intensity and grade more towards neutral gray or blue-gray (see color temperature).

Color temperature: Blue light scatters preferentially to other wavelengths, subtly shifting the color of distant objects toward blue. Yellow, orange, and red colors fade as you move deeper into the background.

Distant tree shapes suggested by
change in value and color

Detail, contrast, warm colors, and overlap
push the bird into the foreground.

Background branches are smaller,
have less detail and less contrast,
and are a lighter value.

Water drops on close catkins
add detail and high contrast.

Compare how foreground
and middle-ground catkins
are painted. What makes the
foreground branch look closer?

A FEW OF MY FAVORITE THINGS

There is no ideal art kit. Every artist will develop a favorite set of drawing tools. Your favorite tools will change over time as you are exposed to new materials and techniques.

Prismacolor Col-Erase Non-photo Blue pencil: This is my essential tool for sketching the posture, proportions, and angles before I start a detailed drawing. Use it lightly and you will not even need to erase your starting lines.

Mechanical pencils: I use a 0.5 mm pencil for fast sketching. A soft lead makes rich dark lines but is more prone to smudging. I prefer HB or 2B lead. For detail work, switch to a 0.3 mm pencil. You will need to draw more slowly and precisely, but it will give you a consistent, delicate line.

A **water soluble pencil** can be used like a regular pencil, but you can add quick shadows with a damp brush.

You can sketch or add details with a hard-tipped **colored pencil** such as Sanford Verithin or Prismacolor Col-Erase. These pencils do not smudge as much as graphite. Try sketching with a dark brown pencil.

White pencils: These can be used over dry watercolor to add or strengthen highlights. They can also be used before applying watercolor to form a wax barrier that prevents watercolor from adhering to the paper.

A **water-soluble fiber-tipped pen** lays down dark lines that can be blended into shadows with a damp brush. Try a Pilot V Razor Point or Razor Point II for great wash effects.

A dark gray **brush pen** lays down dark tones that can be overlaid to black. Some have a small nib on the other end of the pen for detail work. The ink is water-soluble.

Use a **white gel pen** to add white lines on top of dry watercolor. Useful for plant veins, primary edges, or eye highlights. Once it dries, it can be tinted with a quick watercolor wash or lifted out with a damp brush.

You can lighten your pencil lines by tapping them with a soft **kneaded eraser.** Stretch and pull the kneaded eraser like taffy before using it to warm it up. When it is soft, press it firmly over pencil lines and it will lift the graphite without smearing (like silly putty on newsprint). Use a **soft white vinyl eraser** to remove mistakes. This eraser does a good job of lifting graphite without damaging the paper surface.

Use a rolled paper **blending tool** (tortillon or stump) to smear graphite lines and blend shadows. Once the tip has picked up graphite, you can use it like a gray paintbrush, adding tone to background space, creating subtle shadows or mid-value patterns and texture.

FAST SKETCHING COMBINATIONS

Here are some combinations of tools that quickly produce volume and tone. Try them while making quick studies in the field.

Soft pencil and blending stump: A paper blender or stump quickly adds an area of pale gray tone. Start with a soft pencil drawing. Pick up and blend some of the graphite with the blender. You can essentially paint with the blending tool, adding tone to skies or indicating volume with a shadow in seconds. Do not over-soften the edges of shadowed areas. Objects in nature have angles that give the shadows sharper edges.

Brush pen: A dark gray brush pen with a fine tip on the other end can quickly lay down dark values, deepen to black, blend with water to soften edges, or create subtle shadows.

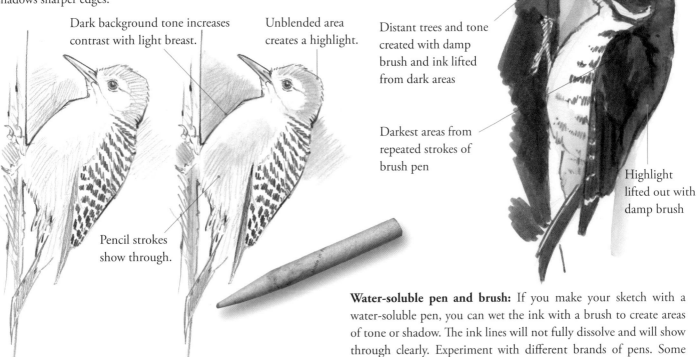

Dark background tone increases contrast with light breast.

Unblended area creates a highlight.

Pencil strokes show through.

Distant trees and tone created with damp brush and ink lifted from dark areas

Darkest areas from repeated strokes of brush pen

Highlight lifted out with damp brush

Water-soluble pencil and brush: Sketch as you would with a regular pencil, then blend darks and create shadows with a damp brush. Leave some parts as unwetted pencil lines.

Water-soluble pen and brush: If you make your sketch with a water-soluble pen, you can wet the ink with a brush to create areas of tone or shadow. The ink lines will not fully dissolve and will show through clearly. Experiment with different brands of pens. Some pens create brown washes while others dilute to gray or blue-gray. Different brands also are soluble to different degrees.

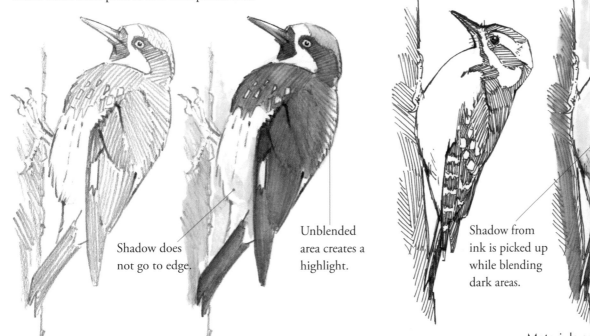

Shadow does not go to edge.

Unblended area creates a highlight.

Shadow from ink is picked up while blending dark areas.

Unblended area creates a highlight.

A PORTABLE WATERCOLOR PALETTE

Watercolors are fast-drying and easy to carry, making them ideal for both field and studio work. Carefully organize your palette to simplify color mixing.

Keep separate mixing zones for different color groups. Do not clean these areas between paintings, but mix new colors from them.

Add dabs of other colors at the edges of your mixing space to test new colors or to add to your palette if you run out of space.

If you choose to use Permanent White gouache to tint colors or make colors opaque, keep the paint and mixing area separate so that you do not dull your other colors.

Mix any color here.

Mix any color here.

This area is for mixing green. Avoid adding large amounts of magenta or red.

This area is for mixing cyan, blue, and violet. Avoid adding large amounts of red, yellow, or orange.

This area is for mixing yellow, orange, red, and magenta. Avoid adding large amounts of cyan or blue.

In the field I fit part of an old sock around my wrist to use as my cleaning rag. When you wear a hole in a sock, wash it and cut off the toe. It is one less thing to hold as you pursue birds though the foliage with your paint set.

Keep your yellow clean. Put the yellow paint in a corner of your palette and never mix it with a dirty brush.

Put a dollop of Hansa Yellow Light into the green and brown mixing areas and put some Quinacridone Pink in the blue-purple mixing area to help keep your base pigments clean.

My favorite brush for both field and studio (used for every painting in this book) is the Pentel Aquash Water Brush with the broad (18 mm) tip. It keeps a sharp point, holds its own water, and is fitted securely with a cap to protect the bristles. Dirty paint water can contain heavy metals and should not be dumped in the field. With this system, you do not need a water bottle to clean your brush. When you want to change colors, simply give it a squeeze and wipe the brush on a rag.

PAPER SELECTION

The type of paper you use dramatically changes your results. Pay particular attention to paper weight, texture, and acidity. Experiment with different paper types to find one that you like.

1. Fabriano Venezia Sketchbook
2. Canson Basic Sketchbook
3. Komtrak Inspiral Notebook (refillable)

Heavyweight paper is less prone to buckling with wet media and can take much more abuse in the form of erasing, lifting out, or embossing. If you have never drawn or painted on quality paper, you are in for a treat. Try at least 140 lb. paper for most watercolors, or even heavier if you plan to make lots of wet washes. For field work, my favorite paper for illustration is Strathmore Writing paper, 110 lb. cover bristol, ultimate white, with a "wove" finish. I get this punched for use in my Komtrak journal. Be certain that your paper is archival or acid free, or else it will yellow and degrade with time.

Paper texture is important. Smooth paper (or hot press) is used for pen drawings or hyper-detailed brushwork. For pencil work, you want a little more tooth to the paper to catch the graphite or color. Rough (or cold press) paper can bring out interesting textures in granulating watercolor washes.

Experiment with drawing on toned paper. You can buy a few sheets of gray or brown toned paper at an art supply store. Cut them to fit into your sketchbook. I use mid-value colors that are a mid-tone so that I can both push darks with my pencil and pull lights with colored pencil or gouache. I like the Canson Mi-Teintes paper. Try Oyster 340 (medium brown), Moonstone 426 (warm gray), Sky Blue 354 (blue gray), and Flannel Gray 122 (flat gray).

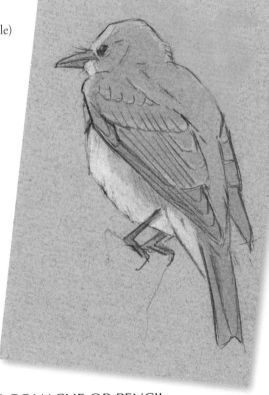

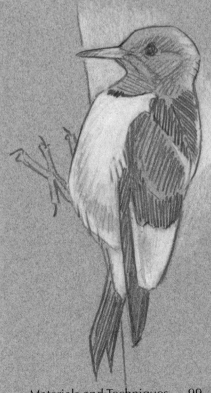

SKETCHBOOKS

Most sketchbooks have light (65 lb.) paper that will warp when you apply water to the page. If you frequently work with wet media, you may prefer a book with heavier paper, such as Fabriano Venezia (90 lb.). You can also take any kind of paper that you like and get it punched to put in a refillable Komtrak sketchbook. I avoid most other spiral-bound books because the pages can rub against each other and smear your pencil work.

COLORED PAPER AND WHITE GOUACHE OR PENCIL

Try sketching on toned pastel paper. Start your drawing with a graphite pencil. Push your darks, looking for the shape of the shadow areas. Then pop in the highlights with a white pencil. The color of the paper provides your mid-tones, so leave some parts of the drawing unmarked with either graphite or the white pencil. You also get interesting effects with watercolor, gouache, or colored pencils. Use wet media lightly or the paper will buckle.

PAINTING ON TONED PAPER

Paint dark areas with layers of transparent watercolor. When this is dry, add the light colors and tones with gouache or opaque watercolor.

1 Build the dark areas with layers of transparent watercolor. I generally start with the lightest washes and build to the darkest, letting each layer dry between coats.

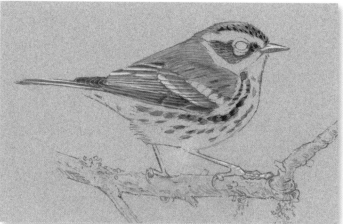

2 Colored paper will buckle if you use a lot of water, so I use fewer, more concentrated washes. If your paintings often end up too pale, try adding a spot of really dark value early and adjust the rest of the values to that dark point.

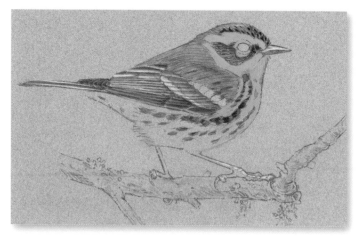

3 Here, I added the yellow with Cadmium Yellow Medium. This semi-opaque watercolor will block the gray from showing through. You could also use yellow gouache for this treatment. Try using transparent washes for the darks and opaque paint for the lights.

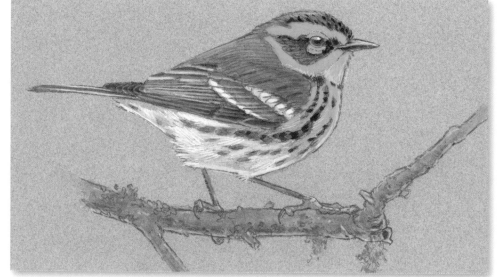

4 Paint the white areas with Permanent White gouache.

5 The shadow on the bottom of the bird was created by lifting out some of the Permanent White gouache with a damp brush.

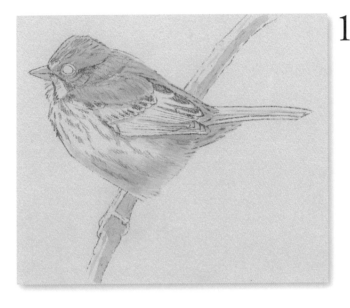

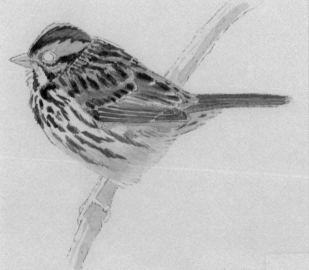

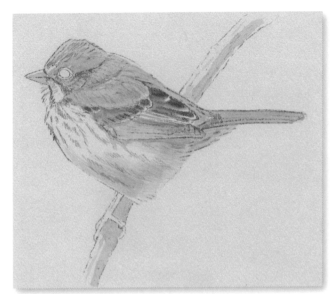

1 Another way to start a painting is to create shadows first. I use a dull purple gray.

2 Paint washes of local color on top of the shadows when they are dry. You can keep adding layers without the paint running together if you let the washes dry between coats.

3 Add darker colors on top of light base-coat washes (work from dark to light). Do not cover the whole bird with paint. Use the color of the paper as one of your hues in the body of the bird.

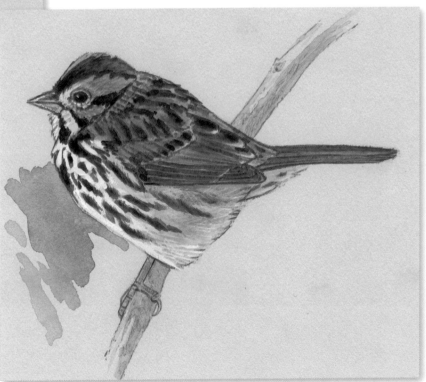

4 The breast areas are painted with Permanent White gouache. This is an opaque water-based paint. The bright white adds contrast and makes the drawing "pop." Apply long, dry brushstrokes on the lower belly to suggest the longer, fluffy feathers.

COLOR THEORY HERESY

Mixing colors can be frustrating. When you combine red, blue, and yellow as primary colors, some mixes turn muddy and other colors are impossible to create. The good news is, it's not you.

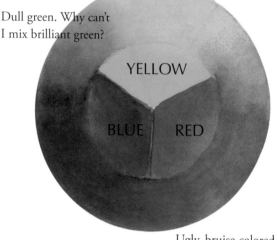

Dull green. Why can't I mix brilliant green?

YELLOW

BLUE RED

Ugly, bruise-colored purple: Why can't I mix clean violet?

If you mix a color wheel using fire engine red, navy blue, and yellow as your primary colors, you will find yourself puzzled and disappointed. You can mix a good orange by combining the red and the yellow, but you will not be able to mix a clear violet. You will also notice that the greens are not as vibrant as you expected. Mix and remix as you will, you will keep getting muddy colors. What is wrong? The error lies in the colors that we think of as primary colors.

By definition, a primary color cannot be made by combining other colors. It is "pure." You should be able to mix the other colors by combining primary colors. It turns out that this is not really true; but three primary colors can actually produce many of the colors that we see. To get started, we need to debunk some color myths. A few color experiments will change the way you look at color forever.

PROBLEM 1: CAN'T GET THERE FROM HERE...

There are colors that you cannot create by combining blue, red, and yellow. Mixing red and blue is supposed to make violet but instead makes a purplish gray. How can you get violet?

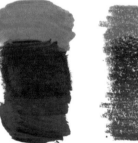

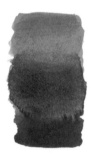

Mixing yellow and blue makes a dull green. How do you mix vibrant, clean green hues?

Hot pink is another problem. If you dilute red paint, you get light red, not pink. The same problem results if you add white paint to red using acrylic or oil paint.

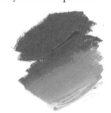

PROBLEM 2. YOU CAN MIX RED AND BLUE!

You should not be able to mix two colors and get a primary color. If you can mix two colors to obtain blue, red, or yellow, then those colors are not primary colors. Mixing yellow and magenta makes red. You can see this with watercolor, opaque paint, or colored pencils. Therefore, red is not a primary color! Similarly, if you mix magenta and cyan, you make blue. This means that blue is also not a primary color.

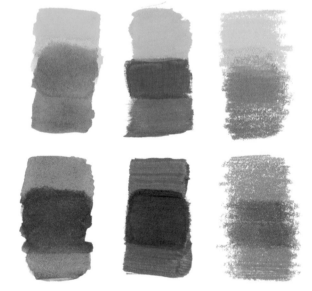

Magenta and cyan are not pale versions of red and blue. They are distinct colors in themselves. You cannot mix them or dilute other colors to create them. Magenta and cyan are in fact the true primary colors, in addition to lemon yellow. If these colors are not a part of your palette, you will not be able to mix clean colors.

Why did the green turn dull? Blue is derived from mixing two primaries. Adding the remaining primary neutralizes (dulls) the color. And purple? Any time you mix red with blue you will get mud because you are mixing two derived colors.

REINVENTING THE WHEEL

The true primary colors are cyan, magenta, and yellow. These can be mixed to make red, green, and blue. These in turn can be remixed with the primary colors to make violet or orange.

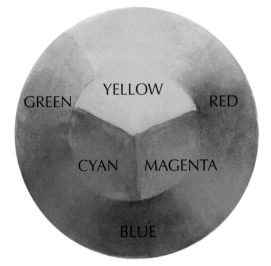

I know, I know, this contradicts so much of what you have been told, but you don't have to take my word for it. Take your colors out right now and experiment with them yourself. If you do not have a clear magenta and cyan, add them to your palette today. See what happens when you mix your own color wheel from just the three real primary colors. No set of primary colors will be perfect and enable you to really mix all of the possible colors, but with the triad of cyan, yellow, and magenta, you will be able to create a much wider range of colors and avoid mixing muddy ones.

If you use Prismacolor colored pencils, the primaries are Process Red (the closest color to magenta), True Blue (actually cyan, even though it says "blue" in the name), and Canary Yellow. If you use watercolor, Phthalo Blue PB15 (for cyan), Winsor & Newton Quinacridone Magenta PR122 or Daniel Smith Quinacridone Pink PV42 (for magenta), and Daniel Smith Hansa Yellow Light PY3 make a good set of primary colors.

The primary color magenta is not pale red. It is a distinct reddish violet color and is a must-have for your palette. Magenta can be diluted with water or with white to make bright, clean pinks.

Cyan is another color you need to get comfortable with. Cyan is not pale blue, and it cannot be mixed from other colors. When mixed with a touch of magenta, it forms blue, and with a little more magenta it becomes a clear, rich violet. Cyan also makes clean greens when mixed with yellow.

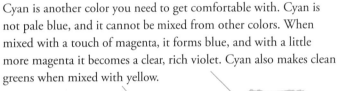

You can mix a bright fire engine red by combining magenta and yellow.

If you combine all three primary colors, you get a gray, brown, or blackish neutral tone. Depending on the relative amounts of each primary in the mix, you can create an infinite variety of neutral tones. A dark tone that you create by mixing primary colors will result in more variable and therefore more interesting shadows or dark areas than those achieved by simply applying a wash of Lamp Black. A quick way of muting a color that is too bright is to mix it with a little of the color on the opposite side of the color wheel, automatically combining all the primary colors.

If cyan, magenta, and yellow are the true primary colors for pigment, the relationship with the light color wheel also makes more sense. Televisions and computer monitors mix beams of red, blue, and green light to make all of the colors you see on your screen. The secondary colors that result from mixing light are cyan, magenta, and yellow. The color wheel for light (also called additive color) has the same colors as the color wheel for pigment (also called subtractive color).

A green that is too vivid can be muted with a little magenta.

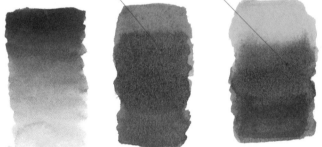

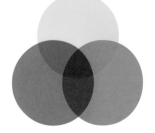

Pigment Color Wheel
subtractive: all colors=black

Light Color Wheel
additive: all colors=white

USING COLORED PENCILS

Colored pencils are great for the field or studio. They are intuitive to use, predictable, versatile, and easy to master. Here are a few pointers that will help you get the results you want.

Color selection: You do not need every color in the jumbo box, especially if you are sketching in the field. Select a set of basic colors, including Process Red, True Blue, and Canary Yellow, and then add a few muddy grays, greens, and browns. These muted colors will probably become your favorites. I also recommend Black Grape and Greyed Lavender, two muted purple-gray pencils that make effective shadows.

Embossing tool: This is a metal stylus with rounded points, one large and one small. It is used to create grooves in the paper that are too deep to be marked by colored pencils, and for making thin pale lines against a dark background.

Colorless blender: This pencil contains wax but no pigment. Use it to burnish the surface of the paper, filling in all of the little white flecks from divots in the paper. This creates a smooth look. Once the paper is burnished, it will be difficult to add layers from other pencils. If you choose to blend with this tool, it should be the final step in your drawing.

Pencil organization: Bundle your cool colors, warm colors, browns and neutrals, and greens separately with elastic bands to make it easier to grab the color you want. This is a lot simpler than putting increasingly short pencils back into their original box.

Layering colors: The most important trick for using colored pencils is to press lightly and layer multiple colors together. Do not simply grab the closest color from your set and fill in with it. You can get an infinite variety of hues by layering colors on top of each other. As long as you do not press too hard and flatten the texture out of the paper, you can always add more color. Your dark areas can sparkle with subtle color instead of a monochromatic black. It helps to keep your pencils sharp.

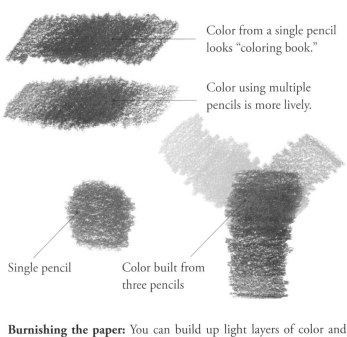

Color from a single pencil looks "coloring book."

Color using multiple pencils is more lively.

Single pencil

Color built from three pencils

Burnishing the paper: You can build up light layers of color and still have white paper showing. As long as your paper maintains its texture, you can add more layers of color. Many illustrators like the brightness and texture that come from the white flecks of paper sparkling through. If you want to get rid of the white flecks, finish with a heavier layer of color, or burnish the paper smooth with a white pencil or a colorless blender.

Light application, shows paper texture

Burnished pencil, smooth texture

Overworked, blotchy

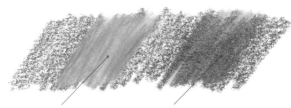

Blended with white pencil. Note pastel appearance.

Blended with colorless blender. Note value and color shift.

Lighten up on the graphite: If you color your drawing with colored pencils, do not use a lot of graphite details or shading. Graphite will smear when you rub it with colored pencils. Instead, add your details and subtle shadows with a colored pencil.

Embossing the paper: If you want a pale line in the middle of a dark area, draw it first with enough pressure to make a groove in the paper. As you add other pencil colors around it, it will be more difficult for the other colors to draw in the groove. For fine, hard-edged light lines, use an embossing tool to make fine grooves in the paper. These lines cannot be erased, so place them carefully.

Lines embossed on white paper

Lines embossed on green pencil strokes, then overlaid with purple

Using colored pencils with watercolor: You can add colored pencil details over dry watercolor washes. This is a great way to achieve texture iridescence or fine details. Colored pencils used before a watercolor wash will make a waxy layer, making it difficult for the watercolor to stick to the paper. Try lightly edging primary feathers with pencil before applying a darker wash to get fine pale edges. Use restraint. Once it is on the paper, the pencil is difficult to remove.

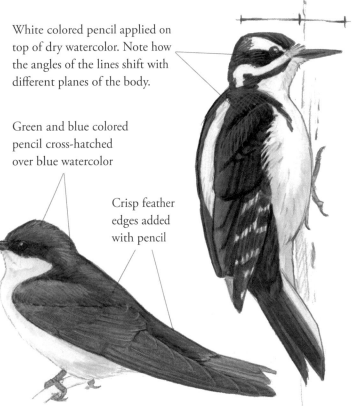

White colored pencil applied on top of dry watercolor. Note how the angles of the lines shift with different planes of the body.

Green and blue colored pencil cross-hatched over blue watercolor

Crisp feather edges added with pencil

Show planes with pencil strokes: If a water drop were to run down the surface of the object that you are drawing, the angle of its path would change as it rolled from one angled surface to another. Pencil strokes that follow the angles of planes in a similar way help describe the shape of your subject. By changing the angle of your pencil strokes, you can indicate changes in the planes of the surface of your subject. If your pencil strokes show through, let these lines work for you.

STEP BY STEP: COLORED PENCIL WARBLER

If you want a subtle shadow on a yellow subject, try shading with Prismacolor Black Grape and Greyed Lavender.

1 Outline with brown pencil. The soft neutral tone will blend easily with other colors and not muddy the yellow. Graphite pencil and black colored pencils will both smudge into the yellow.

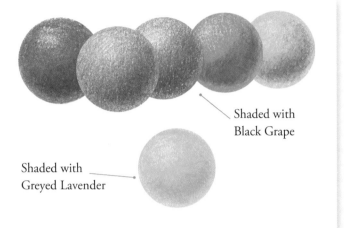

Shaded with Black Grape

Shaded with Greyed Lavender

2 Create shadows on the throat, breast, and belly with Greyed Lavender. Use Black Grape for shadows in the dark areas. Rest the side of your hand on another piece of paper as you draw so that you do not smudge your drawing.

Black grape is a good pencil color for many shadows. Apply it gently in the areas that will receive dark shadows. But the shadows made with a Black Grape pencil are often too pronounced on yellow objects; Greyed Lavender creates terrific shadows on yellow and white objects. Note that real shadows often contain hints of colors reflected from nearby objects. You can warm, cool, or otherwise tint shadows as you desire. Learn to look for the colors within shadows.

Crisp up the edges with a sharp Verithin pencil.

Keep pencils sharp, both to control detail and to allow you to push saturated colors.

3 Add layers of pencil to build up the body colors. Leave the back lighter to suggest a highlight. Do not add the black stripes until the end. Once it is down, it will become difficult to intensify the breast color without smudging the black.

Verithin pencils used to create sharp details

4 Once you are satisfied with the intensity of the breast feathers and shadow, add the black stripes with pressure and intensity. I usually create blacks by overlapping colors (often indigo blue and dark brown). On the breast stripes I only used a black pencil because I did not want to risk smudging or a greenish tint where the indigo pencil might overlap the yellow.

STEP BY STEP: MIXED-MEDIA STELLER'S JAY

Take advantage of the rich colors of watercolor in combination with the precision and texture of colored pencil. By combining media, you get the best of both worlds.

1 Block in the posture, proportions, and angles with a Non-photo Blue pencil.

Keep the guidelines light (these lines are overemphasized to make them easy to see).

2 Outline the feather groups and wings with graphite pencil. The harshness of these edges will fade when covered with paint.

3 Add texture with graphite pencil, following the contours of the bird.

Exclude detail from highlight areas.

4 Lay in shadows with DS Shadow Violet watercolor. Shadows give the bird volume and dimension.

How will the cast shadow of the head and wing wrap around the body?

5 Let the shadows dry and glaze layers of color. Look for subtle color shifts.

Cyan wings (Phthalo Blue)

Violet in tail

Drybrush the tail and wing markings before adding pencil.

6 Add colored pencil once the watercolor has dried completely.

Follow the contour of the body with pencil strokes.

Suggest fluffy breast feathers with longer overlapping strokes.

Indicate some feather edges with a white highlight. Do not overdo it.

WATERCOLOR CHOICES

I look for colors that do not fade in the sun (very important), are nonstaining, and are transparent. I also prefer colors that contain a single pigment rather than prepared mixtures.

The choices you make to fill your palette will change over time as you discover new colors. As you add to or delete from your palette, consider paint quality, lightfastness, staining, granulation, transparency, and single pigments vs. mixtures.

Not all watercolors are created equal. Use high-quality paints from the beginning and you will make your work much easier. Low-quality paint will respond unpredictably and will make it more difficult to achieve intense colors or deep values. I use paints manufactured by Daniel Smith (DS) and some artist-grade Winsor & Newton (WN). Each pigment has an alphanumeric code that you can use to help you keep track of similar pigments made by different manufacturers or understand the ingredients of mixes.

Just as a photograph or couch fades in the sun, so do watercolors. Some colors fade more easily than others and should be avoided. Start your color selection by eliminating all such "fugitive" colors. For this reason I avoid Alizarin Crimson, Rose Madder Genuine, Opera Pink, and Aureolin (Cobalt Yellow). Do your own lightfastness test by painting strips of all your colors and cutting the page in half. Put one side in a dark drawer for three months while the other half hangs in a sunlit window. Compare the colors after three months. If you can detect a change in color, either lightening or darkening, look for a new pigment.

Some colors stain the paper and cannot be lifted out. Others sit as granules on the top of the paper surface and can be lifted out with a damp brush. This makes it possible to correct mistakes or add whites back into a painting. I prefer nonstaining colors as a rule, but often I need to incorporate staining colors to get a better range. Paints may contain heavy particles that concentrate into patterns on rough paper as the paint dries. This is called granulation, and it can create beautiful and surprising effects. If you like (often pleasant) surprises, you will like granulating paint. Wherever possible, I use transparent watercolors, which allow me to layer coats of paint and maintain the brilliance of watercolor.

Some artists prefer to limit their palette to a few primary colors and then mix the rest of their colors. This is excellent training in mixing colors. I prefer to take advantage of the array of colors created by grinding chemicals or earth materials into paint. I can combine these single pigments to mix the rest of my colors. This is neither "cheating" nor taking a shortcut, but taking full advantage of the characteristics of different pigments. Paint suppliers also sell their own mixes of multiple pigments. These are less useful for mixing, but often convenient. If your palette is limited, focus on single pigment colors rather than pre-made mixes.

Neutral Tint WN PBk6 PB15 PV19
This opaque, staining black mix can be used to tone down any color or build up deep black areas.

Payne's Grey DS PB29 PBk9 PY42
A low-staining, semitransparent, cool blue-black mix. Do not use it to create shadows on yellow, as it turns green.

Black Tourmaline Genuine DS
Nonstaining, transparent, warm gray (similar to Davy's Gray WN, but lightfast).

Shadow Violet DS PO73 PB29 PG18
A low-staining, transparent, purple blue-black mix. This granulating pigment can dry in surprising and beautiful ways. My go-to shadow color.

Bloodstone Genuine DS
A nonstaining, transparent purplish brown that dilutes to a warm gray.

Raw Umber DS PBr7
Low-staining, semitransparent, deep cool brown

Burnt Umber DS PBr7
Low-staining, semitransparent, warm brown

Italian Burnt Sienna DS PBr7
Nonstaining, semitransparent red-brown

Monte Amiata Natural Sienna DS, PBr7
Low-staining, transparent, warm light brown

Buff Titanium DS PW6:1
Nonstaining, semitransparent pale tan. One of my favorite colors to paint lighter areas of brown birds.

Perylene Green DS PBk31

Medium staining, semitransparent, rich dark green can be used to mix rich blacks.

Undersea Green DS PB29 PO49

Medium-staining, semitransparent, intense, dull green–brown mix. Fades to soft olive drab.

Hooker's Green DS PG36 PY3 PO49

A low-staining, semitransparent green mix that is a good start for mixing other greens.

Chromium Oxide DS PG17

Low-staining, opaque olive-green, good for sage and greenish warblers

Serpentine Genuine DS

Nonstaining, semitransparent, warm, granulating green

Rich Green Gold DS PY129

Low-staining, transparent yellow-green that is good for mixing with other greens

Phthalo Yellow Green DS PY3 PG36

Medium-staining, transparent, intense yellow-green mix. The yellow becomes more apparent as the pigment is diluted.

Phthalo Blue DS PB15

Strongly staining, transparent primary cyan. Be careful, a little goes a very long way.

Manganese Blue Hue DS PB15

Low-staining, transparent substitute for Phthalo Blue that is less intense and lifts out cleanly

Cobalt Blue WN PB28

Low-staining, transparent blue

Indanthrone Blue DS PB60

Medium-staining, transparent, warm dark blue that appears almost black when applied in a concentrated wash.

Winsor (dioxazine) Violet WN PV23

Medium-staining, semitransparent purple. This formulation stains less than Dioxazine Violet DS.

Quinacridone Pink DS PV42

Medium-staining, transparent primary magenta. A good choice for a primary magenta. Makes clear pinks and mixes to red or violet.

Pyrrol Red DS PR254

Medium-staining, semitransparent, intense fire engine red

Quinacridone Sienna DS PO49 PR209

Low-staining, transparent orange-brown

Permanent Orange DS PO62

Low-staining, transparent, rich orange.

Quinacridone Gold DS PO49

Low-staining, transparent yellowish brown pigment that dilutes to a soft gold

New Gamboge DS PY153

Low-staining, transparent yellow that changes from brownish to a warm yellow in transparent mixtures

Hansa Yellow Medium DS PY97

Low-staining, transparent yellow

Hansa Yellow Light DS PY3

Low-staining, transparent lemon yellow. Use as the primary yellow for mixing.

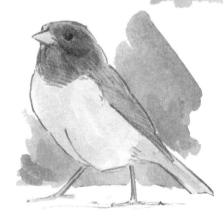

Toxic Paint: Some pigments contain toxic heavy metals or organic compounds such as cadmium, chromium, copper, cobalt, or nickel. Do not clean or point your brushes in your mouth or pour dirty paint water out in the field. Using a water brush and wiping the excess paint residue on a rag is an environmentally friendly way to paint in nature.

WATERCOLOR TECHNIQUES

Here is a handful of watercolor techniques that you should get under your belt. Practice these to learn and to understand how your materials work.

Flat wash: This technique is used to form a solid area of one color that does not have streaks. Mix a of pool your chosen color large enough so that you will not need to remix during the wash. Tilt your paper down towards you at a slight angle. Apply a wet brushstroke along the top of the wash area with enough water so that the pigment and water form a wet bead along the bottom of the wash. Recharge the brush with paint and make successive strokes below the initial stroke, picking up the bead at the bottom of the wash each time with the tip of the brush. The wet bead will prevent lines from forming at the edges of the strokes where the paint dries. Let the wash dry completely. Do not go back in and mess with the wash once it is down. Flat washes are more difficult to paint with a water brush.

Graded wash: Used to create a wash that changes color or value as it moves down the page. Follow the procedure for the flat wash, but add a little water to the mixture with each stroke. If you use a water brush, just let the pigment run out as you paint back and forth across the paper in one continuous stroke. An easy way to get one color to blend into another is to paint one graded wash, let it dry completely, and then do a second wash of another color in the opposite direction. Make the second wash quickly so that you do not lift or disturb the paint that is already on the surface.

Glazing: You can layer washes on top of coats of dry paint. Applying paint on a dry wash will allow you to create or preserve detailed brushstrokes or build up color or value. Let each layer dry completely between coats. If your paint layers are applied quickly and without scrubbing brushstrokes, the bottom layers will not lift and mix with the upper layers.

Wet-on-wet: If you apply paint to paper that is already damp, you will create soft edges as the pigment creeps out into wet areas. This can be done into a wash that is still wet or on clean water that you have applied to the surface. Experiment with different amounts of water on the page. Be careful. If you apply a diluted mixture onto an area of more dense pigment, the watery paint will move into the dense area, creating a "back run," pushing pigment that creates a line as it dries.

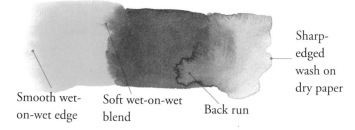

Smooth wet-on-wet edge

Soft wet-on-wet blend

Back run

Sharp-edged wash on dry paper

Lifting out: Some colors sit on the surface of the paper and can be rewetted and lifted out with a soft rag or damp brush. This can create highlights where light strikes your subject. If you want something to be pure white, be sure to leave that part of the paper untouched. You will not be able to lift everything completely out, and some pigments, such as phthalos, stain the paper and cannot be lifted out.

Manganese Blue Hue is easily lifted out.

Phthalo Blue stains the paper and cannot be lifted out.

Drybrush: You can create texture by skimming a damp (not wet) brush lightly over rough-surfaced paper. You can also fan the tip of a damp brush to make strokes that suggest hair or feather texture. It is easy to overdo it with this technique, so suggest texture in a few areas rather than covering a whole bird with drybrush texture.

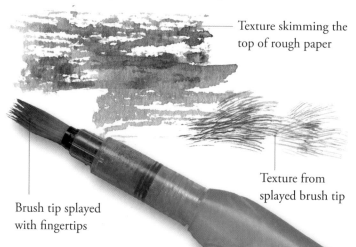

Texture skimming the top of rough paper

Texture from splayed brush tip

Brush tip splayed with fingertips

Paint light to dark but establish a dark point: You can always make a watercolor darker by adding more paint. It is more difficult to lighten an area (see "lifting out"). Any area you want to be bright white should be left as clean paper. Start with your lightest areas and build up to the darkest. If you find that your finished watercolors end up too light (which is a common problem), paint one of your darkest spots early in the process. This will force you to adjust the values of the whole painting to that dark point.

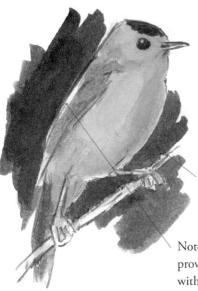

A dark background makes a lighter subject pop from the page.

Note the pale area on the back, providing a highlight and contrast with the dark background.

Fewer washes are better than many: Many paper surfaces will start to fray or felt up as they are scrubbed with multiple brushstrokes. This will make the pigment applied in these areas dark and dull. Minimize the amount of stroking or scrubbing while lifting out in any given area. Once you have destroyed the surface of the paper, washes will become unpredictable and blotchy. With a test scrap of paper, explore the balance between working an area and maintaining the paper surface.

Scar from overworked paper

Know when to stop: This is the most difficult aspect of painting. As you start to apply watercolor, your work grows and develops in front of your eyes. Every stroke brings you closer to representing what you want to show. Then, at some point, the painting turns the corner and becomes overworked and loses its freshness. Stop just before you think the painting is done. Leave a little to the imagination.

MIXING COMPLEMENTARY COLORS

Complementary colors are pairs of colors located roughly on opposite sides of the color wheel. When mixed, they result in a gray neutral tone that is useful for making shadows or for dulling a color that is too intense.

Quinacridone Pink and Perylene Green

Phthalo Blue and Pyrrole Red

Shadow mixed from Perylene Green

Shadow mixed from Pyrrole Red

It is very difficult to find a good complementary color for mixing with yellow. Anything that is a little too blue will quickly turn a shadow into an ill shade of green. Blacks straight out of the tube can overpower a delicate yellow. Try mixing a pale purple gray but use a light touch. I use Neutral Tint WN and Shadow Violet DS.

Many colors, like Payne's Grey, turn greenish when used as a shadow color on yellow

Shadow mixed from Neutral Tint and Shadow Violet

Experiment with color combinations on your palette to discover which colors make the best blacks and grays. Black colors that result from mixing colors look more interesting in a painting than Lamp Black (which is just soot) or other blacks straight out of the tube.

French Ultramarine and Raw Umber

French Ultramarine and Quinacridone Sienna

Chromium Oxide and Dioxazine Violet

Hooker's Green and Dioxazine Violet

STEP BY STEP: MIXED-MEDIA EUROPEAN STARLING

It is difficult to work around small pale spots. Here I use waxy colored pencils to keep paint from darkening the paper and a white gel pen to create sharp details.

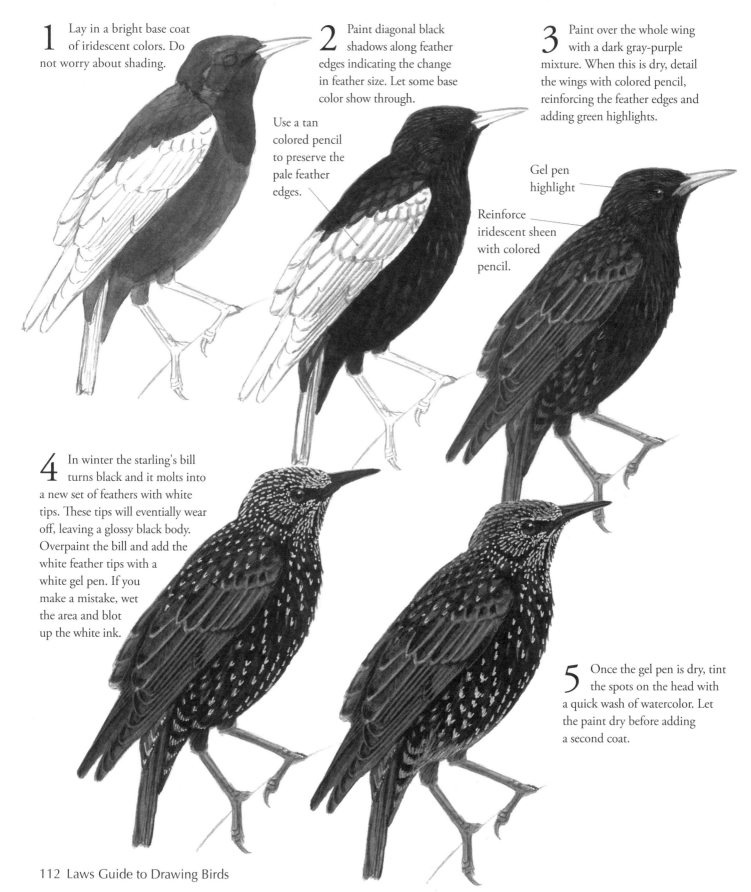

1 Lay in a bright base coat of iridescent colors. Do not worry about shading.

2 Paint diagonal black shadows along feather edges indicating the change in feather size. Let some base color show through.

Use a tan colored pencil to preserve the pale feather edges.

3 Paint over the whole wing with a dark gray-purple mixture. When this is dry, detail the wings with colored pencil, reinforcing the feather edges and adding green highlights.

Gel pen highlight

Reinforce iridescent sheen with colored pencil.

4 In winter the starling's bill turns black and it molts into a new set of feathers with white tips. These tips will eventially wear off, leaving a glossy black body. Overpaint the bill and add the white feather tips with a white gel pen. If you make a mistake, wet the area and blot up the white ink.

5 Once the gel pen is dry, tint the spots on the head with a quick wash of watercolor. Let the paint dry before adding a second coat.

USING REFERENCE MATERIAL

Science museum collections, taxidermy mounts, video, and photos are useful reference sources and can supplement your field observations.

DRAWING FROM MUSEUM COLLECTIONS

Scientific bird collections are an invaluable resource. Specimens, along with essential collection information, such as the location and date that the skin was collected, are carefully preserved and catalogued. Researchers can quickly get the sense of genetic and regional variation by examining drawers full of prepared skins. The skins are stuffed and dried to preserve space, but they still show essential morphological details. While feathers are easily observed, the birds are not in lifelike poses, but instead resemble corn dogs with white cotton showing through the eyes.

These collections will preserve birds for hundreds of years and the value of these biological libraries only grows with time. Access is limited to those who can demonstrate a legitimate need to see the collections and who can also demonstrate proper care and handling of the specimens. If you are permitted to access a research collection, work carefully with the curators to learn and follow their procedures. Consider volunteering at a local museum to help prepare specimens. There is no better way to learn external anatomy.

DRAWING FROM MOUNTED BIRDS

Taxidermy is a difficult art. Many mounted birds are lumpy and distorted. If you copy a stuffed bird's posture, your drawing will only be as good as the taxidermy and will show all the subject's flaws. Even poor mounts can be used as study skins to check feather detail. Eyes, bills, and legs may be painted and do not show the same colors as seen on a living bird. Another disadvantage of drawing from mounted birds is that the collection information, such as where and when the bird was killed or found, is seldom kept with the mount. This may result in your drawing the incorrect subspecies or plumage. If you do find the work of a master taxidermist, make sketches of one bird from multiple angles in order to learn how to rotate a bird in your mind.

DRAWING FROM PHOTOGRAPHS AND VIDEO

Photographs and video are a terrific resource for illustrators. The popularity of digital photography has resulted in rich online photo resources. You can also freeze high-definition video to capture virtually any pose. Some caution is warranted, however. Many photographers like to catch unusual behaviors or actions, so a photo may not be representative of the typical posture or plumage of a bird. The shadow contrast in many photos is much stronger than what you see with your naked eye, so copying the values of a photograph may make a drawing appear unnatural. Color photographs in magazines are frequently oversaturated and may distort color.

Illustrators should respect the copyrights of other artists. Any time you use a photograph or a drawing for reference, be respectful of the copyright and intellectual property of the photographer or artist. These laws apply whether or not there is a copyright notice accompanying the photograph. You can combine elements of different reference materials to make a unique work that is not obviously derivative. It is illegal and unethical to copy another person's work (including photographs) if you intend to show, sell, or use the art in a publication without first requesting the permission of the photographer or artist.

DRAWING FROM OTHER ILLUSTRATIONS

It is inspiring to study and learn from the work of other artists. There is a long tradition of studying the masters. If you find artists or illustrators that you particularly admire, find reproductions of their work and try to copy the drawings line by line. You will teach yourself volumes about how that artist works. I find it particularly helpful to study sketches or unfinished work, where the process of the drawing is easier to decipher. Drawings can be misleading reference material. Any mistake made by the original artist will be transferred to your own work. Copyright laws apply to artwork just as they do to photographs.

BIBLIOGRAPHY

Here are some of the most helpful and inspiring articles and books I have found. Study to improve your understanding of bird anatomy and learn from the styles of other artists. Follow the work of your favorite artists and glean used bookstores for dusty treasures.

ESSENTIAL REFERENCES

Alderfer, Jonathan K. "Building Birding Skills: A Detailed Look at Upperwing Topography. *Birding* 33, no. 3 (June 2001).

Alderfer, Jonathan, and Jon L. Dunn. *National Geographic Birding Essentials*. Washington, D.C.: National Geographic Society, 2007.

Dunn, Jon L., and Jonathan K. Alderfer. *National Geographic Field Guide to the Birds of North America*, 5th ed. Washington, D.C.: National Geographic Society, 2006.

Griggs, Jack L. *All the Birds of North America*. New York: Harper Collins, 1997 (American Bird Conservancy's field guide).

Hume, Rob. *Birds by Character*. London: Duncan Petersen Publishing, 1990.

Jonsson, Lars. *Birds of Europe*. Princeton: Princeton Univ. Press, 1993.

Proctor, Noble, and Patrick Lynch. *Manual of Ornithology*. New Haven: Yale Univ. Press, 1993.

Pyle, Peter. *Identification Guide to North American Birds*, Part I and II. Pt. Reyes Station, Calif.: Slate Creek Press, 1997, 2002.

Royse, Robert. *Robert Royse's Bird Photography Pages*, http://roysephotos.com.

Sibley, David Allen. *Sibley's Birding Basics*. New York: Alfred A. Knopf, 2002.

———. *Sibley Guide to Birds*. New York: Alfred A. Knopf, 2000.

———. "What is the Malar?" *British Birds* 94 (February 2001), 80–84.

BIRD ILLUSTRATION

Busby, John. *Drawing Birds*. Portland, Ore.: Timber Press, 2004.

Eckelberry, Don. "Techniques in Bird Illustration." Cornell Lab of Ornithology *Living Bird Annual* 4, 1965, 131–160.

Partington, Peter. *Learn to Draw Birds*. New York: Harper Collins, 1998.

———. *Learn to Paint Birds in Watercolour*. New York: Harper Collins, 1998.

Rayfield, Susan. *Painting Birds*. New York: Watson Guptill, 1988.

———. *Wildlife Painting: Techniques of Modern Masters*. New York: Watson Guptill, 1985.

Wootton, Tim. *Drawing and Painting Birds*. Marlborough, U.K.: Crowood Press, 2010.

ARTWORK TO INSPIRE

Artists for Nature Foundation. *Artists for Nature in Extremadura*, ed. Nicholas Hammond. Lavenham, U.K.: Wildlife Art Gallery, 1995.

Bateman, Robert. *Birds*. New York: Pantheon Books, 2002. You can't go wrong with any book of Bateman's work.

Brockie, Keith. *Keith Brockie's Wildlife Sketchbook*. New York: Macmillan, 1981.

———. *One Man's Island*. New York: Harper and Row, 1984.

———. *One Man's River*. New York: Harper and Row, 1988.

Busby, John. *Nature Drawings*. Shrewsbury, U.K.: Arlequin Press, 1993.

Cornell Laboratory of Ornithology Project FeederWatch. Birds of the Garden poster series and "Hummingbirds of the United States and Canada." Illustrated by Lawrence McQueen. Portland, Ore.: Windsor Nature Discovery.

Jonsson, Lars. *Birds and Light*. Princeton: Princeton Univ. Press, 2002.

———. *Lars Jonsson's Birds*. Princeton: Princeton Univ. Press, 2008.

Lansdowne, J. Fenwick. *Birds of the West Coast*. Vol. I and II. Toronto: M. F. Feheley Arts, 1976, 1980.

Ott, Riki. *Alaska's Copper River Delta*. Seattle: Univ. of Washington Press, 1998.

Rees, Darren. *Bird Impressions*. Shrewsbury, U.K.: Swan Hill, 1983.

Schulenberg, Thomas S., et al. *Birds of Peru*. Princeton: Princeton Univ. Press, 2007. Watercolor illustrations by Lawrence McQueen.

Sibley, David Allen. Sibley Birder's Year calendars. Sibley Guides, http://www.sibleyguides.com. See Sibley's illustrations closer to the size they were originally painted.

Tunnicliffe, Charles. *A Sketchbook of Birds*. New York: Holt, Rinehart and Winston, 1979.

———. *Sketches of Bird Life*. New York: Watson-Guptill, 1981.

———. *Tunnicliffe's Birds*. London: Victor Gollancz Ltd, 1984.

Warren, Michael. *Shorelines, Birds at the Water's Edge*. London: Hodder and Stoughton, 1984.

LIST OF ILLUSTRATIONS

Birds are identified clockwise from top left, unless otherwise stated.

Front cover: Northern Cardinal

Title page: American Robin, Allen's Hummingbird, Loggerhead Shrike, Red-tailed Hawk, Yellow-rumped Warbler, Belted Kingfisher

ii Song Sparrow

iii Olive-sided Flycatcher, Tufted Titmouse, Red-bellied Woodpecker, Northern Cardinal, Eastern Pheobe, Brown Thrasher, Black-capped Chickadee, Chimney Swift

iv White-throated Sparrow

v Yellow-rumped Warbler, White-crowned Sparrow, White-throated Sparrow

vi Song Sparrow, House Finch, Black-and-white Warbler, White-throated Sparrow, Song Sparrow

viii Dark-Eyed Junco

x Townsend's Warbler, Malachite Kingfisher, Bald Eagle, Northern Cardinal

1 Loggerhead Shrike, Song Sparrow, House Wren

3 Bohemian Waxwing

4 Northern Cardinal

5 Scrub Jay, Savannah Sparrow, House Wren

6 American Robin, Song Sparrow, Hermit Thrush

7 Pileated Woodpecker, Wrentit, Yellow-billed Magpie

8 Loggerhead Shrike, Mountain Chickadee, Yellow-billed Magpie, Loggerhead Shrike

9 Marbled Godwit, Golden Eagle, Redhead

10 Townsend's Warbler

11 Townsend's Warbler

12 Song Sparrow

13 Song Sparrow

14 Yellow-rumped Warbler, Song Sparrow, Blue Grosbeak

15 Song Sparrow, Acorn Woodpecker, American Robin, Chestnut-sided Warbler,

16 Acorn Woodpecker, Bewick's Wren, Spotted Towhee, White-throated Sparrow, Yellow Warbler, Chestnut-sided Warbler

17 Spotted Towhee, Yellow Warbler, American Dipper, Military Macaw, American Woodcock, Golden-cheeked Warbler

18 Top: Song Sparrow

 Bottom row, left group (clockwise from top): Golden-winged Warbler, Blue-headed Vireo, Olive Warbler

 Middle group: Smith's Longspur, Savannah Sparrow, Green-tailed Towhee

 Right group: Magnolia Warbler, White-throated Sparrow, Kentucky Warbler

19 Townsend's Warbler, Song Sparrow, American Pipit

20 Black-throated Gray Warbler

21 White-throated Sparrow, Yellow-rumped Warbler

22 Song Sparrow

23 Song Sparrow, Hooded Warbler

24 Yellow-rumped Warbler, Song Sparrow, American Robin

25 Yellow-rumped Warbler, White-crowned Sparrow, Ovenbird, Savannah Sparrow

26 Yellow-rumped Warbler, White-crowned Sparrow

27 White-crowned Sparrow, Yellow-rumped Warbler, Olive-sided Flycatcher, Carolina Wren, Chipping Sparrow, Gray Jay

28 Calliope Hummingbird, Rock Pigeon, Laysan Albatross

30 Hermit Thrush

31 Blue Grosbeak, American Kestrel, Broad-winged Hawk, Tree Swallow, Peregrine Falcon, Western Wood-pewee, Pine Grosbeak, Grasshopper Sparrow, American Pipit

35 Song Sparrow, Dark-eyed Junco, White-headed Woodpecker, White-crowned Sparrow, Evening Grosbeak, Steller's Jay, Tricolored Blackbird

36 Dark-eyed Junco, Northern Flicker, Dark-eyed Junco, Barn Swallow, Song Sparrow, Yellow-rumped Warbler

37 Bewick's Wren

38 Hermit Thrush, Greater Roadrunner, Black-necked Stilt, Common Raven

39 Blue Jay, Song Sparrow, Lawrence's Goldfinch, Common Snipe

41 Top row, left to right: White-crowned Sparrow, White-throated Sparrow,

 Next row: Song Sparrow, White-throated Sparrow, Yellow-rumped Warbler, White-throated Sparrow

 Bottom row: Great Cormorant, Great Cormorant, Long-tailed Cormorant, Gull-billed Tern

44 Black-throated Green Warbler, Yellow-rumped Warbler, Dark-eyed Junco, Common Yellowthroat

45 Brewer's Blackbird, Anna's Hummingbird heads, Ruby-throated Hummingbird, Ruby-throated Hummingbird, Costa's Hummingbird, Rufous Hummingbird, Anna's Hummingbird

46 Allen's Hummingbird, American Kestrel; group of Short-billed Dowitchers, Western Sandpipers, and Long-billed Curlew; Snowy Plover

47 Mallard, Great Blue Heron, Great Blue Heron, Red-tailed Hawk, Northern Pintail

48 Red-tailed Hawk, American Kestrel, Red-tailed Hawk, Golden Eagle, White-tailed Kite, Ferruginous Hawk, Merlin

49 Ferruginous Hawk, Great Horned Owl, Merlin

50 American Kestrels, Red-tailed Hawk, Gyrfalcon

51 Peregrine Falcon

52 Greater Scaup, Northern Pintail, Barrow's Goldeneye, Mallard,

53 Center of page, left: Ring-necked Duck; others are Greater Scaup

54 Mallard, Greater Scaup, Lesser Scaup,

55 Top three: Mallard

Group of three in center of page: Mallards and a Trumpeter Swan

Bottom row, left to right: Northern Shoveler, Canvasback, Common Merganser, Mallard, American Wigeon

56 Mallard, Green-winged Teal; Canada Goose "At rest"

57 Ruddy Duck

58 Greater Yellowlegs, Long-billed Curlew, Lesser Yellowlegs, Snowy Plover, Western Sandpiper, Long-billed Curlew

59 Great Blue Heron, Greater Yellowlegs, Willet, Great Egret

60 Top: Great Blue Heron, Great Egret

Row at left, top to bottom: Snowy Plover, Ruddy Turnstone, Black-necked Stilt, Short-billed Dowitcher, Long-billed Curlew

Right: Marbled Godwit (top) and Willet

61 Short-billed Dowitchers, Western Sandpipers, and Long-billed Curlew

62 Anna's Hummingbirds

63 Anna's Hummingbird, Rufous Hummingbird (bottom, left)

64 Red-tailed Hawk, White-throated Swift, Osprey

65 Red-tailed Hawk, White-tailed Kite (bottom)

66 American Kestrel, Ferruginous Hawk, Peregrine Falcon

67 Left column, Peregrine Falcons; right column, Red-tailed Hawk

68 Northern Harrier, Great Blue Heron, Red-tailed Hawk, Northern Harrier, Black-billed Magpie

69 Top circle: Red-tailed Hawk

Bottom: Black-billed Magpie, Northern Harrier

70 Western Gull, Red-tailed Hawk

71 Winter Wren, American Robin, and Calliope Hummingbird; two Black-billed Magpies, White-throated Swift; Little Gull, Western Gull

72 Osprey, American Kestrel

73 Common Raven

74 Double-crested Cormorant, Great Horned Owl

75 White-faced Ibis, Peregrine Falcon, Little Bee-eater, House Wren

76 Left, Rock Wren; right, Horned Lark

77 Bohemian Waxwing, American Crow

79 Merlin, Bullfrog, White-faced Ibis, American Coot

80 Cedar Waxwing

81 Horned Lark; American Wigeon, Northern Shoveler, Greater Scaup; Olive-sided Flycatcher

82 White Ibis; Great Egret, Roseate Spoonbill, White Ibis; Great Egret, Wood Stork, White Ibis, Snowy Egret; Common Snipe; Roseate Spoonbill, Little Blue Heron, Wood Stork; Red-breasted Sapsucker

83 Chin Spot Batis, Great Blue Turaco, Sacred Ibis, Black-headed Heron

84 Black Redstart, Crested Lark, Stonechat

85 American Robin

86 Hairy Woodpecker, Horned Lark, Broad-billed Roller, Hairy Woodpecker

87 Great Egret, Great Blue Heron

88 Horned Lark

89 Horned Lark

90 Dark-eyed Junco (Gray-headed), White-crowned Sparrow

91 Dark-eyed Junco (Gray-headed), Mountain Bluebird

92 Great Egret, Canada Goose, Great Egret, Hairy Woodpecker

93 Canada Geese, Canada Geese on tinted paper, Great Blue Heron, Ring-necked Ducks, Mallard, Snowy Egret

94 Clark's Nutcracker

95 Townsend's Warbler

97 Red-bellied Woodpecker, Black-backed Woodpecker, Hairy Woodpecker, Acorn Woodpecker

99 Olive-sided Flycatcher, Red-headed Woodpecker

100 Townsend's Warbler

101 Song Sparrow

105 Left, Tree Swallow; right, Hairy Woodpecker

106 Magnolia Warbler

107 Steller's Jay

109 Dark-eyed Junco

111 Wilson's Warbler

112 European Starling

117 Great Egret

ABOUT THE AUTHOR

John Muir Laws is a naturalist, educator, and artist with degrees in conservation and resource studies from the University of California, Berkeley; in wildlife biology from the University of Montana, Missoula; and certification in scientific illustration from the University of California, Santa Cruz. He is an Audubon TogetherGreen Fellow and a Research Associate with the California Academy of Sciences.

HEYDAY
into California

About Heyday

Heyday is an independent, nonprofit publisher and unique cultural institution. We promote widespread awareness and celebration of California's many cultures, landscapes, and boundary-breaking ideas. Through our well-crafted books, public events, and innovative outreach programs we are building a vibrant community of readers, writers, and thinkers.

Thank You

It takes the collective effort of many to create a thriving literary culture. We are thankful to all the thoughtful people we have the privilege to engage with. Cheers to our writers, artists, editors, storytellers, designers, printers, bookstores, critics, cultural organizations, readers, and book lovers everywhere!

We are especially grateful for the generous funding we've received for our publications and programs during the past year from foundations and hundreds of individual donors. Major supporters include:

Anonymous (6); Alliance for California Traditional Arts; Arkay Foundation; Judith and Phillip Auth; Judy Avery; Paul Bancroft III; Richard and Rickie Ann Baum; BayTree Fund; S. D. Bechtel, Jr. Foundation; Jean and Fred Berensmeier; Berkeley Civic Arts Program and Civic Arts Commission; Joan Berman; Nancy Bertelsen; Barbara Boucke; Beatrice Bowles, in memory of Susan S. Lake; John Briscoe; David Brower Center; Lewis and Sheana Butler; California Historical Society; California Indian Heritage Center Foundation; California State Parks Foundation; Joanne Campbell; The Campbell Foundation; Graham Chisholm; The Christensen Fund; Jon Christensen; Community Futures Collective; Compton Foundation; Creative Work Fund; Lawrence Crooks; Lauren B. Dachs; Nik Dehejia; Topher Delaney; Chris Desser and Kirk Marckwald; Lokelani Devone; Frances Dinkelspiel and Gary Wayne; Doune Fund; The Durfee Foundation; Megan Fletcher and J.K. Dineen; Richard and Gretchen Evans; Flow Fund Circle; The Fred Gellert Family Foundation; Friends of the Roseville Library; Furthur Foundation; The Wallace Alexander Gerbode Foundation; Patrick Golden; Nicola W. Gordon; Wanda Lee Graves and Stephen Duscha; The Walter and Elise Haas Fund; Coke and James Hallowell; Theresa Harlan and Ken Tiger; Cindy Heitzman; Carla Hills; Historic Resources Group; Sandra and Charles Hobson; Nettie Hoge; Donna Ewald Huggins; JiJi Foundation; Claudia Jurmain; Kalliopeia Foundation; Marty and Pamela Krasney; Robert and Karen Kustel; Guy Lampard and Suzanne Badenhoop; Thomas Lockard and Alix Marduel; Thomas J. Long Foundation; Sam and Alfreda Maloof Foundation for Arts & Crafts; Michael McCone; Giles W. and Elise G. Mead Foundation; Moore Family Foundation; Michael J. Moratto, in memory of Major J. Moratto; Stewart R. Mott Foundation; The MSB Charitable Fund; Karen and Thomas Mulvaney; Richard Nagler; National Wildlife Federation; Native Arts and Cultures Foundation; Humboldt Area Foundation, Native Cultures Fund; The Nature Conservancy; Nightingale Family Foundation; Northern California Water Association; Ohlone-Costanoan Esselen Nation; Panta Rhea Foundation; David Plant; Restore Hetch Hetchy; Spreck and Isabella Rosekrans; Alan Rosenus; The San Francisco Foundation; Santa Barbara Museum of Natural History; Sierra College; Stephen M. Silberstein Foundation; Ernest and June Siva, in honor of the Dorothy Ramon Learning Center; William Somerville; Martha Stanley; John and Beverly Stauffer Foundation; Radha Stern, in honor of Malcolm Margolin and Diane Lee; Roselyne Chroman Swig; Sedge Thomson and Sylvia Brownrigg; Tides Foundation; Sonia Torres; Michael and Shirley Traynor; The Roger J. and Madeleine Traynor Foundation; Lisa Van Cleef and Mark Gunson; Patricia Wakida; John Wiley & Sons, Inc.; Peter Booth Wiley and Valerie Barth; Bobby Winston; Dean Witter Foundation; Yocha Dehe Wintun Nation; and Yosemite Conservancy.

Getting Involved

To learn more about our publications, events, membership club, and other ways you can participate, please visit www.heydaybooks.com.